Painting like
the Impressionists

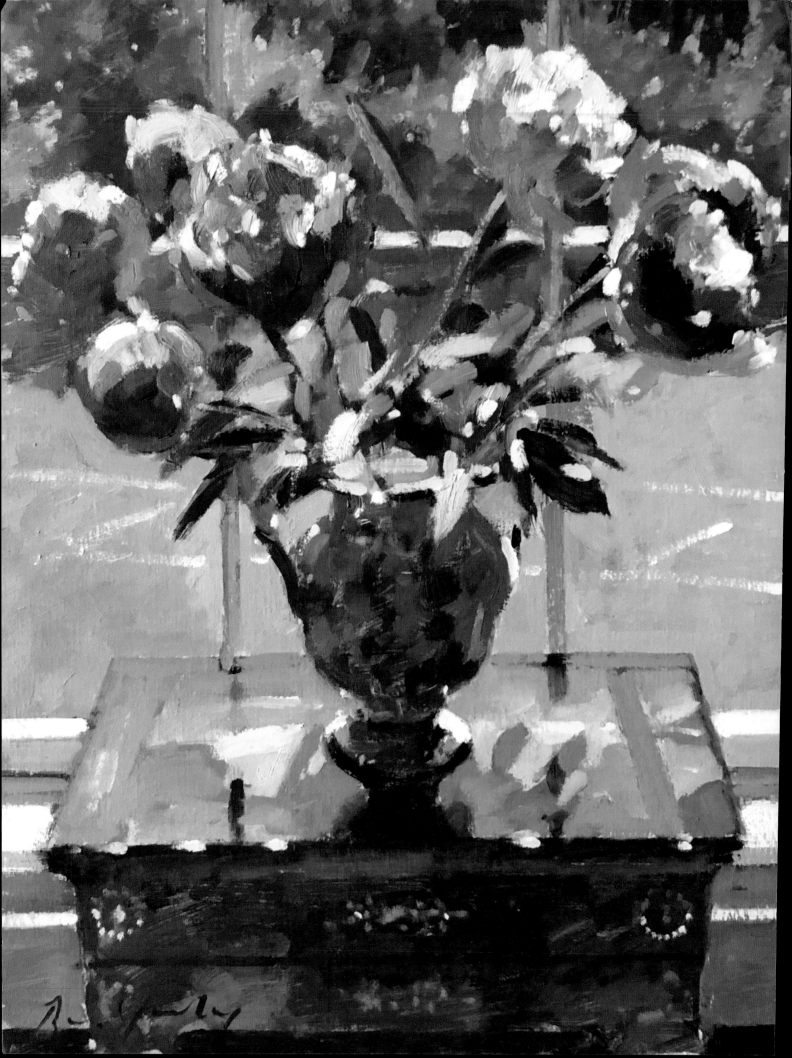

Painting like
the Impressionists

Bruce Yardley

THE CROWOOD PRESS

First published in 2021 by
The Crowood Press Ltd
Ramsbury, Marlborough
Wiltshire SN8 2HR

enquiries@crowood.com
www.crowood.com

British Library Cataloguing-in-Publication Data
A catalogue record for this book is available from the British Library.

ISBN 978 1 78500 910 5

Cover design: Peggy & Co. Design
Frontispiece: *Peonies and Work Table*, oil on canvas, 41cm x 30cm

Graphic design and typeset by Peggy & Co. Design
Printed and bound in India by Parksons Graphics Pvt. Ltd., Mumbai.

Contents

Preface

In writing this book I've tried to picture a reader who has been working in oils recreationally for some time, and who wishes their paintings to acquire something of the expressiveness they see in Impressionist art, the style of painting first brought to public attention by a small group of French artists in the third quarter of the nineteenth century. But I've also had in mind a wider audience, one that simply wishes to know more about how the Impressionists actually made their pictures. For it struck me, while doing the research for this book, how rare it is for conventional art historians to address this question head-on. Whatever practical information they do provide is often buried beneath a welter of less practical criticism.

I therefore discuss the Impressionists' working practices as well as my own, at least in the main text. As a result, readers might expect to see more illustrations of Impressionist paintings, which are here confined to the pages of the Introduction. In response, I'd say two things. First, the cost of including more of these pictures would have made this book prohibitively expensive; with a couple of shining exceptions, custodians of Impressionist works are not very generous in their image-sharing arrangements. Secondly, the most efficient way of consulting an Impressionist picture is to look it up online. All of these paintings are now out of copyright and in the public domain: anyone with a computer or tablet to hand can call up the relevant image in quicker time than it would take to flick through the pages of the book in which it is mentioned.

My book was put under contract in late 2019 and I began work on it at the start of 2020. The Introduction and most of Chapter 1 were written by the time that the UK went into lockdown over the Covid pandemic. This put me in a quandary. Should I refer to these events in the book, knowing that they were disrupting our painting lives? For one thing, the opening paragraph of the Introduction, in which I suggest that museums and public collections might solve their financial difficulties by putting on Impressionist-themed exhibitions, no longer held true. In the end, though, I decided to make no adjustment to what I had already written and to carry on as though nothing had happened, even at the risk of sounding out of date. Who knows what the world will look like when this book is published; the impulse to paint will never leave us.

Bruce Yardley
Bath, October 2020

◀ *St Paul's: Summer Morning*, oil on canvas, 122cm × 102cm

The Appeal of Impressionism

The board of a civic art gallery or museum struggling for funds would be well advised to put on an exhibition of Impressionist painting, for the public appetite for such shows – inevitably labelled 'blockbusters' – appears insatiable. If the resulting show can include the name Claude Monet, so much the better. Why has the wider public taken this form of painting, above all others, to their hearts?

There are, I think, a number of reasons. The vigorous brushwork and elimination of detail that you see in a typical Impressionist painting give it an immediacy and impact that more carefully wrought artworks often seem to lack. As a result, for me and for others, these pictures offer the most satisfying balance between representation and abstraction, with not too much and not too little left to the imagination. Next, the wide-ranging subject matter, presented without any predisposition to flatter, moralize or edify, is for most of us nearly always more congenial than the homilies in paint one so often sees in the pre-Impressionist era, and the mysteries in paint one so often sees in the post-Impressionist era. Finally, and perhaps crucially, the Impressionists' ability to suggest and summarize with a few deft dabs of paint invests the act of painting with an alluring simplicity. As Neil MacGregor wrote, when introducing an exhibition of Impressionist paintings at the National Gallery in the 1990s, 'There is the heady illusion that we could almost have painted these pictures ourselves.'

Before I expand upon these opening remarks I should explain that I am really referring to the first flush of Impressionism, the period dating from the late 1860s through to the early 1880s. The later works of the main protagonists, while still labelled Impressionist in most art books, only rarely provide a working model for the kind of painting I am advocating here. Even Monet, who is justifiably called the 'quintessential' Impressionist, had by the mid 1880s abandoned the 'quick impression' in favour of a much more laborious style, in which a densely worked paint surface is assembled over very many sittings (he was known to complain about how long these paintings took him). The huge, rhythmic waterlily compositions he undertook in the last thirty years of his life are different again, and have more in common with Expressionism than with Impressionism. Camille Pissarro was similarly mercurial, turning the interest in broken colour that he shared with other Impressionists into a pointillist obsession: the resulting works are demonstrations of colour theory that have little to do with Impressionism as I understand the term.

◀ *Mixed Flowers in the Window*, oil on canvas, 76cm × 51cm

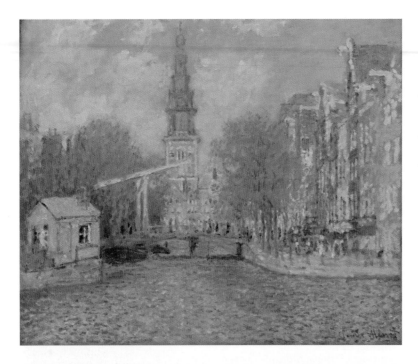

Claude Monet, *The Zuiderkerk, Amsterdam,* 1874, oil on canvas, 55cm × 65cm

Monet's canvases became much more laboriously worked after the mid 1870s, when the number of sittings he required to complete his paintings spread over days, weeks and even months. This painting just predates that period, and we can perhaps see the beginnings of his later manner in the dense broken colour of the canal water.

(Courtesy Philadelphia Museum of Art. Purchased with the W.P. Wilstach Fund)

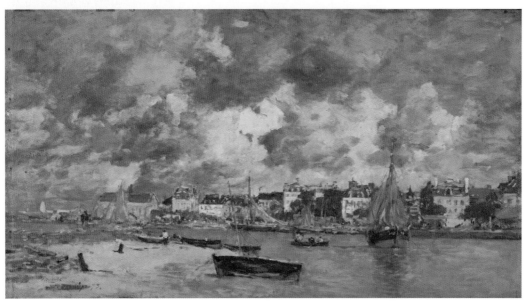

Eugène Boudin, *View of Trouville,* 1873, oil on panel, 32cm × 58cm

Boudin was a proto-Impressionist, inasmuch as he introduced the young Monet to the pleasures of plein air painting in his native Normandy, and continued to exert an influence over Monet and Monet's student colleagues Renoir and Sisley. Many of Boudin's landscapes were effectively cloudscapes, for which he had a real facility – Corot called him 'King of the Skies'.

(Courtesy Philadelphia Museum of Art. John G. Johnson Collection)

On the other hand, the principles that underpinned the pure Impressionism of the 1870s were quickly taken up elsewhere, so for every lapsed Impressionist there is a credible alternative whose paintings *do* provide a good working model for the kind of painting I am advocating. I am thinking here particularly of the Englishman Walter Sickert and the American (resident in London) James Abbott Whistler, two painters who are cited frequently throughout this book. Sickert in his younger days was a disciple of Degas, and although his painting methods owed little to Impressionist precept, inasmuch as he disdained painting out of doors

('Never paint from nature', he told his students), the pictures themselves were imbued with the spirit of Impressionism. The same is true of Whistler's works, especially his spare, atmospheric crepuscules and nocturnes.

Sickert and Whistler were both instrumental in introducing French Impressionism to the English art establishment, who were initially resistant to its charms. By the end of the nineteenth century, however, England was developing its own native brand of Impressionism, one decidedly less colourful and more tonal than that of the French. And it is in the context of English Impressionism that I must mention

Claude Monet, *Railway Bridge, Argenteuil*, 1873, oil on canvas, 54cm × 73cm

Rail travel helped free the artist from the studio, so I find it somehow fitting that railways feature in some way or other in so many Impressionist paintings. This is Monet's depiction of a railway bridge near his then hometown of Argenteuil; the colours of the sunlit engine steam are duplicated in the bridge pillars and the various river reflections.

(Courtesy Philadelphia Museum of Art. John G. Johnson Collection)

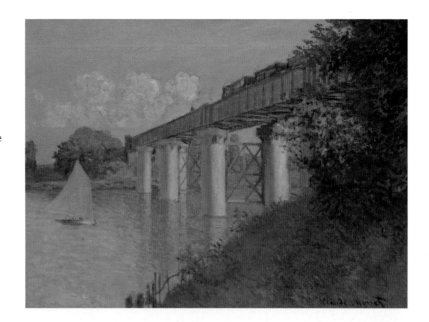

Alfred Sisley, *Flood at Port-Marly*, 1872, oil on canvas, 46cm × 61cm

Sisley is less well known than his fellow students Monet and Renoir, but he never suffers in the comparison when they shared subject matter. Sisley and Monet sometimes painted together in the late 1860s and early 1870s, and their paintings are easily confused. This low-horizoned, gentle painting has a warm glow, due in large part to the happy combination of the orange of the building's lowest storey, and the pale green-blue of the floodwater.

(Courtesy National Gallery of Art, Washington. Collection of Mr and Mrs Paul Mellon)

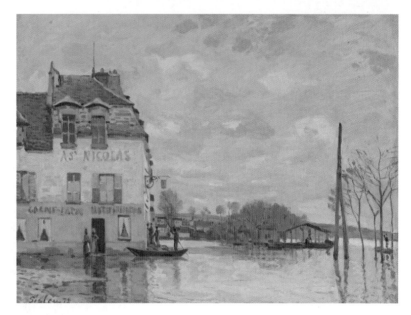

a further painter, one still active today, whose work has been a big inspiration to me: Ken Howard. His subject matter is very wide and his influences are not obvious, though Monet, Sickert and Eugène Boudin, the proto-Impressionist who specialized in small-scale beach scenes, all come to mind at different times when viewing his oeuvre. The point is, there now exists a rich and varied Impressionist tradition, and all of us who operate within it today might take our lead from any number of different painters from the last 150 years.

The original French Impressionists were reacting against the art traditions in which they had been schooled. Each of them was academically trained, with the sole exception of Berthe Morisot, who nevertheless received instruction from several professional painters, including the celebrated Barbizon artist Camille Corot (women were not allowed to enrol at the École des Beaux-Arts until 1897). The quartet of Monet, Renoir, Sisley and Bazille attended the same atelier, and by the end of the 1860s all the key participants in what were to be the 'Impressionist' exhibitions of the 1870s and 1880s already knew each other well. Their collective self-promotion was intended, in the first instance, to create an alternative marketplace to that of the Salon, the annual

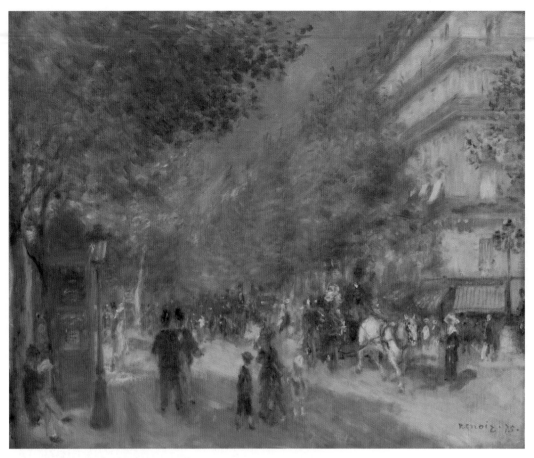

Auguste Renoir, *The Grands Boulevards,* 1875, oil on canvas, 52cm × 63cm

Renoir's brushwork was always distinctive – 'he paints with balls of wool', said the acerbic Degas – and the general view is that it was better suited to soft, sensual portraiture than to the unromanticized landscape of Impressionist preference. Here, though, the strong composition and relatively restricted palette give the painting a solidity that Renoir's work sometimes lacks.

(Courtesy Philadelphia Museum of Art. The Henry P. McIlhenny Collection in memory of Frances P. McIlhenny)

exhibition closely regulated by the École des Beaux-Arts where young painters would hope to find patrons, and the kind of art promoted by the renegades was quite different from that sanctioned by the École.

The best way to appreciate that difference is to take a chronological stroll through the nineteenth-century rooms of any major public art gallery. In the mid-century rooms you will encounter intricately designed, highly romanticized interpretations of historical or mythological narratives, executed in sombre colours with theatrical lighting effects and a detailed, superfine finish. Enter the rooms given over to Impressionism, however, and you will encounter the exact opposite – spontaneous, unsentimental, boldly coloured and wilfully under-finished observations of ordinary life as lived at the time. It's easy to see why the names of Monet, Renoir *et al* are well known today, while those of the Salon favourites such

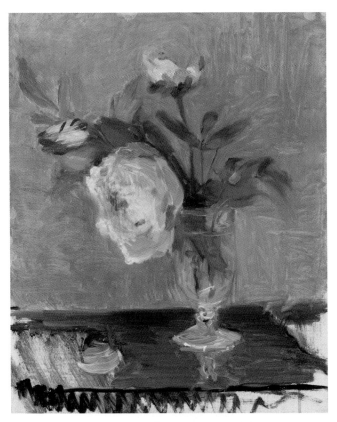

Berthe Morisot, *Peonies,* c 1869, oil on canvas, 41cm × 33cm

As the only woman among the original Impressionists, and perforce as the only artist not to have received formal training (women could not enrol at the École des Beaux-Arts until the 1890s), Morisot was condescended to throughout her career. Yet her brushwork and paint-handling were as vigorous and original as any. This small, quite early picture of peonies, a favourite flower subject among the Impressionists, displays two of her traits – the warm grey background, scrubbed on in such a way as to allow the under-tint to shine through, and the idiosyncratic zig-zag brushwork at the bottom.

(Courtesy National Gallery of Art, Washington. Collection of Mr and Mrs Paul Mellon)

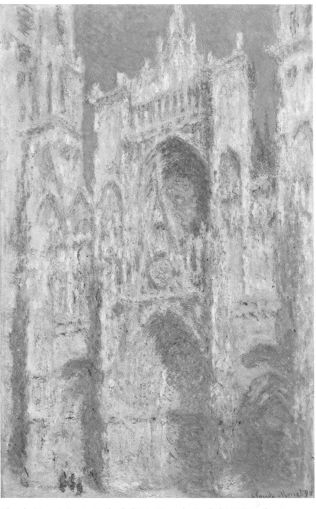

Claude Monet, *Rouen Cathedral, West Façade, Sunlight,* 1894, oil on canvas, 100cm × 66cm

By the time Monet came to paint his Rouen Cathedral sequence, working from a cramped milliner's shop opposite, he had evolved a painting style that created a very dense paint surface, achieved by working on a large number of canvases at the same time over a long period. The pictures were thus very different from the 'quick impressions' he had produced as a young man. In this canvas the sun seems to be melting the surface decoration of the Gothic building.

(Courtesy National Gallery of Art, Washington. Chester Dale Collection)

as William-Adolphe Bouguereau, and their Royal Academy counterparts across the Channel, are not. To the modern eye there is something artificial and even hypocritical about those polished and pious Academy-approved canvases; the Impressionist works, with their unaffected celebration of the everyday, seem honest and reliable in comparison.

That unaffected celebration of the everyday took many forms. It might be a jovial, well-dressed party of young professionals enjoying a dinner-dance, or a solitary, care-worn derelict nursing a drink in a bar. It might be a gang of labourers mending the flagstones of a boulevard, or that same boulevard bedecked with flags on a public holiday. It might be a cathedral of God or a cathedral of the railway. The weather might be sunny, cloudy, or rainy; there might be snow or fog or floods, or gusts of wind. Refusing to accept the long-held belief that some subjects were more worthy than others of

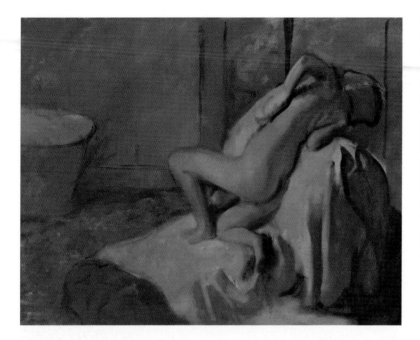

Edgar Degas, *After the Bath, Woman Drying Herself*, c 1896, oil on canvas, 90cm × 117cm

Degas had a semi-detached relationship to the younger members of the Impressionist group; he participated in all but one of the group shows but his working methods were quite different from theirs, relying as he did on a careful assemblage of studio drawings before undertaking the actual painting. He's best known for his informal portraits of ballet dancers and women at their toilette; this large canvas is a late, hot-coloured example of the latter.

(Courtesy Philadelphia Museum of Art. Purchased with the funds from the estate of George D Widener, 1980)

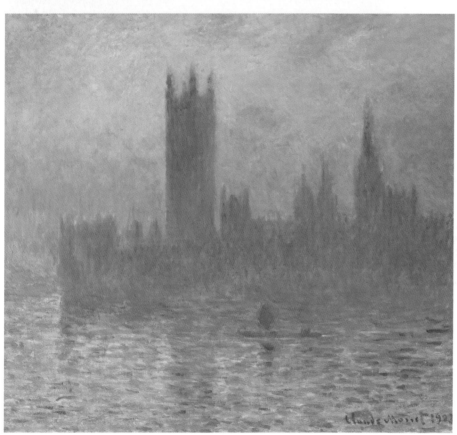

Claude Monet, *The Houses of Parliament, Sunset,* 1903, oil on canvas, 81cm × 93cm

Monet made three painting trips to London in successive years from 1899–1901, finishing many of the resulting paintings in his studio on his return to Giverny, as the date here demonstrates. He particularly liked the fog and smoke that settled over the Thames, and in consequence there is a soft, ethereal quality to these later works. The younger Monet, the Monet who first came to London in 1870, would have painted these buildings with greater definition and solidity of colour.

(Courtesy National Gallery of Art, Washington. Chester Dale Collection)

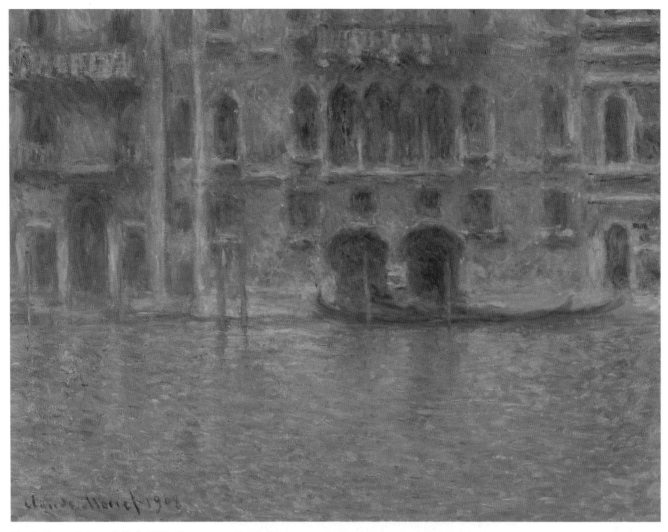

Claude Monet, *Palazzo da Mula*, 1908, oil on canvas, 61cm × 81cm

Monet's much-anticipated trip to Venice in the autumn of 1908 was his last major painting excursion; widowed once more, he bunkered down in his Giverny water garden, painting the enormous, mural-like canvases that were to dominate his last years. The viridian-and-violet pulse of this Venetian painting shows how far he had departed from his more literal palette of the 1860s and 1870s. Is it in fact a symptom of the cataracts that were increasingly to plague him?

(Courtesy National Gallery of Art, Washington. Chester Dale Collection)

the artist's attention, the Impressionists put on a pictorial variety show, the different exhibits united by a sense of light and movement captured in paint.

All of this is brought into sharper relief when you wander into some of the other rooms in that hypothetical gallery I referred to above. The medieval and Renaissance rooms will probably yield a high count of gurning faces and writhing limbs belonging to saints and sinners caught in the throes of religious agony or ecstasy. The seventeenth- and eighteenth-century rooms will almost certainly parade the alternately smug and stern countenances of the rich and powerful of the temporal world, sharing wall space with land battles and sea battles and menageries of freshly killed wild animals posed unappetizingly upon the dining table. As for the twentieth-century rooms, they can be relied upon to plot the course of a growing introspection, in which the mental and emotional health of the artist is allowed to assume the role of the subject itself. I don't mean to denigrate

non-Impressionist art with these reductive caricatures. Outstanding paintings have been produced in every era. But it's hard to deny that for many of us there is more comfort and joy to be had from the paintings of the Impressionist era than from those of other eras. Indeed, for unapologetic fans like me, the dozen-odd years during which French Impressionism first came to public notice represent the extended moment when painting was at its most humane.

Those years also represent the extended moment when art acquired a new painterly language without sacrificing its ability to communicate a recognizable and believable image of the visual world. With a few notable exceptions such as Velázquez, Frans Hals and Rembrandt, earlier artists rarely allowed the actual paint surface to feature prominently in the finished work: the paint was smoothed and modelled as if to divert attention away from the medium. The Impressionists were far more willing to let us see their pictures for what, in essence, they were: agglomerations of different marks of pigment. A typical Impressionist painting gives us a strong sense of the artist's pleasure – and occasionally frustration – in the act of putting paint to canvas. The result is artwork with vastly more textural interest than what went before.

The Impressionists' vibrant palette was another expression of this painterly quality. Informed by the latest thinking in colour theory, they strove to suggest light and form by means of firmly differentiated, juxtaposed brushstrokes of paint. Seurat, Pissarro and others developed this 'broken colour' into pointillism, covering the canvas with a mosaic of differently coloured dots – too methodical a technique to be truly impressionistic, but the use of broken colour in whatever guise had the effect of heightening the colour register. (It helped that the artists had access to newly available pigments of greater vividness and intensity, but we can't make too much of this as their non-Impressionist contemporaries enjoyed the same access.)

Now, one person's painterly quality is another person's sketchiness, and if earlier artists had routinely displayed the oil sketches they had made in preparation for more fully worked out canvases – Constable and Corot come to mind here – we might not be so ready to credit the Impressionists with inventing a new way of painting. For the oil sketch was an integral part of the formal process of art composition, and the French had evolved a rich vocabulary to distinguish the different types: *étude, pochade, esquisse, croquis, ébauche.* Monet and his colleagues sometimes appended these terms to the titles of their paintings, especially in the first 'Impressionist' exhibition of 1874, but by signing and exhibiting them as artworks in their own right they closed the gap between the sketch and the finished painting (*tableau*, in academic parlance) and changed forever the way in which art was made and perceived.

One important difference between a sketch and an Impressionist painting has only recently come to light. Sketches are generally made at speed entirely in front of the motif, and it's widely assumed that this is how the Impressionists worked. They themselves did much to foster this belief, Monet disingenuously claiming never to have had a studio. But we now know, thanks to close analysis of the paint surface in a number of iconic Impressionist canvases, that the vast majority of these paintings were completed over several sittings, and that much of the work would perforce have been done in the studio. The most iconic of them all, Monet's early morning depiction of Le Havre harbour entitled *Impression: Sunrise* (1872), is now reckoned to have been a three-session picture, rather than the dashed-off study it purports to be.

The Impressionists have always had their detractors, of course. 'Five or six lunatics, one of whom is a woman' was how *Le Figaro* described the group at the time of their second exhibition, in 1876. Specifically, they were criticized for producing scruffy and unfinished work, and for being passive translators of the scenes before them, substituting straight observation for the more active task of imaginative construction. Cézanne said as much when he remarked that Monet and his like 'caught', while he and his supposedly more ambitious post-Impressionist colleagues 'created'. This condescending attitude has continued ever since, with modern critics apt to dismiss Impressionist art as intellectually lightweight.

The trouble is, these readily comprehensible pictures offer the salaried explainers of art far less scope for scholarly exhibitionism than do other painting types. With the Old Masters they can have fun elucidating the often-arcane iconography, and with abstract art they can have even more fun saying pretty much whatever they please, secure in the knowledge that most of their assertions will be exquisitely immune to proof or disproof. Even the ones who approve of Impressionism seem to resent their subject's accessibility, and end up writing the kind of impenetrable English that is all too common in academic art criticism. For example, the curator of *Impression: Painting Quickly in France, 1860–90* – an enjoyable and influential exhibition, as it happens – after making the reasonable if unexceptional point that the Impressionists, with their well-documented interest in the science of optics, were more acutely aware than previous generations that a scene will look different when transposed onto the single plane of a canvas, inflicted the following sentence on his readers: 'This dissociation from the material and three-dimensional and the concomitant embrace of the optical or two-dimensional is a primary paradigmatic in artistic consciousness, the radical nature of which has not yet been properly appreciated.'

The contrast with Monet's limpid advice, as recalled by his neighbour the American artist Lilla Cabot Perry, could not be starker. It's often quoted but is worth quoting again, as it incidentally reveals that Monet possessed a strong abstracting impulse:

> When you go out to paint, try to forget what objects you have before you – a tree, a house, a field, or whatever. Merely think, here is a little square of blue, here an oblong of pink, here a streak of yellow, and paint it just as it looks to you, the exact colour and shape, until it gives your own naïve impression of the scene before you.

Sounds easy, doesn't it? His words lend weight to Neil MacGregor's comment, quoted at the start of this Introduction, that these pictures look like something we could almost do ourselves. That's the rationale behind *Painting like the Impressionists*, and while I don't for one minute suggest that painting *is* easy, I do feel there's been a conspiracy among art professionals, painters and critics alike, to create a mystique around it, as something requiring God-given talent honed by years of training and a lifetime of practice. This can only be discouraging for the would-be painter.

For my part, I've always believed that a successful painting comes about at a point where skill intersects with taste, and that no amount of the one will compensate for a serious deficiency of the other. Taste is a slippery concept, I know, and there are folk who maintain it is unimportant, or at any rate unteachable. Degas went so far as to state that 'taste kills art'. That sounds to me like the kind of thing someone would say *pour épater les bourgeois*, a favourite pastime of the French artistic community in the late nineteenth century. (*Épater* has no direct equivalent in English, lying somewhere between 'shock' and 'provoke'.) Degas seems here to equate taste with a deplorably genteel aesthetic sensibility, whereas I see it as a vital critical faculty, one that allows us to judge what makes a fitting subject, or a satisfying composition, or a harmonious palette, and so on. By this definition, the Impressionists showed consistently good taste throughout the painting process. It's therefore my hope that this book, by introducing you to the philosophies and practices of the Impressionists, and by demonstrating how these have shaped my own painting style, will help you to attain a bit more taste, as well as a bit more skill.

Materials and Equipment

The person who wishes to paint like the Impressionists will be comforted to know that many of the painting products we use today are not so very different from those available to the Impressionists themselves. The nineteenth century saw profound technical and commercial innovations in the art world, with the arrival onto the marketplace of new and more portable paints, different types of paintbrush and conveniently prepared canvases, all dispensed by a new breed of specialist art retailer. For the first time ever, oil painting could be taken up as a hobby as well as a profession. These developments helped to loosen the grip of the academic schools of painting, and in the wake of that, a painting style that took advantage of these new materials became, if not inevitable, then at least very likely. That painting style turned out to be Impressionism.

PAINTS AND PALETTE

In the first seven decades of the nineteenth century a large number of new chemical compounds such as chromium and the chromates were discovered by chemists and subsequently exploited by paint manufacturers, with the result that the palette of colours available to the Impressionists was almost unrecognizable from that available to painters a generation or two before them. Furthermore, from the mid century onwards the finished paint was sold in tin tubes very similar to those we buy today. This followed the invention in 1841 of a squeezable, re-sealable paint tube by an American

portrait painter, John Goffe Rand, living in London. The importance of this invention to the Impressionist credo cannot be overemphasized. According to his son Jean, Renoir is supposed to have declared, 'Without paints in tubes there would have been nothing of what the journalists were later to call Impressionism.' Why? Because the portable paint tube made it infinitely easier for the artist to leave the studio and set up their easel in the great outdoors. Until then, the normal storage vessel had been a pig's bladder, which, being insufficiently airtight, allowed the paint to gradually harden as the oil that bound it oxidized.

Renoir himself was fastidious about his paints, using colours hand-ground for him by the colour merchant Mulard. Monet, by contrast, seems to have been much more casual about the provenance and preparation of his paints. The Impressionists as a whole were united in their enthusiasm for the new pigments, nearly all of which were more intense and vivid than those in use before. This goes at least some way towards explaining why their palette was so much more vibrant than that of their immediate predecessors, although the widely held belief that they used pure, unmixed pigments in preference to mixing the colours has been exploded by recent analysis of the pigments used in a representative group of Impressionist works. An artist such as Monet might construct his colours from elaborate blends of many different contributing pigments.

Today's painter has a wider choice of paints than their nineteenth-century counterpart for in addition to the continuing development of new colours, there are now different qualities of paint made for different sectors of the

◀ *Freesias and Bath Abbey,* oil on canvas, 76cm × 51cm

market: artists' quality and students' quality. Which should you buy? The standard advice is for beginners to start with students' paints and only trade up to the much more expensive artists' paints once they have reached a certain level of proficiency. I don't question the logic of this but I do think you should invest in both in the first instance and compare them in order to understand better what the extra money gets you. Artists' pigments are more finely ground and consequently more powerful than students'; also, the rare or difficult-to-produce pigments such as the cobalts and cadmiums are generally excluded from the students' range. Bear in mind that, being more powerful, the artists' paints stretch further, which helps offset the difference in cost. I'd be especially cautious of buying tubes labelled 'hue'; this indicates that a cheaper substance has been substituted for the named pigment, and in my experience hues are always frustratingly weak.

There is no reason not to mix artists' and students' paints if you find that some colours warrant the extra cost while others do not, though you may find the difference in pigment strength complicates the business of mixing colours. (When mixing paints of unequal strength, you should start with the weaker and add the stronger; if you do it the other way round you are liable to end up with more of the mixture than you need.) Nor is there any reason to keep to the same brand: the paints I use are a mix of Old Holland, Michael Harding and Winsor & Newton brands. Even if you restrict yourself to artists' quality, the prices of individual colours vary tremendously; mine range in price from about £6 a tube right up to a whopping £50 a tube – the culprit here is Old Holland Cerulean Blue, in case you were wondering. I would, though, resist the temptation to conduct lengthy experiments with different pigments: working with the same colours allows you to get to know their strengths and weaknesses, and how they perform together.

How many colours you choose is really a matter of taste. I currently have twelve on my palette, and lay them all out each time, squeezing out token amounts of those I feel I might not use: a small wastage of paint is, to me, less important than having the colours in their familiar positions with their familiar neighbours, allowing muscle-memory to take me to the colour I want almost without thinking. Other painters restrict or expand their palette according to the subject in hand: Monet, for example, used ten pigments in *Gare St-Lazare* (1877), but at least fifteen in *Bathers at La Grenouillère* (1869). However it is organized, your palette should enable you to obtain whatever colour you want while at the same time maintaining chromatic harmony.

Blues

Three blues are on my palette – French ultramarine, cobalt and cerulean. All three were staple colours in the Impressionist palette and differ from one another both in hue and tone. The synthetic form of ultramarine (as against the natural form, the rare and precious lapis lazuli), French ultramarine was first produced in the 1820s and was greatly favoured by Impressionist painters, not least because it was far cheaper than cobalt or cerulean. It is the warmest and darkest of the three blues, and like many painters both today and in the Impressionist era I use it as a base colour in my darks and as a substitute for black: mixed with burnt umber, it makes a rich warm black. As I tend to work from dark to light, ultramarine and burnt umber are actually the first two paints I squeeze on to my palette, laying the colours out from left to right (I am left-handed). Ultramarine makes a good all-round mixing pigment on account of its relative transparency, which prevents the colours containing it from becoming too muddy.

I rarely use ultramarine as a pure blue, for which I prefer the softer cobalt, especially for skies. Cobalt was discovered in 1802 and quickly adopted by painters, who appreciated its extraordinary stability. Its only disadvantage was its cost, unfortunately still the case today. Costlier still is cerulean, another cobalt derivative, with a greenish tinge not unlike turquoise. I'd be a richer man if I had found a good alternative to cerulean, yet it earns its place on the palette as a vital component of sky-blue colours, particularly for that section of the painting where the sky bleeds down to the horizon. I've tried doing without it from time to time, mixing cobalt with Naples yellow or cadmium lemon in the hope of replicating cerulean's blue-blue-green qualities, but it's never been quite the same.

Earth Colours

'Earth colour' is art world jargon for the six members of the Brown family (raw and burnt sienna, raw and burnt umber, red and yellow ochre) plus a dirty green, terre verte. All are inexpensive and relatively quick drying, though they differ in power and transparency. The Impressionists used them with discretion; their general feeling was that these colours could be mixed from other, higher-keyed pigments. The drab colours in Monet's paintings of bathers at the Paris pleasure resort of La Grenouillère were often combinations of much brighter pigments. But while it is true that browns can always be mixed, my own feeling is that earth colours are an essential component of a balanced palette, and mixing them from the primaries (red, blue and yellow), as well as being more

San Giorgio Maggiore and the Lagoon, oil on canvas, 76cm × 61cm

The blues of the sky and water have here been transmuted into soft greenish-blues and lilacs with the additions of Naples yellow and permanent rose, and by repeating these tints throughout the painting I've tried to bring the upper and lower halves of the composition closer together.

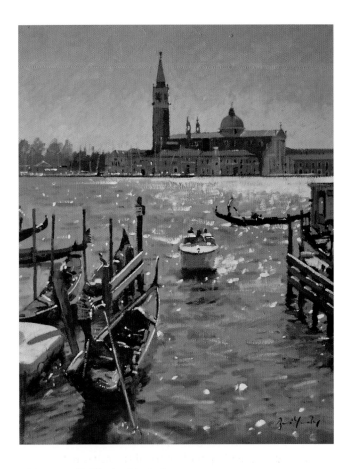

Browns Brasserie, Bristol, oil on canvas, 51cm × 61cm

One of the attractions of this subject was the subdued, restricted palette, which aptly reflects the name of the establishment. At first sight it looks as though an earth palette has been deployed, but I would have laid out my twelve standards in the normal way, and a closer look reveals that all twelve colours have a role to play somewhere or other in the composition. A second, more sentimental attraction of the subject for me is that, before Browns took it over, this used to be my university refectory. It served up pretty basic fare, and I can't think that the interior was as paintable in those days.

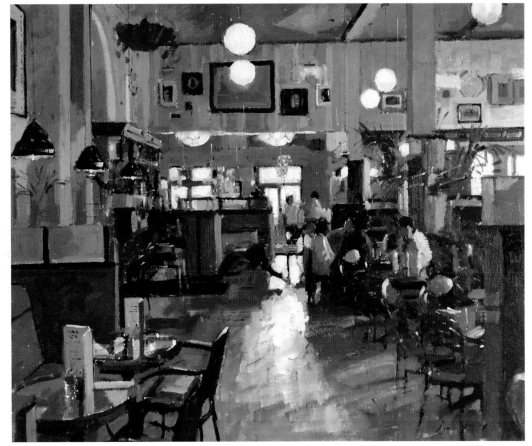

expensive, slows the painting process unnecessarily for a painting style where speed is desirable.

Burnt umber is a particularly useful, powerful dark pigment, and nearly all my darks will contain at least some burnt umber. I've always preferred the siennas to the similar-hued ochres as they're slightly more transparent, and therefore perform better when thinned. This is why I use a combination of raw and burnt sienna as a general-purpose warm ground on which to paint (the burnt sienna is much the stronger of the two, so the ratio is roughly four parts raw sienna to one part burnt sienna). My three earth colours alternate with the three blues on my palette (in order from left: ultramarine, burnt umber, cobalt blue, raw sienna, cerulean blue, burnt sienna) as I find I often use them together in various combinations in order to obtain the sludgier colours, as well as my darks.

It occurs to me that another reason for the Impressionists' sparing use of earth colours is that earth colours are better suited to indirectly lit indoor subjects than to directly lit outdoor subjects. Such a theory is supported by the comments of the modern English Impressionist Ken Howard, who has written that he uses an earth palette for his studio paintings and a limited primary palette for his beach paintings. His phrase 'earth palette' should not be taken too literally: if you excluded all non-earth pigments from your palette you would end up not with a painting but with a *camaïeu* in brown. (*Camaïeux* are images based on varying tints of the same colour, often made by artists as an aid to understanding the tonal range of the painting in progress.) It's really a question of using more or fewer of certain colours depending on the subject matter, and to that extent the indoor/outdoor, earth/primary division holds true.

Reds

The highest quality, most intense reds for use today are the cadmiums. They are always expensive but are so powerful that you never need much on your palette, and the various red 'hues' on the market are simply no substitute. Cadmium red did not appear until 1892 and was not in full commercial production until the twentieth century, so this was a colour denied to the Impressionists. Their reds were either vermilion or the lake pigments, all of which had good intensity and colour saturation.

Reds are not easy to use as part of a mix, especially as the cadmiums are all opaque colours. Our knowledge of the colour spectrum might lead us to suppose that red and blue make mauve or purple when in fact it makes a much dirtier colour akin to brown. That may explain why cobalt violet, which first appeared in 1859, was so enthusiastically taken up by the Impressionists. Monet had it on his palette by the end of the 1860s, using it especially for his purple-hued shadows in sunny compositions. I myself have used a ready-mixed mauve from time to time, but clean mauves and purples may be created from a mix of blues and pink-reds such as permanent rose or alizarin crimson, and I've since dropped mauve from my palette.

Yellows

In the Impressionist era chrome yellow was versatile and cheap to manufacture but not very stable, having a tendency to fade or discolour. This persuaded most Impressionists to switch either to cadmium yellow, available since the 1840s, or Naples yellow. Renoir abandoned chrome yellow in favour of Naples yellow in the 1880s, while Monet replaced his chromes with cadmiums. Cadmium is still the principal bright yellow used by artists today, ranging in temperature from lemon, the coolest, right up to orange. These yellow cadmiums have all the virtues and vices (the high cost) of their red cousins.

I have three yellows on my palette: cadmium lemon, cadmium yellow, and Naples yellow. Naples yellow is more of a buff colour, and I use it – specifically, Winsor & Newton Naples Yellow Light – mainly as a white substitute. Until a few years ago the active ingredient of this paint was zinc oxide and the paint itself was quite weak: I went through it by the bucket. Then in about 2003 the active ingredient was changed to titanium dioxide and suddenly the colour was colder, more opaque and far more powerful. This took a bit of getting used to, but was a welcome change as it made it less expensive and even more useful as a white substitute.

Greens

The use of ready-mixed green pigments is controversial. Many painters, myself included, avoid using pre-mixed greens, and indeed many painters could be said to avoid using greens altogether. In their landscape paintings Barbizon School representatives such as Corot and Courbet often employed silvery greys and earthy browns where, with a more literal representation on their part, we might have expected greens.

What is it about green that painters don't like? According to Ken Howard, 'Green is difficult to fit into a tonal sequence – it can so easily jump out of place'. That's a statement in need of some further explanation, but I *think* I know what he means. Green is a pervasive colour that can easily dominate those

Sezincote House, South Front, oil on canvas,
51cm × 61cm

I very rarely do paintings in which green
features prominently. When it does, as
here, I try to subdue it with Naples yellow
and one or two of the earth colours;
the green of the grass was more vivid in
reality, and would have been less restful
on the eye. A brighter green would also
have fought with the pale turquoise of
the copper-clad onion dome on this
very exotic-looking country house in the
Cotswolds.

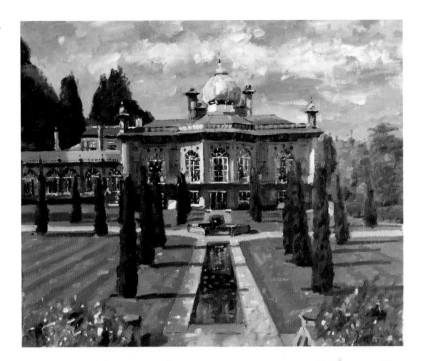

Kensington Gardens Picnic, oil on board,
20cm × 25cm

Another picture in which I have taken
down the green of the grass, which has
enabled me to get more value from the
sunlit lower leaves of the horse chestnut
tree, picked out in lemon-green.

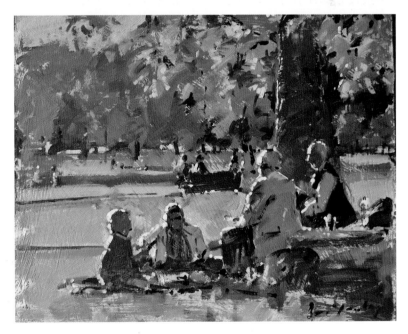

around it. It can also become too acidic and wearing on the eye, especially if you've used lemon yellow in the mix. The Impressionists saw things differently, being enthusiastic users of ready-mixed greens such as *Vert Véronèse* (Emerald Green), a strong, even lurid, colour that for them was impossible to obtain from any straightforward combination of other pigments. Viridian, a powerful, transparent pigment first made in the 1830s, was also popular with the Impressionists, as it is with painters today. I detect its presence a lot in the early landscapes of Morisot, but its bluish note is not something I myself see in nature, except occasionally in watery reflections, so the Morisot grass often looks to me like water. Viridian comes into its own for fabrics, awnings and so on, whenever a deep turquoise-like colour is wanted; taken down with a little white it also provides the closest approximation to the green of a traffic light.

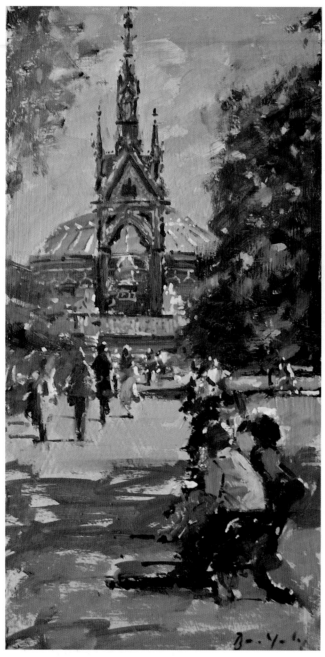

Albert Memorial, oil on board, 30cm × 15cm

This view of Kensington Gardens was painted earlier in the day when the sun was higher, which makes for a more colourfully diffuse palette. I've pushed the memorial into the top half of the painting so that I can include the foreground figures on benches; all the figures in the painting lead the eye towards the memorial.

Black and White

There's a rather fatuous debate in both art and science circles over whether or not black and white are actually colours. They may not be part of the colour spectrum but they are manifestly pigments that artists use, so to distinguish them from spectral colours seems pedantic. That said, black is frequently omitted from artists' palettes on the grounds that it is easily replicated with combinations of other dark pigments: ultramarine plus burnt umber, for example. Nor is it an easy colour to mix with, as it dirties any blend it contributes to. Its normal role is two-fold: first, as a colour-neutral background for portraits and certain still life subjects (Whistler erected a black velvet cloth as a backdrop for his full-length portraits), and secondly, for the depiction of black clothing. The only time I have used black was for a portrait of my wife wearing a black evening dress; the problem was that it was by far the slowest-drying paint I had come across, and I've not used it since. (The pigment in question was a Winsor & Newton artists' colour, though I can't now recall whether it was the warm, brown-tinged ivory black – the name derives from its traditional extraction from roasted elephant tusks – or the cooler, bluish-tinged lamp black. What surprises me is that Winsor & Newton currently categorize both these colours as 'medium-drying'; perhaps they've changed the recipes.)

The Impressionists were divided over the use of black. Many of them initially made much use of ivory black, often mixed with other pigments. Monet's tutor Charles Gleyre taught his pupils to use it as the base from which to judge other tones, and Renoir in particular was said to be horrified at the notion that black might be banished from the palette. Later on, however, many did banish it, citing the adage, 'there is no black in nature'. Monet recalled that he abandoned black while still 'quite young', to the exasperation of Sargent, who, painting alongside him and in need of some black paint, despaired of continuing his own picture when he learned that Monet had none. This reveals, I think, that Sargent was at heart a portraitist, not a landscapist.

The most-used whites in Impressionist times were lead-based, even though zinc white had appeared as an alternative as early as the eighteenth century. Lead white was later marketed as flake white, before its withdrawal from the market owing to the toxicity of its lead content. The two basic whites on the market today are zinc and titanium. They are very different in performance, and it is feasible to have both in your box of colours. Zinc white is quite transparent, making it good for glazing and for lightening colours without

Thames Sparkle, oil on canvas, 51cm × 61cm

The serpentine course of the Thames as it flows through London creates a number of sun-on-water subjects at different times of day, with much greater clarity of light than Monet would have enjoyed when he was painting the river. This view is looking towards Hungerford Bridge and Whitehall beyond. Having completed the painting I realized I had used almost pure titanium white for the highlights, which gave the painting an inappropriately cold feel. I therefore had to warm them up by adding Naples yellow. More of a buff than a yellow, Naples yellow is a great attenuator for white.

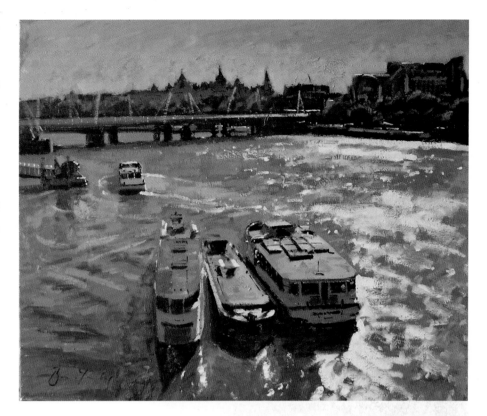

Dappled Light, Jardin des Tuileries, oil on canvas, 61cm × 45cm

In this painting all of the highlights are a mixture of titanium white and Naples yellow light in varying proportions, the lightest – or whitest – colours being on the statuary in front of the palace, a sign that this is a different type of stone from that of the building. I've made the sky less strongly blue than it was in reality in order to keep the palette tighter and more harmonious.

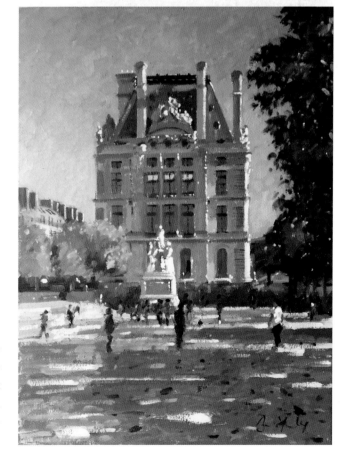

overpowering them. The trade-off is that it lacks power. Titanium white, which first appeared as an oil colour in the 1920s, is the opposite – cold, opaque, powerful, and apt to dominate the colours it partners. Titanium is my choice, but I rarely use it pure; instead, I blend it with Naples yellow in order to achieve a warm, soft white that, while still quite powerful, is easier on the eye.

Grey

I see little need to buy ready-mixed greys, and certainly no need to base your greys on black and white (which would result in a cold, dead colour), as the most expressive greys are obtained by mixing any two complementary colours, for example red and green, blue and orange, yellow and purple, with white or – in my case – Naples yellow light. Whatever your preferred recipe, you're much more likely to obtain lively, harmonious greys if you view it as a positive colour, and not as a neutral non-colour. Of the Impressionists, it was perhaps Morisot who made the best use of grey as an active colour, often scrubbing it in as a background, with the warm honeyed-coloured canvas breaking through.

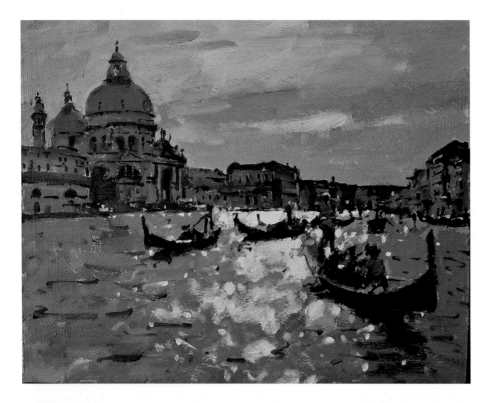

Lagoon Sparkle, oil on board, 20cm × 25cm

Grey can be as warm or as cool as you like, depending on the constituent colours you've used to obtain it, and on your choice of ground colour. Here the lilac greys are definitely at the warm end of the grey spectrum, thanks to the honey-coloured tint of the board on which they're painted.

Grand Canal, La Volta, oil on board, 15cm × 30cm

In this small painting the warm grey of the water turns out on closer inspection to be a grey-blue overlaid with a sort of puce colour, a deeper version of which recurs in the background palazzi. This repetition of colours in different parts of the painting is one of the ways in which we can ensure that the picture hangs together.

MEDIUMS AND DILUENTS

These two materials overlap in function, as mediums are used to thin the paint as well as to improve their consistency, add gloss and extend drying times. Both are referred to as 'modifiers' by the manufacturers of art products today.

There ought to be less call for the use of mediums these days as modern paints are generally very stable, but the multiplicity of different products currently on the market suggests otherwise. The traditional medium is a mixture of refined linseed oil and distilled turpentine; poppy oil has also been used. Mediums are rarely deployed in the initial stages of a painting, as most of us want these first layers of pigment to be quick drying. I hadn't used a medium until very recently, when the disappearance from the market of my usual primer meant I was no longer able to push the paint across the surface of the canvas with any fluency (this is discussed at greater length below): adding a small amount of linseed oil to the paints made them a little more workable. Pale colours such as white and Naples yellow, which are generally laid on unthinned, can also benefit from the addition of oil to improve their flow.

As regards Impressionist practice, Degas, who sought a matt finish for his paint surface, employed a sort of anti-medium: he would drain the pigment of its oil and then dilute it with turpentine; paint treated thus was known as 'essence', and several Impressionists followed his example. Walter Sickert, a younger painter who in his early career attached himself to Degas, was similarly sceptical of the benefits of mediums; as he wrote in a letter to his friend Nina Hammett, 'The difficulty in oils is we don't like it clumsy with thickness but if we thin it with medium it gets nasty and poor'.

Elsewhere, Sickert commented that you should thin your colour by the vigour with which you apply it; in other words, there's no need for a diluent at all. He's very much on his own here, for most painters accept the need to stretch the paint and speed drying times. The addition of turpentine, or white spirit, to the paint accomplishes this by diluting the oil content of the paint. Turpentine is made from pine resin and is somewhat viscous with a pungent and pervasive but not unpleasant smell, while white spirit is made from petroleum oils, is non-viscous, less pungent and considerably cheaper.

Received opinion is that turpentine is much to be preferred to white spirit as a thinner of paint, but I think this view is prejudiced. Indeed, inasmuch as turpentine (unless it is specifically artists' turpentine) contains a gum that oxidizes and yellows on exposure to air, it can be a dangerous choice for the painter. I used turpentine for the first few years until, having run out of it on one occasion, I used instead the white spirit with which I cleaned my brushes. Not noticing any significant difference – other than smell – I have continued with the white spirit ever since, and any qualms I might have had in making the switch were quashed when I read that Jane Corsellis, a painter whose work I really like, prefers the 'texture' of white spirit to that of turpentine.

BRUSHES

The Impressionists painted differently from their predecessors because their paintbrushes were different. That's the sort of provocative statement one might expect to see in a Fine Art exam paper, with the students enjoined to 'discuss'. But there's a great deal of truth in it, for the nineteenth century saw the innovation of the metal ferrule, which enabled the production of flat as opposed to round brushes, and which in turn enabled artists to produce a different kind of brushstroke. This brushstroke, known as the *tache* and very characteristic of Impressionist painting, is a broad streak of paint put on with a brush that is not only flat in section but also square-ended. Strictly speaking, the Impressionists were anticipated in their use of the *tache* by the Barbizon painter Charles-François Daubigny, but by employing it so profusely throughout their paintings the Impressionists, who were sometimes referred to as *tachistes*, were explicitly challenging – much more so than Daubigny – the academic tradition of disguising the brushwork behind a closely modelled, highly finished paint surface.

Anyone wishing to paint like the Impressionists, then, will have to make the square-ended brush their principal weapon in their struggle with the motif. Not only that, the brushes should really be the traditional hog's hair, rather than a modern synthetic fibre: the hog's hair is tough and springy and responds well to the vigorous handling that brisk, impressionistic painting demands; synthetic fibres such as nylon seem to lack the in-built resistance of the hog's hair. The paint-marks that these square-ended brushes produce are rather jagged and discourage further modelling with the brush, but that is something to be embraced. As Ken Howard puts it, the flat hog brushes allow 'mosaic-like facets of paint which merge to make a reality when viewed from a distance'. That seems to me to be a neat description of Impressionist technique. This is not to say that you should use flat hogs exclusively, or try always to achieve a mosaic-like effect. The Impressionists, after all, revelled in their variety of brushstrokes, and recent close analyses of several of their

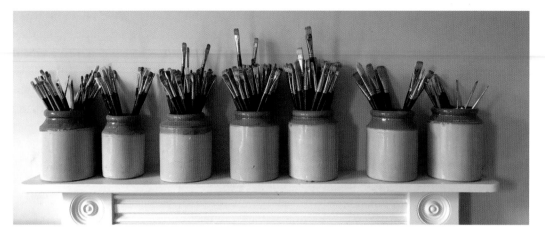

My brushes – different ages and conditions, but all still on the payroll. The vast majority are short flat hogs, the Impressionists' preferred brush type. The green-shafted, copper-ferruled ones are Roberson series 41 Bright, which, I'm sorry to say, have been discontinued at the time of writing.

paintings reveal that they did in fact continue to use round brushes alongside the flats. Sisley, for instance, liked different kinds of brushwork to be visible in the same painting.

Still, I have always used hog hair flats, without necessarily realizing that this usage had been sanctified by Impressionist practice. As a general rule, I try to use as large a brush as possible, to stop myself from fiddling too early on in a painting. The bulk of my work is therefore done with brushes size 7 to 12. I use the smaller brushes – sizes 3 to 6 – for two distinct purposes: first, to make the initial drawing on the canvas in paint; and secondly, to add small details and highlights in the final session of painting. I am unusual but not unique in drawing with the brush rather than the pencil. Sickert certainly drew in paint directly on to the canvas for his large Basilica San Marco paintings, where there is no indication of any graphite drawing. As for the finishing details, I try to keep these to a minimum by avoiding using the smallest brushes. An Impressionist painting, according to Pissarro, should be viewed from a distance of three times the diagonal length of the canvas. I've found this to be a very good yardstick, so there's no real justification for the kind of minute detail provided by a size 1 or 2 brush, detail that can only be seen on a close inspection. I relax this rule for those rare occasions when I am happy for the viewer to pay close attention to a particular part of the painting, and for my small boards where, if I am pursuing them to a finish rather than keeping them as aides-memoire, I use a very small (size 0) synthetic brush.

The other flat brush made possible by the invention of the metal ferrule is the filbert, with long bristles that are rounded at the top. The marks it makes are much less angular than those produced by the square-ended brushes, which means they're better able to cope with softer forms such as clouds. In fact, I have in the past bought filberts specifically to paint clouds, but have never really got on with them; the actual bristles are just that bit too long, such that I rarely feel in control of the brush. Fortunately, the remedy is close to hand: with use, the square-ended hogs become increasingly rounded and end up resembling controllably short filberts. That is why I hardly ever throw brushes away.

Soft brushes are not really suitable for textured canvas surfaces, and an expensive sable – the traditional soft brush hair – will be quickly worn down by such use. However, soft brushes do have a role, and that is for glazes – transparent layers of thinned paint added to lend a glow to the colours they overlay. Visible brush-marks are unwanted here, so soft brushes work better than hogs; and, since precision is not so important with glazing, synthetic bristles are every bit as good as sable. I don't myself glaze very often, and I might add that glazing was not normally part of the Impressionist repertoire; it seems to have been one of those academy-taught techniques that the Impressionists were keen to slough off.

A brief coda here on that other implement that some painters use to put paint to canvas: the palette knife. The Impressionists seem not to have used the palette knife in this way after the early 1870s, and neither do I. Nor do I use it to cut and mix the paints on the palette, as many painters do, preferring instead to use the brush in hand for the sake of speed. For me, then, the sole function of the palette knife is to scrape the paint from the palette.

DRAWING MATERIALS

As I draw out my painting with brush and paint, my comments here relate to sketching materials. Ordinary graphite pencils, the standard sketching tool, range from the very hard to the very soft. Hard pencils, numbered with an H, produce a thin, grey line and are intended more for technical or detailed drawing than for sketching. Most painters prefer to work with soft pencils, 2B and above (B stands for blackness). The softest or blackest – 8B or 9B – allow you to vary the intensity of black with only slight variations of pressure, and are therefore excellent for tonal sketches. A 'carpenter's pencil', flat and wide, is likewise good for shading large areas quickly, as is natural charcoal made from vine or willow. Charcoal is smudgable, which is sometimes a virtue and sometimes not. Clutch pencils, equipped with retractable leads, are usefully break-proof but cannot offer the same breadth of feel. Pencils sharpened with a knife, rather than a sharpener, acquire a jagged point that produces a more expressive, modulated line.

As for paper, you really need a weighty paper with some texture to get the full benefit of the subtle differences in mark these pencils make. A stout paper will also enable you to sketch more vigorously.

CANVAS

'What a cursed medium oil is anyway! How is one to know the best canvas to use – rough, medium or fine? And as for the preparation, is white lead better or glue? Should there be one layer, or two, or three?'

The agonized words of Edgar Degas. In fact, there are even more decisions to be made than Degas allowed for, starting with the type of canvas. Canvas has been the favoured support for oil painting for centuries now: the way its tooth grips the pigment while at the same time allowing the painter to work it around the surface is unrivalled. In the Impressionists' day linen (flax) was the usual canvas fabric, but cotton and hemp were also available. Today, canvases are generally marketed as linen or cotton. Linen is taupe-coloured, while cotton is white or cream. So, if you are unsure whether a pre-primed canvas is linen or cotton, simply look at the back to check the colour.

As with paints, I would urge you to at least try the more expensive product, which in this case is the linen. I don't want to bankrupt my readers, but to my mind linen offers a vastly more pleasurable painting experience, mainly by virtue of its more variegated grain, and I worry that aspiring painters might be put off oils if they never try it. Personal experience has shaped this view. When I first started painting I was lucky to be given, via my father, dozens of oil paintings by a local artist that I could re-prime and re-use for my own early efforts. These canvases turned out to be of very high quality linen. Once I had exhausted this supply and was obliged to source my own I naturally, as a hard-up beginner, went for cotton. It was then that I realized how spoiled I had been. Some of these cottons had a ridged texture that made it all but impossible to push the paint around; others had a grid-like grain that lent a dull uniformity to the painting surface. This latter complaint seems to be a widespread problem with the cheaper fabrics: I cannot count the number of times I have seen accomplished paintings, professional and amateur alike, let down by a canvas with a monotonous grain. The often-impecunious Impressionists used cheap fabrics as 'sketching canvases', which seems a sensible economy, but for anything else I would recommend you try linen: the difference in cost is not that great when you consider that canvases may be re-primed and re-used.

Those second-hand linen canvases I had been given were of a coarse weave, although by the time I came to paint on them they had been rendered smoother with the accumulated layers of paint and primer. For the modern painter, as for the nineteenth-century Impressionist, there are typically three grades of weave available – coarse (*ordinaire* to the French), medium (*demi-fine*) and fine (*fine*). As may be readily guessed, the coarsest weaves produce the most broken paint surface, as the pigments used by the painter rest upon fewer raised threads. (Whistler and Sickert both favoured coarse canvas throughout their careers, but avoided creating a broken paint surface by using highly thinned paint.) Coarsely woven canvas therefore lends itself to vigorous, broad-brush painting; using a small brush on coarse canvas is unrewardingly hard work, like riding a bike across a ploughed field. It's tempting to conclude from this that one should match the weave to the scale of the painting. The danger here, though, is a slightly predictable finish to the painting: one could probably guess the broad dimensions of any given painting from a reproduction of it if the artist adhered to such a strict formula. Certainly I am not aware of painters calibrating canvas weave and canvas size in this way: Monet, for example, used different weaves for similar-sized works within his Gare St-Lazare sequence of paintings.

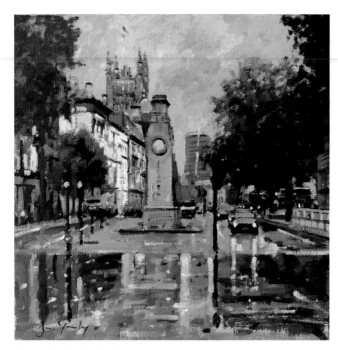

Cenotaph, Whitehall, oil on canvas, 41cm × 41cm

I don't often do square paintings, possibly through a vague awareness that the square is not a shape one encounters in Impressionist painting. Here the Cenotaph monument is placed slightly off-centre, to deliberately compromise the geometrical neatness of the square format.

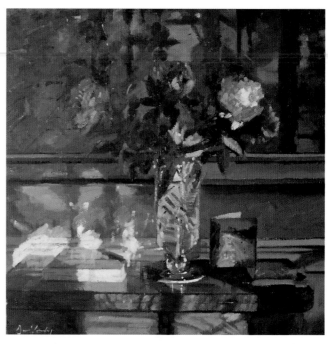

Peonies and Birthday Card, oil on canvas, 61cm × 61cm

Another square painting, and this time the principal subject, the vase of half-lit flowers, is placed pretty much at the centre of the composition. The large painting on the wall behind has become abstract at this close quarter, whereas the picture on the greetings card, although very briefly indicated, is recognizably the view from the Accademia Bridge in Venice.

For the last few years I have painted exclusively on fine linen – labelled no. 13 here in the UK – for all paintings from 30cm × 41cm up; for smaller paintings I use board. I cannot now remember why I moved away from the coarser weaves; I probably felt that I needed to tighten up my painting style. A painting diary I kept in the early noughties reminds me that I briefly switched back from fine to medium (no. 66) weave, in the belief that my work needed more texture, but quickly abandoned the experiment when I found it was forcing me to loosen up my brushstrokes more than I wished. The lesson here is obvious: if you wish to loosen up your painting style, try using a coarser grained canvas; if you wish to tighten up, however, try a finer grain.

Stretched Canvas

Anyone entering a room of Impressionist works in a gallery will be struck by their similarity of scale and shape. The similarity of scale has a lot to do with the fact that quite a few of them would have started out as plein air exercises, which obviously imposed a limit on the size of painting tackled. The similarity of shape, on the other hand, reflects the fact that the Impressionists tended to buy canvas ready-stretched at standard sizes. Renoir was unusual in buying canvas on the

roll, priding himself on his ability to stretch and prepare the fabric, but even he used ready-stretched canvases for his portraits as he wished in these cases to use antique picture frames that usually corresponded to the standard sizes. These standard sizes were absolutely constant, regardless of supplier, and were numbered from 1 (the smallest: 12cm × 22cm) to 120 (the largest: 130cm × 195cm). Within each number, three slightly differing rectangular shapes were on offer, designated *figure, paysage* and *marine.* The Impressionists evidently felt little need to go outside these standard sizes: I am not aware of any notable paintings of theirs in either a square format or an elongated format such as one finds in Dutch Golden Age paintings of harbours and seascapes. (Monet's enormous *Turkeys* [1877] is more or less square, the exception that proves the rule. The same painter's waterlily pondscapes are of course extravagantly panoramic but these are not really Impressionist works.)

The cheapest way to buy canvas is on the roll, but stretching and priming the fabric oneself requires skill and patience, and I confess that I have never been tempted to seek this particular saving. In any case, we have an advantage over the Impressionists, as these days bespoke canvases – that is, canvases whose dimensions may be specified by

the customer – are not the out-of-reach luxury one might suppose. My own canvas supplier charges by canvas area, and I've never detected much difference in price between an off-the-peg canvas and a bespoke one of roughly the same cloth area. Which is good news for those of us who wish to paint in a wide variety of shapes and sizes. Operating as I do exclusively in oil, I try to compensate for narrowness of medium by working on a wide range of shape and scale: rectangles, squares, double-squares and even treble-squares. Of these, the square is probably the shape I use the least: a square painting always has a defiantly contemporary look, and lends itself more to abstract art than to figurative art. There are, though, occasions when the composition falls naturally into a square.

Primed Canvas

The purpose of priming canvas is to provide a firm, non-absorbent surface on which to paint. Left unprimed, canvas is highly absorbent and, as I understand it, forces you to press or stab thick, undiluted pigment into the fabric in order to achieve any vibrancy of colour. It is also much more difficult to work the paint around. To be frank, it doesn't sound a very enjoyable painting experience, though Degas, Manet and Morisot all experimented with unprimed canvas at certain times in their careers. If you want to try painting on unprimed canvas you still have to seal it first, for without a sealant the oil in the paints will eventually rot the canvas fibres. The normal sealant is rabbit skin glue, which can be bought ready prepared from all good art suppliers, although it is easy enough to prepare at home (for which see the section on boards, below).

With ready-primed canvas you typically have the choice of single-primed (*à grain*) or double-primed (*lisse*), the latter offering a slightly smoother texture. Ready-primed canvases sometimes suffer from a factory greasiness, which prevents the paint from adhering properly, so to overcome this I add a further coat of primer. For many years I used Roberson's oil primer for this additional coat; the surface it provided was noticeably glossier and more slippery than other primers on the market, allowing me to push the paint around with ease, which made the initial painting sessions enjoyably brisk affairs. Alas, this product has recently disappeared from the market owing to what the manufacturer calls 'ingredient sourcing issues'. The problem is clearly a general one, since other manufacturers have also stopped marketing oil primers. Many have substituted something called thixotropic alkyd primer: 'thixotropic' denotes a substance that becomes temporarily more fluid on being stirred or agitated, while an alkyd is a type of synthetic oil. This new type of primer is often described as having a gesso-like opacity, and the (unwelcome to me) practical consequence of this is that the painting surface is much more resistant to the brush – I find I can no longer push the paint around the canvas, but have to scrub it in, which is no pleasure at all.

The quick-drying water-based acrylic primers, which despite their name can be used for oil painting – though their long-term stability in this role is untested – produce an even grippier surface, and whenever I've used these I've had to sandpaper the surface afterwards to smooth the texture, not a clever thing to do on a flexible surface such as canvas. In some desperation, I've tried using an eggshell house-paint in place of a commercial primer, on the unscientific grounds that its semi-gloss finish looks superficially very similar to that of the Roberson oil primer. It's been an improvement on the acrylic primers, but it seems to sit on top of the canvas grain and if anything makes the surface too smooth. I've also tried adding linseed oil to the paints in an effort to improve their flow, and I think this may be the way forward, should I not be able to find a suitable replacement for the oil primer. I understand that Roberson hope to reformulate their oil primer; I can only hope that it is a good approximation to the old product.

Of course, not every painter is looking to move the paint around quickly, and the very fact that the now-discontinued Roberson product had such distinctive properties suggests that I am relatively unusual in seeking the slippery surface that facilitates a brisk sort of painting. But there's no denying that speed of execution is an important feature of Impressionist work, and anything that hampers this, such as an overly grippy primer, is problematic. What these primer tribulations have brought home to me is that a seemingly minor alteration in material can have a huge impact on the painting experience. It's therefore worth keeping an eye on the market and experimenting with different products, to combat an over-reliance on one alone. I certainly feel I'd have been better equipped – mentally as well as literally – to cope with this enforced change had I been familiar with some of the alternative primers.

Tinting the Canvas

Although it is perfectly possible to paint directly on to the primer, modern primed canvas is almost always a cold white colour and there are drawbacks to using white as a ground. The main one is that it makes it more difficult, at least in the early stages of a painting, to judge tones and colours accurately. Colours appear darker against a white ground than they would against a neutral or mid-toned ground,

which can lead to your painting in too light a key. The same argument applies to white palettes, whether of melamine or tear-off waxed paper (though you can now buy tear-off palettes coloured grey). A neutral or mid-toned stain or tint laid on with thinned oil paint not only makes it easier to judge tone and colour, it also means you get full value for your lights and darks as soon as you put them down. Finally, and perhaps most importantly, a coloured background is an effective means of unifying the composition in terms of tone and colour, especially for the kind of brisk painting advocated here where the ground is often allowed to show through the pigments in the finished work.

The use of thinned colour as a preliminary ground dates back to the Renaissance, and is formally known as *imprimatura*. An earth pigment such as raw sienna is the traditional colour choice. In keeping with their iconoclastic spirit, the Impressionists were not at all consistent in their practice of *imprimatura*. We know that Manet often painted directly on to white canvas, and later in his career Monet restricted himself to white, having started out with dark grounds, apparently in imitation of the sombre, tonal work of the Barbizon painter Gustave Courbet; in between, his paintings were variously grounded in white, cream, grey, buff, mauve and brown. Sickert, dogmatic and fickle in equal measure, sometimes told his students that a brown ground was essential, and other times that a brilliant white ground was essential.

The serendipitous nature of plein air painting did not permit the Impressionists to anticipate their subjects with any great precision, so we shouldn't read too much in to their choice of ground colour, which would have been applied over the primer long before they set out on their painting expeditions. The ideal, I suppose, is to have a number of canvases all tinted slightly differently, so that you can tackle subjects in different colour registers. It may sound counter-intuitive but the tint works best when it differs markedly from the colours of the actual painting. A good rule of thumb is to choose a tint more or less complementary to what is to be the dominant colour in the finished painting. Constable often used a burnt sienna ground in his landscapes as it set off the greens of his trees and meadows. In much the same way Whistler, in his dusk and nocturne compositions, would lay the blues atop a red ground in order to accentuate them, while Sisley used a brown tint as a foil for the white snow in his snowscapes of Marly-le-Roi.

Even when the ground colour is all but covered over, the actual process of laying paint upon a complementary ground colour during the early stages of a painting is very satisfying: the freshly applied colour 'tells' immediately. For sketches and the most rapidly executed canvases, where the ground colour is likely to make more of a mark in the finished work, the ground may even be used as a pigment in its own right. In *Piazza San Marco, Venice* (1881) Renoir left a lot of the buff-coloured ground visible towards the bottom left of the painting, which gives an airy, sunny feel to the foreground piazza. Sickert took this a stage further in his picture *St John's Churchfront at Sunset* (c 1899–1900), where he left the red-brown ground untouched in order to portray the orange glow of the setting sun on the church façade, and thereby achieved a powerful economy of brushwork.

In my early painting days I opted for a very neutral ground composed of raw sienna plus a little ultramarine. Later on, I warmed this up with the addition of permanent rose. I was in the habit of using a lot of blues in my painting, and wanted a warm ground to throw these into greater relief, on the principle outlined above. I should explain here that the paintings in question tended to be sunny scenes, where blue skies and bluish shadows played a large role: a 'hot' subject need not imply the use of 'hot' colours. The resulting ground, anyway, was so like burnt sienna that I decided instead to use burnt sienna straight from the tube, a strong pigment that had the additional advantage of going further than the hitherto-used blend. It goes without saying that inexpensive pigments such as the earth colours should be used for ground tints, and in recent years my basic ground tint has been a mix of raw and burnt sienna. Even more cost-efficient is to assemble your tint from the paints remaining on your palette at the end of a day's painting: assuming a conventional range of colours, the resulting tint should be a sort of khaki, which makes a perfectly acceptable ground, though opaque colours such as titanium white should be excluded from the mix. I occasionally clean my palette on to a fresh canvas in this way, but not routinely as I find the colour can be somewhat dirty.

For the purposes of this book I did try, for the first time ever, painting on an untinted white canvas. Unsurprisingly, I struggled in the first session to get the colours I wanted, and more generally found the business of putting paint to canvas less satisfying than if it had been a tinted surface. Readers will be able to judge whether this shows in the final painting (*St Paul's from Peter's Hill*, illustrated in a three-step sequence).

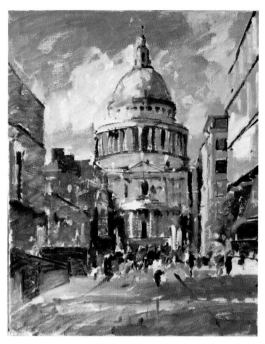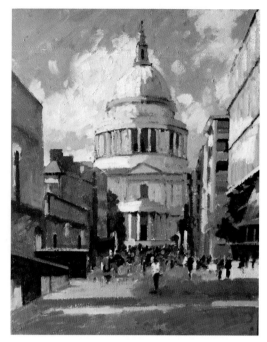

For research purposes I broke the habit of a lifetime and painted on a white, untinted canvas. There's respectable precedent for the practice: Monet in his later days and, more recently, Ken Howard have both favoured pure white canvas. It was to be expected that I would struggle to get the tones and colours I wanted straight off, but even so I was surprised that the first colours I put on seemed so dirty and wayward. Was I over-compensating, having assumed that the paint would be much brighter against a white background?

Here at the end of the second session I feel I've got things under control. The colours seem cleaner, warmer and more unified throughout the painting. The lesson is not to panic: oil, unlike watercolour, gives you a second chance. Note that I've made no effort to increase the level of detail. If anything, there's less detail than in the previous session: the windows beneath the dome and the foreground paving lines have been painted over, for at this stage I'm just trying to tidy things up, and details like this get in the way of the tidying-up process.

St Paul's from Peter's Hill, oil on canvas, 51cm × 41cm

I've resisted the temptation to add much detail, using a small no. 3 hog brush to reinstate those lost details and to indicate other small areas where the sun is catching the architecture. The picture as a whole undoubtedly has a brighter, harder feel as a result of its pure white underlay, and I can report that some people seem to prefer this. A gallery owner who visited shortly after I had completed the picture was very taken with it, and I probably didn't help matters when, remembering my first session frustrations, I told her that I was unlikely to repeat the experiment. She sold the painting almost immediately, so naturally I've revised my opinion!

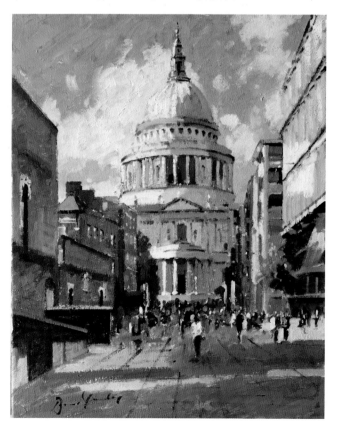

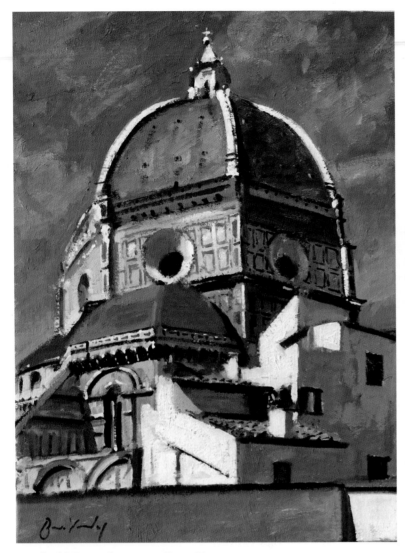

Brunelleschi's Dome, oil on canvas, 41cm × 30cm

A different sort of dome and a very different treatment from me, since this painting, unlike the St Paul's sequence, has been executed on a very positive, burnt sienna ground colour. The greater warmth that this bestows feels appropriate for a picture of Florence, which is apparently the hottest city in Italy during the summer months.

Duomo Corridor, Florence, oil on canvas, 76cm × 30cm

The busy marble cladding underneath Brunelleschi's dome is a nineteenth-century addition and not to everyone's taste, but in full sun it is blindingly bright and lights up the narrow streets that radiate out from Piazza del Duomo. I've tried here to capture that explosion of light at the end of one such shady street.

BOARDS

I was astonished to learn that the smallest standard canvas size in Impressionist times was a miniscule 12cm × 22cm. This would explain why so few Impressionist paintings were made on anything other than canvas. The fact that composite boards such as hardboard did not appear until the early twentieth century also plays a role here. But that 12cm × 22cm canvas must surely refer to canvas laid on board of some kind, rather than stretched across bars: it would be nigh impossible to stretch the cloth at this minute scale; nor would there be room for the wooden wedges that are inserted

Yellow Coat, Bath Abbey, oil on board, 25cm × 20cm

For many years I made oil sketches on canvas board. I was never very happy with it – the canvas element is rather monotonous in its grain – and I never exhibited the sketches. A few years ago, however, I bought some MDF board that I then had coated in layers of gesso, and found I much preferred the painting surface. Sketches that I would have previously set aside as source material for larger paintings I now pursued to a finish as paintings in their own right, using a small nylon (0 series) brush for the fine detail. This was the first oil on board sketch I completed in this new manner.

into the corners of the stretcher so that the canvas may be tightened whenever it slackens off.

Canvas board is popular for smaller sized paintings, but the canvas surface of ready-made canvas board is rarely of a high quality. You can make your own by sizing thin fabric such as muslin on to board with rabbit skin glue, but I prefer to use MDF board without a cloth overlay. I buy this from a local plywood merchant; I must be their smallest client but such are the economies of scale with this arrangement that I often end up with a year or two's worth of useful offcuts in various shapes and sizes. My usual order is for board laser-cut to the following four sizes: 20cm × 25cm (the standard small *pochade* size), 15cm × 30cm, 20cm × 30cm, and 20cm × 51cm.

Anything larger and the board has a tendency to warp after priming, although this can be overcome to a great extent by priming both front and back.

Commercially available primers may be used on board just as on canvas; most manufacturers recommend two coats. I make up my own primer from a mixture of gesso and rabbit skin glue, the traditional ground used by framers and gilders. It's a rather time-consuming exercise but it does give me absolute control over the consistency of my primer and, as I prime dozens of boards in a single session, works out cheaper than buying the ready-made commercial products. For those interested the preparation is as follows. First, I seal the boards by brushing them with rabbit skin glue. You can buy this from all good art shops: it comes in granulated form, looking like sugar, and has to be soaked overnight in water (c 15ml of water to every gram of glue), then liquefied by warming over a bain-marie. Next, I make up the gesso mixture by adding whiting (a chalk powder also available from art shops) to the remainder of the liquefied glue until its texture is somewhere between that of single and double cream. To ensure it doesn't go lumpy I sieve it two or three times into another bowl – anyone who has toiled over a béchamel sauce will be familiar with the process. Finally, still keeping it warm over the bain-marie, I apply two or three coats of this 'cream' to each board with a gesso brush, allowing each coat to dry before proceeding to the next. The boards are now ready for tinting in the normal way. (Incidentally, this gesso primer is not suitable for use on canvas, since it can crack if applied to a non-rigid surface.)

In contrast to canvas, which is positively textured to start with, relatively smooth boards such as MDF acquire more, not less, texture the more coats of primer there are, the texture coming in this case from the brush used to apply the primer. For some artists these ridge-like brush-marks are a very desirable feature, and by using fairly dry oil pigments when they come to do the actual painting they ensure that these brush-marks remain visible in the finished work, creating an appealingly fractured finish to the paint surface. The best-known practitioner of this technique is probably Edward Seago, the much-imitated English Impressionist from the twentieth century. It can become a little mannered if over-used, and is not an effect I strive for myself, much as I admire Seago's work. So, whenever I feel the brush-marks on my primed surface have become a little too emphatic I simply take them down with sandpaper.

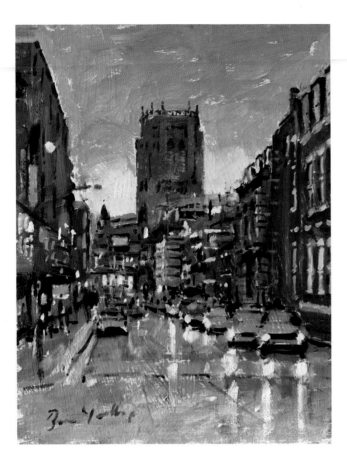

Liverpool Cathedral, Dusk, oil on board, 25cm × 20cm

Many of my small board paintings are urban/architectural, where the architectural detail can be indicated at speed with the earlier-mentioned small nylon brushes. More than that, they are often of cathedrals, or other grand ecclesiastical buildings. Giles Gilbert Scott's enormous Anglican cathedral at Liverpool dominates the Georgian quarter of the city, and with the lights coming on at four on a wet December afternoon I thought it made a paintably brooding presence. The palette is accordingly dark and restricted.

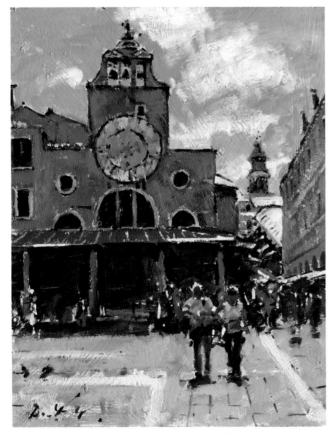

Chiesa San Giacometto, Venice, oil on board, 25cm × 20cm

This tiny, unusual church is tucked away behind the Rialto markets: you can just glimpse Rialto bridge sweeping up between the church and the right-hand building.

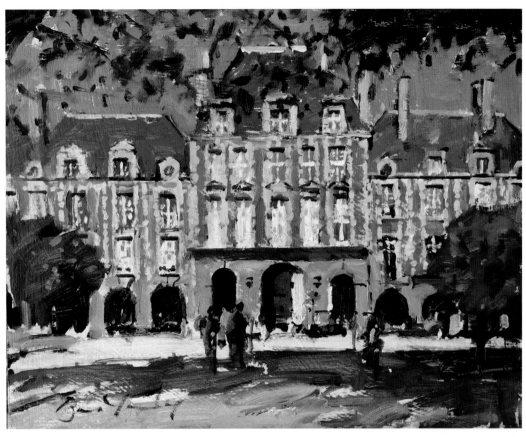

Place des Vosges, North Range, oil on board, 20cm × 25cm

The only problem with this lovely square in the Marais district of Paris is that there are relatively few places in which you can step back to get a good view of the architecture, as the central green space is enclosed on all sides by hornbeam hedges; this view is taken from one of the four entrance paths where you can get a proper look at the buildings. The overhanging branches at the top, besides explaining the foreground shadows, help to condense the subject, lending a glow to the buildings.

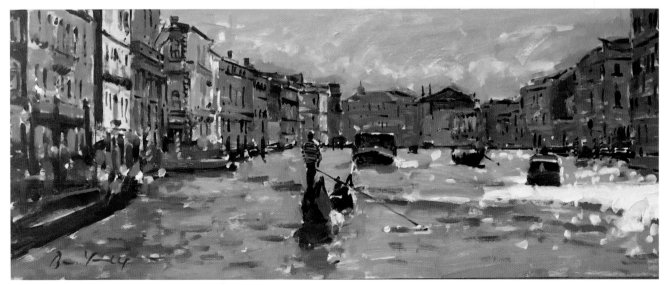

Grand Canal: Towards La Volta, oil on board, 20cm × 51cm

MDF can be laser-cut to any shape or size, and quite a few of my small board paintings are of a panoramic shape – 15cm × 30cm, 20cm × 51cm, 20cm × 61cm – for which it's near-impossible to stretch canvas. In this Grand Canal scene I've used a quiet, restricted palette; I believe I hardly had to clean my brush, until putting on the highlights. The right-hand wake that is catching the sun is from a waterbus (*vaporetto*) moving off from the San Silvestro stop.

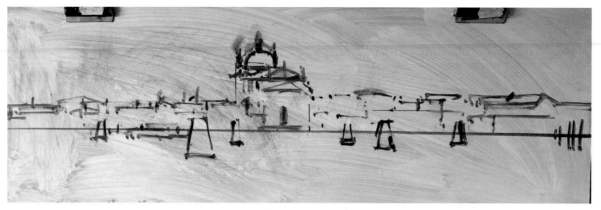

On our trips to Venice we stayed several times on the Zattere, virtually opposite Palladio's splendid church of Il Redentore. I'd always wanted to paint this church but couldn't really see the subject until, strolling along the quay one day, I noticed how at a certain point the lagoon channel markers (*bricole*) all converged on the church. They break the waterline, too, which helps to connect the upper and lower halves of the composition. I decided to widen the subject into a panorama, to include the surrounding buildings on the Giudecca. The waterline is put on with a T-square, and then the rest quickly drawn in paint with a size 3 hog brush. Because the church is facing a little to the right I have positioned it slightly left of centre.

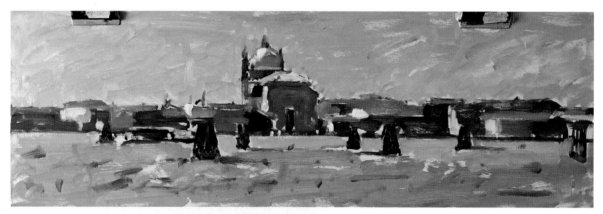

I've now laid on the initial paint with a no. 7 brush, working from dark to light. The water has a viridian glow (actually achieved by mixing cerulean blue with Naples yellow) that is not reflected in the sky, so I've tried to enhance the communication between sky and water by painting them in a similar, scrubby sort of way.

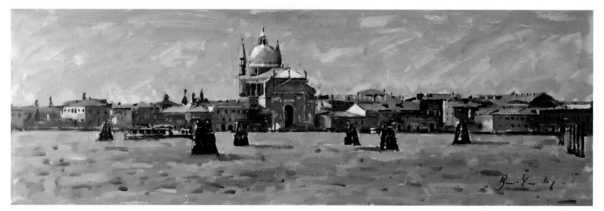

Il Redentore and the Giudecca, oil on board, 20cm × 61cm

For smallish board paintings like this I like to leave the initial passages of paint to speak for themselves, and switch almost immediately to a very small (0 series) nylon brush with which to put on the architectural detail, as well as the tonal highlights. I've used a larger brush to modulate the green of the water with some suggestion of lilac-y shadow; I've also scumbled some lighter paint into the sky but I've not tidied it up in any other way as I wanted to retain the feeling of a fresh breeze chopping up the water. The picture has taken about an hour and a half from start to finish.

EASELS

I don't propose to say much about easels, as what you choose here is governed by how you deport yourself in front of your painting, which is a very personal thing. Pictorial evidence in the form of paintings of fellow artists at work by Renoir (of Frédéric Bazille), Manet (of Monet) and John Singer Sargent (of Monet and of Paul Helleu) suggests that many of the Impressionists sat down to paint, both indoors and out. Whistler used such thin paint that he would sometimes dispense with an easel altogether, laying the canvas on the floor to keep it horizontal and ensure that the paint did not run off the edge. I've always painted standing up – as did Berthe Morisot – before a more or less vertical canvas; I find it less constricting than sitting down, and it is far easier to step back from the painting and assess its progress when standing up, something vitally important when you're working on a larger scale.

For studio work, an easel with a cranking mechanism is essential if you wish to tackle large paintings; the mechanism itself should be kept well oiled. I like to have the easel raked back at a slight angle, but you should be aware that the rake might distort the lines of perspective; it's therefore a good idea to have a T-square to hand to make sure the verticals and horizontals are as they should be.

Outdoors, I use a French box easel, sometimes called a field easel. The design dates back to the mid nineteenth century, and it's hard to see how it could be improved upon. The box element is large enough to hold a decent-sized palette, my full range of paint tubes and, unlike small *pochade* boxes, full-length brushes. White spirit or turps would have to be decanted into unusably small jars if they were to fit in the box, so I normally carry these separately. The easel is not as tricky to set up as some make out, and is remarkably stable once set up, yet closes up into a compact, portable size. Although known as a French easel, mine happens to be made by an Italian firm, Mabef, as are my studio easels.

For more detailed advice and information I recommend you consult the literature put out by the various easel manufacturers. It's not disinterested advice and information – they're trying to sell you their product, let's not forget – but it will give you a good idea of what the different models are intended to do.

When I began the research for this book I had little idea that there was so much overlap between the artists' materials of today and those of Impressionist times. I was especially pleased to learn that many of the paints, brushes and paint supports I myself use would have been familiar to those earlier artists, and while I don't suggest you slavishly follow nineteenth-century precedent it's obviously reassuring for the latter-day Impressionist to know that their materials have stood the test of time in this way. In fact, with ecological considerations increasingly trumping straightforward commercial considerations, there is a real possibility that some of the more synthetic modern materials will be phased out in favour of the natural ones of former times. These natural products are always quite expensive, and I'm well aware that I may have strained your budget with some of my recommendations in this chapter. All I can say is that I'm as keen to save money as the next person, but have found these choices to be worth it.

Here is my French or travelling easel, not long after I bought it, set up in the back garden, with an oil sketch of the back of our house in progress. As you can tell from the photograph, the easel can accommodate far larger canvases than this small board. It's relatively easy to set up, provided you're happy to loosen and tighten a multitude of wing nuts.

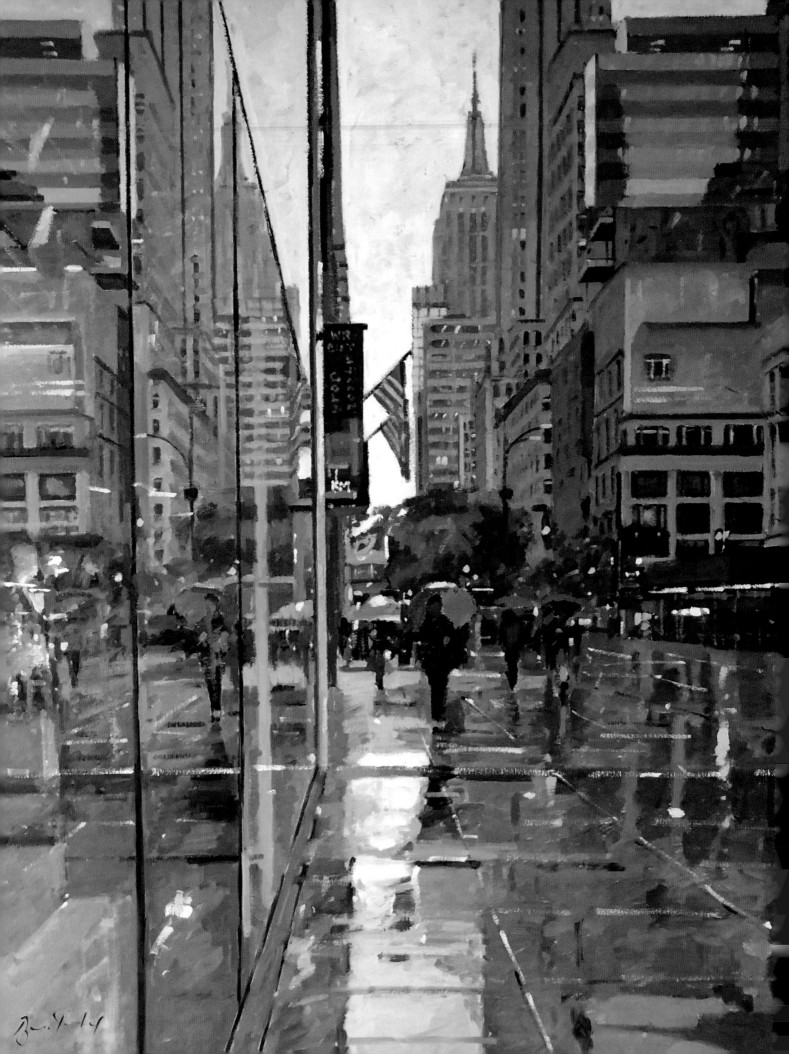

Making an Impressionist Painting

The title of this chapter requires a brief word of explanation, for you could be forgiven for thinking that it's just a reformulation of the book's title. It is in fact subtly different, for what I'm concerned with here are the basic steps by which a three-dimensional subject is translated into a two-dimensional Impression. To this end I shall be looking first at the ways in which we can gather information about the subject, then at the ways in which we progress the painting to a finish. I'm not at this stage concerned with the finer artistic aspects of the task such as composition, light and tone, and colour; nor with the selection of subject matter, all of which are dealt with in later chapters. As elsewhere in the book, I shall buttress my comments with constant reference to how the Impressionists themselves operated.

DRAWING

Impressionism, even in its most loosely painted forms, is figurative art, as distinct from abstract or surrealist art, and as such rests on the artist's ability to offer a recognizable and believable – though not necessarily literal – representation of what the eye of a normal, non-hallucinating person might be expected to see. The foundation of that ability is and always will be drawing. As art-instruction books never tire of pointing out, the very act of drawing teaches you to look more closely at, and respond more sensitively to, the world around you. Whenever you draw, and especially when you

draw from life, you are exercising the muscles in your hand and eye, and stimulating the electrical impulses in your brain.

This is why art schools have traditionally attached so much importance to teaching the principles of draughtsmanship. The rigorous schooling that the Impressionists underwent required them to pass examinations in perspective, expression, historical composition, landscape and anatomy. Their formal training was in fact confined to draughtsmanship; expertise in the handling of oil paint was seen as a lower skill, and teaching of it was left to the ateliers that operated on the periphery of the Academy. Many of the Impressionists, notably Monet, later reacted against this regimen by pursuing a painting style in which drawing played a relatively minor role. The poet and art critic Jules Laforgue provided a combative theoretical justification for this aspect of their art when he wrote, by way of introduction to an 1883 Impressionist exhibition in Berlin: 'In Impressionism, forms are obtained not by contour drawing but solely by means of vibrations and contrasts of colours... Where the academic sees only the exterior outline enclosing the form, the Impressionist sees actual living lines without geometric form constructed by a thousand irregular brushstrokes'.

This seems to me to be wishful thinking on the part of the twenty-three-year-old Laforgue, who was penning a manifesto as much as a commentary on the works being exhibited. At any rate, when I look at Impressionist paintings, certainly those dating from the 1860s and 1870s, I don't detect an abandonment of contour drawing in favour of irregular brushstrokes. Nor do I imagine that many Impressionists of the time would have agreed with Laforgue's sneering reference to 'the childish illusion of the translation of three-dimensional living reality by means of contour drawing

◄ *Red Umbrella, Fifth Avenue,* oil on canvas, 122cm × 102cm

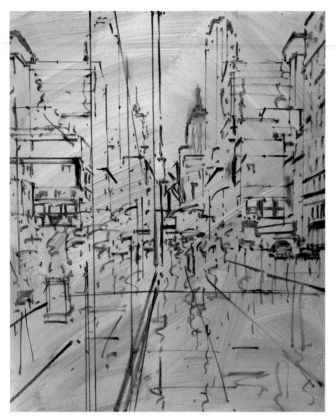

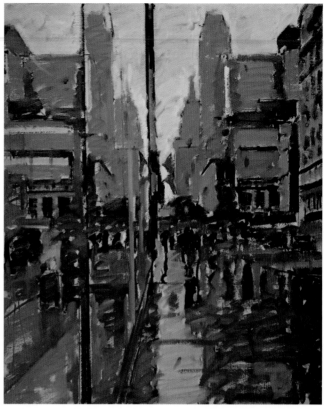

Any drawing of a built-up, high-rise architectural subject such as Fifth Avenue in New York is a nightmare of linear perspective. The buildings have to relate to one another, so the perspective lines have to be accurate; together, these convey the sense of recession. A very practised architectural draughtsman could probably draw this freehand but there's no shame in reaching for the T-square to ensure that the verticals are true. I wouldn't want these buildings to be listing one way or the other, inducing a sense of drunkenness in the viewer. Also, any departure from the vertical would complicate the reflections – the left-hand side of the drawing reflects the right-hand side; that may not be obvious at first glance. Although it is a small part of the painting in terms of area, the Empire State Building is very important in terms of subject recognition, and it's vital that it looks right: hence my rubbed-out correction.

This is not a full step-by-step sequence but I thought I'd illustrate the broad stages by which the under-drawing becomes the finished painting. This first sitting shows a lot of the coloured ground showing through the initial blocks of paint. I'm not worried that some of the perspective lines have been covered over; I'd already satisfied myself that the drawing provided a strong enough base for the subsequent painting. All of the paint has been applied with a no. 10 brush.

and applied perspective'. Perspective is indeed the tool by which we translate a three-dimensional reality into a two-dimensional picture of it, and anyone wishing to make a figurative painting needs to have a grasp of the basic rules of perspective drawing.

There are three basic rules of perspective. First, objects appear smaller as their distance from the viewer increases; secondly, objects are subject to foreshortening, meaning their dimensions along the line of vision appear shorter than their dimensions across the line of vision; and finally, objects recede to vanishing points on an implied horizon line in the distance. The level of this horizon usually corresponds to your eye level, so horizontal lines above eye level travel

down towards the vanishing point, while horizontals below eye level travel up towards it; parallel horizontals therefore taper as they travel towards it. (Art books often illustrate these rules with complicated-looking diagrams that take me back to school geometry lessons and bring me out in a sweat.) Verticals are unaffected by perspective: when you see painters holding a pencil or brush at arm's length vertically in front of their eyes they're unlikely to be checking that the uprights of the scene are true; they're more likely to be reading off the angles of the various horizontals where they meet the vertical of the brush or pencil, to make sure that they've got the lines of perspective right. Or they might just be posing in the presence of onlookers.

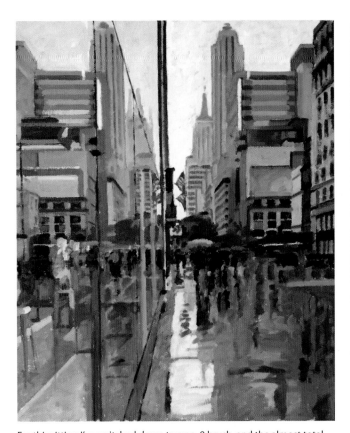

For this sitting I've switched down to a no. 8 brush, and the almost total elimination of the background tint has, it would seem, had the effect of lightening the palette. The no. 8 brush is small enough for a certain level of detail – the stars and stripes on the flags and the basic forms of the umbrella'd pedestrians – but not too small as to encourage finickiness. The sharper details, for which one needs a smaller brush, will have to wait until the paint is dry. At this stage, lacking these finer details, the painting has rather a woozy, uncoordinated look. The splashes of colour in the leftmost section represent shop window spotlighting breaking through the reflections.

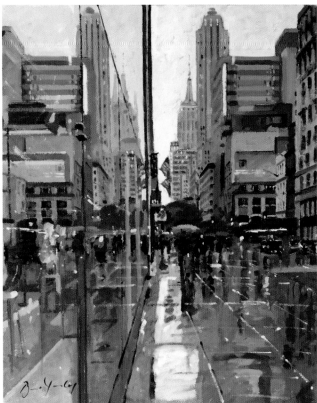

Umbrella Weather, Manhattan, oil on canvas, 61cm × 51cm

The final sitting is all about detail, here put on with (I think) a no. 6 brush. These details up the energy and texture, and the reinstatement of the foreground diagonals – the paving stone edges catching the light – is crucial in leading the eye into the picture. The composition is a sort of double mirror: the glazed shopfront provides reflections on the vertical axis, while the wet pavement provides them on the horizontal axis. Every highlight earns a reflection of its own, and you have to be quite methodical to make sure that all the various reflections are where they should be, ticking them off one by one.

The above paragraph describes linear or point perspective. There's also something called aerial or atmospheric perspective, which dictates that distant objects are less visible than near objects on account of air density and other atmospheric factors. ('Aerial' is rather misleading here, as for most of us it conjures up an image of a bird's-eye view.) This kind of perspective is of more relevance to painting, where control of tone and colour may be used to convey distance. For example, in daylight objects get paler with distance, and in particular, distant scenery looks bluer. It is by observing all the rules of perspective that we create a sense of recession in a drawing or painting; if you abandon perspective you automatically sacrifice that sense of recession. The artist who chooses to do this has to be pretty confident that their painting has strengths enough to compensate – although,

as I say, I don't myself believe that the Impressionists did abandon perspective drawing.

Academic teachers have other ways of ensuring that their students draw accurately. One is to make drawings 'to a module': that is, selecting a key component of the subject – such as a head, if it is a life drawing class – as a basic unit of measurement against which to judge other parts of the composition. A discipline such as this is most useful when drawing the human figure, but more generally it should encourage you to constantly relate objects to one another and prevent you from committing gross errors of scale. These are all too common when the objects in question are moving parts. I'm thinking here of things like pedestrians and cars in urban landscapes; it's very easy to have the car dwarf the pedestrian, and vice versa.

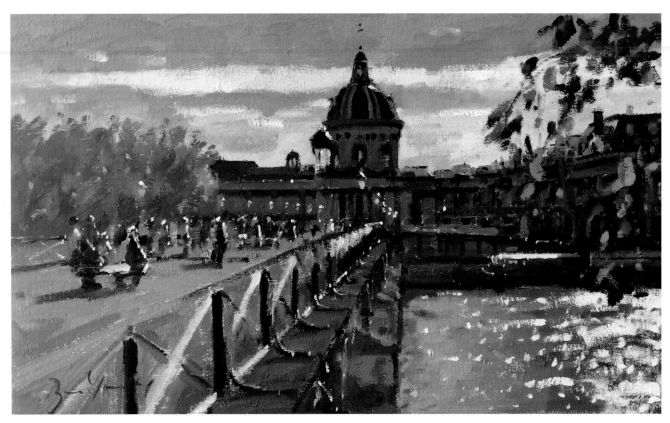

Instiut de France and Passerelle des Arts, oil on canvas, 30cm × 51cm

This Parisian landmark was painted by both Monet and Renoir in their student days. I've tackled it from across the Seine with the Passerelle des Arts acting as the lead-in for the eye. The overhanging foliage on the right, added when the paint underneath was dry, is another compositional device I favour when it is available.

Sickert, meanwhile, taught his students to make their drawings to the 'scale of vision': that is, to place themselves at such a distance from their subject that the size of the subject as it appeared to the eye was exactly the same as it appeared on their drawing surface. To do otherwise, Sickert argued, would over-tax the brain. That sounds logical to me, and I suspect that many of the Impressionists instinctively practised scale of vision drawing, as nearly all their paintings fall within the size range for which it is feasible; when you think about it, the method wouldn't be feasible for very small or very large pictures, such as *pochade* panels or full-length portraits.

To stay with the ever-quotable Sickert for a minute: he viewed drawing as a three-stage process – 1) the initial 'tentative line', 2) the shading-in, and 3) the final 'definitive line'. Numbers 1 and 3 are self-explanatory; with regard to the shading-in, he taught his pupils to hatch the lines according to the direction of the light. This minor-looking piece of advice has a wider significance than you might realize. In drawing, we instinctively hatch in a diagonal direction, right-handers going from upper right to lower left, left-handers from upper left to lower right. Being made to hatch in different directions has the effect of loosening the wrist and preventing your drawing from becoming stiff and mannered. I find I've semi-consciously applied the same lesson to the painting process, by scrubbing in the initial blocks of colour with differently directed brushstrokes, in part because I don't want the viewer to be able to tell at a glance whether I'm right-handed or left-handed.

SKETCHING

The sort of drawing we are most concerned with here is the sketch, the deliberately rough and unfinished drawing intended for the artist's eyes alone, as some form of preparation for a painting. The art-instruction books quite rightly stress the need for the artist to keep a sketchbook at all times; it not only helps improve and sustain your drawing skills, it can also be mined for source material at the painting stage.

There are sketches and there are sketches. Just writing that short sentence brings home the poverty of the English language in this small sector of the fine art world; the French, by contrast, can call upon at least four words to distinguish the different types of sketch – *croquis, ébauche, étude, esquisse.* A sketch may be a simple contour drawing to test the compositional possibilities of a subject; it may be an assemblage of shading to test the tonal possibilities of a subject; it may be an analysis of an isolated element: a cloud formation, say, or a line of trees; it may be the briefest of vignettes (another French word, see), perhaps of a figure caught mid pose; or it may be a full dress rehearsal in graphite for the oil painting to come.

Whichever it is, you can't just decide to dash off a sketch – speed comes with practice and confidence. But given that we are seeking an Impressionist style in our painting, it does make sense to strive for the quick impression in our drawing too. And there *are* ways of educating yourself to work at speed. Sickert, for example, forbade his students to rub out mistakes, insisting that they overdraw the error in order to achieve a greater fluency. Self-imposed time limits are another way of disciplining yourself to get down as much information as you can in the shortest possible time.

The Impressionists were not, by and large, compulsive sketchers. Sketchbooks survive belonging to Sisley and Bazille, showing that both made pencil studies for their landscape canvases, but they seem to have been quite unusual in doing this. Monet avoided using drawings because, he said, it would detract from the spontaneity he was after. I must have read or looked at dozens of books on Monet over the years, and the only drawings of his I remember seeing, apart from his youthful caricatures, are a very rudimentary outline drawing of the town of Vétheuil, and a series of equally brief studies – some graphite, some pastel – of boats and bridges on the Thames, and of the Houses of Parliament. His dealer Philippe Durand-Ruel told a fellow dealer that Monet destroyed his 'sketches', but it's not clear whether he was referring to pencil drawings or oil studies.

The only prominent Impressionist to make extensive use of preparatory drawings was Degas, and some argue that this very activity disqualifies him from true membership of the group. Whatever one makes of that argument, Degas remained influential among his peers. Sickert fell under his

spell in the mid 1880s, and quickly adopted the master's practice of transferring preparatory drawings on to canvas by means of 'squaring up'. Squaring up works as follows: so long as canvas and drawing are precisely the same shape, a grid containing the same number of squares may be superimposed on each, and the drawing copied square by square on to the canvas at (what is usually) the larger scale. It was a fairly mechanical task, which painters would often leave to their assistants or apprentices. The modern artist Ken Howard not only squares up, he's also quite happy to leave traces of the graphite grid visible in his finished painting as evidence of the process.

Drawings that were thought suitable for transfer on to canvas like this would in all probability have been worked up from a series of smaller drawings. For his atmospheric music-hall paintings – a deliberate attempt on his part to create an English equivalent of Degas' paintings of *cafés-chantant* – Sickert made tiny, postcard-sized drawings that he annotated with colour notes and the lyrics of songs, the latter jotted down as a kind of aural aide-memoire. There was no other way of proceeding in such dimly lit, crowded spaces; and even then, he would not have been able to absorb enough useful information had he not also been able, night after night, to occupy the same seat in the theatre.

It's long been the practice for painters to annotate their sketches with colour notes, but I often wonder at its usefulness. It was fine for Sickert because, as I say, he could take up the same position night after night, and the palette of the scene would have been burned on to his retina. Most other painters' annotations record only the briefest of encounters with the motif, and are generally a straightforward naming of a commercial tube colour – burnt sienna, alizarin crimson and so on. Yet how many of us use our paints straight from the tube? It seems to me that colour notes are only effective if (a) the precise nuance of every colour is noted down – an impossible task – or (b) the painting for which these notes serve as reference is made within a very short time of the sketch. For unless you have a photographic memory, the odd colour prompt is hardly going to allow you to duplicate what you saw with any sensitivity. It would be far better, dare one say it, to supplement the pencil sketch with a photograph or two as a colour guide. Either that, or substitute an oil sketch for the pencil sketch. Which brings us on to…

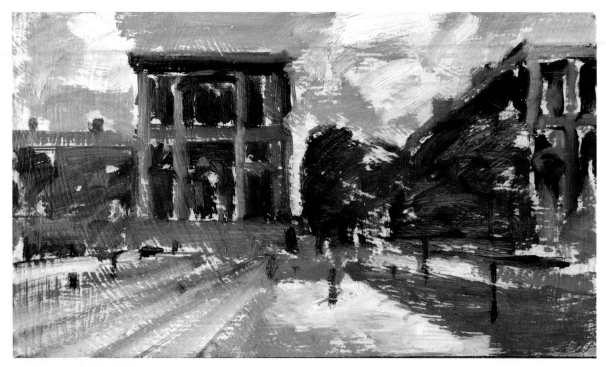

I shall be illustrating a number of small oil sketches, to show how you can get quite a lot of information down in a very short space of time. For time is of the essence if you are painting in front of the subject, and in my experience it's better to jot something down and move on, rather than to stay painting what might have become a very differently lit subject. This is a fifteen-minute sketch of campus buildings at Columbia University, New York, in breezy autumn sunshine. I liked the subject because at ground level the grid-like layout of the blocks and sidewalks creates a dynamic series of verticals, horizontals and diagonals.

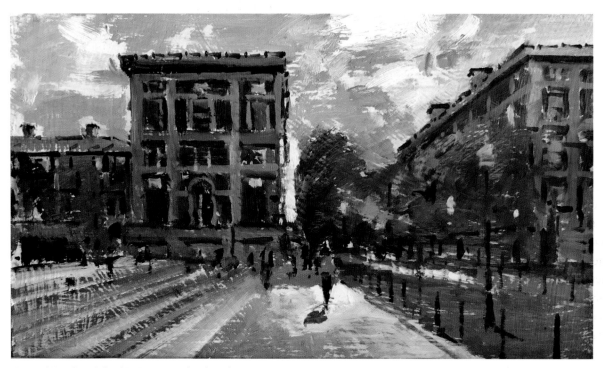

Kent and Hamilton, Columbia University, oil on board, 15cm × 25cm

The sketch pursued to a finish, albeit with minimal intervention; in particular, I forced myself to leave the sky well alone. The *contre-jour* figure walking into the painting is a device I often employ, as it's so useful in directing the eye and interrupting a dull expanse of foreground. Kent and Hamilton, besides being the names of boys in my year at school, are the names of the two parallel buildings.

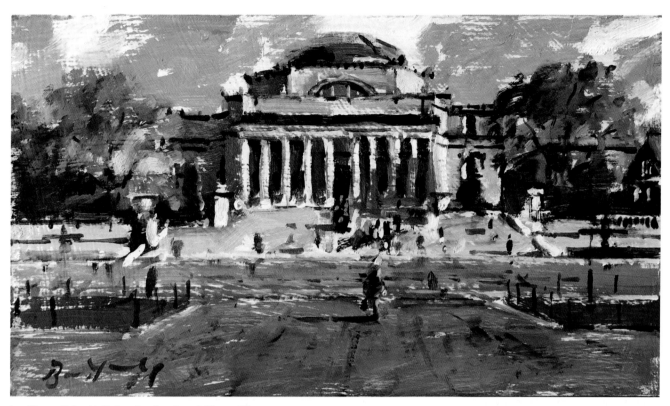

Low Library, Columbia University, oil on board, 15cm × 25cm

This domed library, modelled – like a number of American public buildings – on Palladio's Villa Rotunda, is the defining structure of Columbia University, so I couldn't leave the campus without making an oil sketch. As is my custom, I've tackled it fully front-on with a fairly high horizon line. The composition is symmetrical, which I thought was appropriate for such a classical building.

PLEIN AIR PAINTING

Plein air, open air: the words mean the same, so it's a comment on cultural hegemony that the French expression is the more widely used even in English, which is why I've dropped the italic designation that conventionally marks out the foreign import. (I do, however, italicize the words when using them as an adverbial phrase with the French preposition *en*.) Plein air painting seems, just now, to be threatening a takeover of the art world's principal agencies: there are plein air societies, plein air galleries, plein air workshops, plein air holidays, plein air competitions – all thriving testament to the reasonable assumption that those who enjoy painting indoors will enjoy painting outdoors even more.

So they may, but the artistic value of the activity is what matters. For many, this value is best summed up in the words of one of the early plein air practitioners, Eugène Boudin: 'Everything that is painted directly and on the spot has always a strength, a power, a vivacity of touch that one cannot recover in the studio... three strokes of a brush in front of nature are worth more than two days of work at the easel'. There's more than a hint of the glib in that final, much-quoted phrase, but few would dispute that painting outdoors in front of your chosen subject will help to sharpen your painter's instincts. In particular, you should develop a keen sense of how the world around you responds to the ever-changing light. The changing light in its turn forces you to make usefully quick decisions at the easel, to eliminate the non-essential, to overcome the temptation to fiddle or correct. The resulting painting should, in theory at least, gain much in the way of immediacy, vibrancy and spontaneity.

These jingly abstract nouns are the virtues of Impressionism, so it's easy to see why plein air painting and Impressionism have become as one in the public imagination. Not that the Impressionists invented the practice. The Romantic painters, such as Constable in England and Delacroix in France, had earlier worked outside in order to make oil sketches in varying degrees of finish, as had members of the Barbizon school. But the very fact that these works are referred to as sketches, and not as paintings, reveals a crucial difference: it was only the Impressionists who were willing to present their outdoor efforts as finished works of art.

The Impressionists were also able to take advantage of some technological developments denied to previous generations of painters. The coming of rail travel and of reliable tubed oil paint gave them access to subjects at ever-greater distances from their studios, with the result that an artist based inland could now journey to the coast in order to paint. It's probably no accident that our plein air publicist Boudin was someone who commuted between his base in Paris and the harbours and beaches of his native Normandy. And it was Boudin who taught the young Monet the importance of painting outdoors directly in front of the subject. Monet in his turn championed the practice to his fellow students Renoir, Bazille and Sisley, as well as to Pissarro, sharing painting expeditions with each of them at different times.

Monet's commitment to plein air painting turned out to be deeper rooted and longer lasting than that of his Impressionist colleagues, and by taking a closer look at his evolving and idiosyncratic approach over the course of his long career we can get a good feel for both the possibilities and the limitations of painting outside.

Monet and Plein Air

Monet's first essays in plein air painting were made alongside Boudin on the Normandy coast, but his ambitions in this direction quickly outstripped those of his mentor, to include life-size portraiture out of doors. In particular, he sought to create his own plein air version of Manet's *Déjeuner sur l'Herbe* (1863), a recent sensation at the Salon des Refusés. As Monet later recalled, his own version, the enormous and only fragmentarily complete *Luncheon on the Grass* (1865–6), was not painted entirely out of doors; he made some use of preparatory studies in the traditionally approved way. However, a follow-up painting, *Women in the Garden* (1867), was, he said, painted entirely in front of the subject. Its huge scale necessitated the digging of a deep trench into which the canvas could be progressively lowered, to enable him to work on the upper sections without climbing a ladder, which would have thrown out the angle of vision. The Salon rejected the painting, and Monet, who at this stage of his career was still craving Academy recognition, never again attempted outdoor figure painting on such a grandiose scale.

Monet's plein air paintings dating from the late 1860s to the late 1870s are to my mind the quintessential examples of Impressionism. They are extraordinarily varied in subject matter – town and country, land and sea, work and leisure, day and night – and most were completed over three or four sittings, with at least a day left between sittings to allow the paint to dry. One-sitting paintings (referred to as *alla prima*: 'at first attempt') are very rare, and include the charming studies of his new wife Camille on the beach at Trouville in 1870; the paint surface of one of these is evocatively peppered with grains of sand. Not all these pictures were plein air in its literal sense, for Monet was resourceful at finding subjects that could be tackled from the shelter of indoors, but the important thing was that they were made in front of the subject, or as the French have it, *en face du motif*. According to painting theorist Jules Laforgue, this is indeed the true definition of plein air. Thus the famous *Impression: Sunrise* (1872) was 'something done out of my window at Le Havre', a rented room on the harbour front to be exact. For his paintings of tricolour-bedecked Paris on the public holiday of 30 June 1878 Monet rented rooms high up in buildings on two different streets.

As the number of sittings he required for his paintings increased, it became ever more important for Monet to find places looking onto the motif where his easel could be left *in situ*. For the large sequence of Rouen Cathedral paintings (two trips: 1892–3), he secured easel space in a milliner's shop opposite, cramped conditions in which he could never get more than a metre away from his canvas. For his paintings of the Thames (three trips: 1899–1901), he had the luxury of a suite of riverside rooms in the Savoy hotel, emptied of furniture, in which to set up a number of easels. By this time, he could be working simultaneously on a vast number of canvases over a period of weeks, months, even years. It was the result of an obsessive determination, conceived in the early 1880s, to capture what he called the 'instantaneity' of a scene by switching to a fresh canvas as soon as the light changed. He told the American painter Lilla Cabot Perry that in one of his paintings of poplars the light effect lasted only seven minutes, or until the sunlight left a certain leaf, at which point he took out the next canvas and worked on that. The process was repeated day after day at the equivalent time of day, so that in due course a large sequence of paintings was created documenting the passage of time upon a single motif. This, he said, was the only way to obtain a true impression, and not a 'composite' one.

Bath Abbey, Morning: View from the Studio, oil on canvas, 30cm × 91cm

How many painters are lucky enough to be greeted with a view like this when they come in to work? It quite dispels any misgivings over the room's south-west orientation (most artists hanker after the stable light of a north-facing studio). I've painted the Abbey in all seasons but this panoramic treatment is only feasible in winter, when you can see through the trees. I've a notion that the sky was less interesting when I started the painting, which is why it occupies a smaller area than this quite dramatic cloud formation warrants.

Monet's 'series' paintings were all composed according to this formula, but what neither he nor his tame publicists mention is that nearly all of them were finished in his studio at Giverny – in the case of the London pictures from 'notes' made on the spot. I don't think this disqualifies them as plein air exercises, but it does point up one of the limitations of using late Monet as a model for plein air painting.

And there are other, bigger limitations. The chances of locating a vantage point to which you can return at the same time each day for maybe weeks at a time are pretty remote, and carting around the numerous canvases that painting in sequence demands is far too onerous for most of us; Monet had specially made boxes fitted with grooves to hold the wet canvases, and a troupe of young helpers to do the transporting. Also, without wishing to sound philistine, I must point out that Monet's late manner is only really suitable for someone who can afford to make a huge investment in both time and materials. Monet's long-standing supporter Philippe Burty remarked in 1883 that the artist was able to devote more time to each canvas because his paintings were now fetching higher prices; the 'series' projects that he undertook from the 1890s onwards were literally inconceivable without his newfound confidence that his dealers would indulge him. I'm lucky to have a very paintable motif on view from my studio window – Bath Abbey beyond the recreation ground – and have duly painted it at different times of day and year; but I simply couldn't afford to treat Bath Abbey as Monet did Rouen Cathedral. No, the work of the younger Monet is much the better model for someone wishing to paint impressions in front of the subject.

Equipment and Approach

So, if you wish to follow the young Monet's example and paint outdoors, how should you prepare, and what should you be looking to achieve?

To start off, you will need a different kind of easel from the one you use in the studio. There are options here. Sargent's paintings of Monet and Paul Helleu working *en plein air* show their canvases propped up by simple pole easels. You can still buy these, but they're only really suitable for sit-down painting on a relatively large scale. For those like me who prefer to paint standing up, the most versatile travelling easel is the French box easel, in essence an easel and paintbox combined. It holds everything you need in terms of palette, paints and brushes, and closes up into a compact, portable 48cm × 33cm × 10cm. A narrower model, designated a half box easel, is also available. The easel is reassuringly stable once set up, and the actual setting up is not tricky; it just involves a lot of loosening and tightening of wing nuts. Some people find the easel too heavy to carry any distance; my own is about 6.5kg fully loaded – the equivalent of five bottles of wine, or one well-fed cat, whichever best helps you imagine the weight.

Then there are *pochade* boxes, designed for the laptop yet convertible in some cases into a floor-standing easel by being mounted on a tripod. *Pochade* boxes allow you to paint

in confined spaces such as a car or perhaps a café, but the smallest boxes can't carry standard-length brushes, and none will accommodate a canvas; just a board that fits into the box lid. The box easel, by contrast, supports canvases up to quite a large size. There's a limit to the size of canvas you can take outdoors if it's at all breezy, for the canvas acts as a sail and will pull your easel over with it, unless the easel is weighted or lashed down in some way. On sunny days, the larger canvases will need to have an opaque board clipped behind them, otherwise the sun, as it swings round in front of you, will shine through some or all of the translucent canvas fabric and make it impossible for you to see what you're painting. This is rarely a problem for me, as I tend to work on board when on site. But whether your painting surface is of canvas or board, you should take several pieces with you, as it's likely you'll want to start more than one painting.

I won't insult your intelligence by telling you how to dress for the weather, but I might just mention that a wide-brimmed hat, or alternatively a deep-peaked cap with a neck shade, is vital to keep the sun from your eyes and neck. Even if by habit you paint standing up, it's worth taking a folding stool with you, as sometimes the best subject is to be found at eye level when seated.

Setting out, I tell myself that I'm more likely to find a subject that will inspire me to paint if I'm not trying too hard to seek one out. I can best explain what I mean by reference to Sargent and the way in which he came across subjects for what he called his 'out-of-door things'. According to his friend Edmund Gosse, Sargent would plonk his easel down 'nowhere in particular, behind a barn, opposite a wall, in the middle of a field. The process was like that in a game of musical chairs where the player has to stop dead, wherever he may happen to be, directly the piano stops playing'. He would then proceed to paint whatever lay in front of him. This was deliberate: he wanted to respond to a scene without having first tried to 'arrange' it in the way he had been taught in the atelier of Carolus-Duran. Sargent's genius was such that he could have made a subject out of a kaput refrigerator fly-tipped athwart a littered roadside verge on a sunless day... but the point is, 'found' is usually more successful than 'sought'. I certainly like to stumble upon a subject; if I set out with something particular in mind I'm often frustrated.

Having found what I want to paint, I make an oil study on a small board prepared with a gesso primer. I try to produce something usable within about twenty or twenty-five minutes. Beyond that time, the sun will have moved round and the tones and colours of the scene will have changed,

sometimes out of all recognition, creating what is effectively a new subject. In these circumstances I prefer to start a new board, rather than continue to work on the original one. Sometimes I progress these oil sketches to a higher level of finish with smaller brushes back in the studio, at other times I leave them in their very rough state as reference material for future paintings. In doing this, I take my lead from Sickert, who, when he was in Dieppe, painted small panels out of doors on sunny days, which he would then use as source material for 'usual sized pictures', painted in the studio on dull days. 'I shall hoard [my panels]', he wrote, 'and yearly work from them'.

I'm also, in a very modest way, referencing Monet's habit of taking up a new canvas whenever the light conditions altered. For Monet, that switch could be made at anything from a few minutes to about one hour. When he was working on his Rouen Cathedral sequence he switched canvas every fifteen minutes; he was, it seems, putting into practice the recommendation of Jules Laforgue, who a decade earlier had written:

'Suppose that instead of painting the landscape in a few sessions, the artist has the good sense to establish the life of its tone in *fifteen minutes...* In these fifteen minutes, the lighting of the landscape has varied infinitely; the living sky, the terrain, the greenery... In these fifteen minutes the optical sensitivity of the painter has been subject to ceaseless variation.'

So far as Laforgue was concerned, a painter who worked like this was not so much capturing as 'summing up' the lighting of the landscape in that fifteen-minute spell.

But what should you do if you want to carry on working at the same painting while the light continues to change before your eyes? The standard advice is to resist the temptation to update the work as the sun moves round, and to retain the tones and colour values that you first laid out, as well as the original placement of shadows and so on. This is surely correct: the updating process could be never-ending otherwise. But it does require you to have a very reliable visual memory of how the scene first looked. The problem recedes if the sun is not out, and many plein air painters like to work in a flat, uniform light for this very reason. The only drawback with this is that if, as I think we should, we characterize Impressionism as an attempt to capture in paint the fleeting effects of light, you're not here painting like an Impressionist.

This little sketch, of St Paul's from Gabriel's Wharf, was made as part of a commission to do a picture of City of London Boys' School, the principal building of which is the hipped and dormered block to the left of the cathedral. By coincidence, I had painted this same scene a few years before, and had established with the client that this was indeed the kind of scene she had in mind. The jetty on the right counters what would otherwise be a too-stark horizontal of bridge (Blackfriars) and quay.

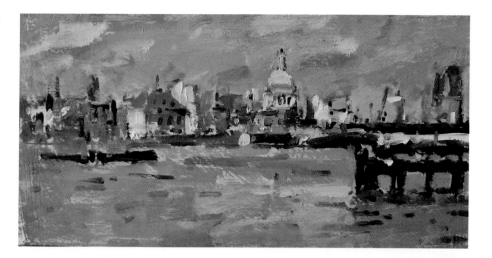

St Paul's and City of London Boys' School, oil on canvas, 51cm × 102cm

In the event, I did two slightly different versions of the same scene and gave the client the final say. Because the school buildings were clearly important to her I have used small brushes to indicate a higher level of architectural detail than I would normally do in a painting of this size. In addition, at the client's request, I omitted the crane activity – it appears in the sketch as red marks on the skyline to the right. The painting was made about four years ago; I daresay that if I were to revisit the scene today there would be new additions to the skyline, and St Paul's might not stand so proud.

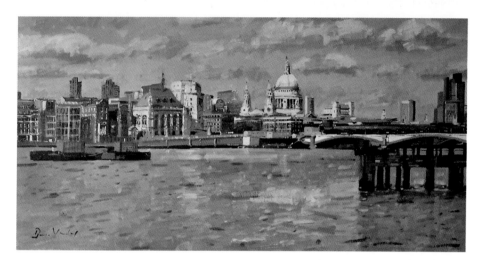

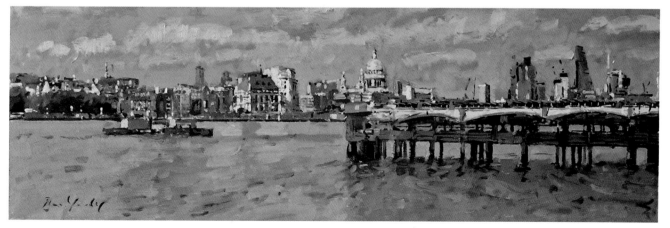

The Thames from Gabriel's Wharf, oil on board, 20cm × 61cm

Having completed the commission, I thought that the subject could make an even more panoramic painting, embracing some of the modern buildings that the client preferred not to see.

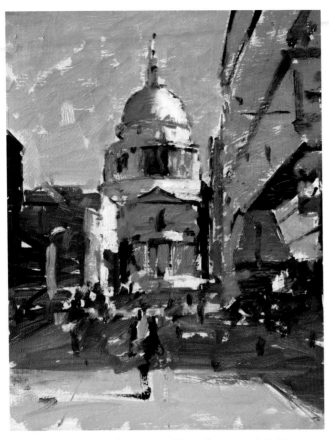

An oil sketch of St Paul's from Peter's Hill in early morning light (the paintings illustrated in the previous chapter were of afternoon light), before the arrival of the day's tourists. I've therefore tried to make it clear that the foreground figure is a besuited city worker.

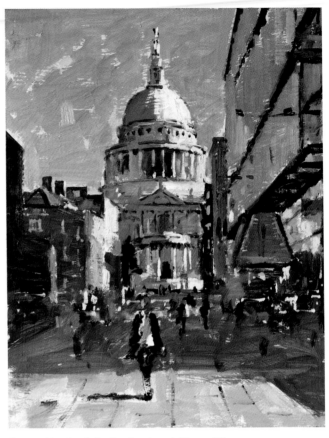

Summer Morning, St Paul's, oil on board, 25cm × 20cm

The same sketch pursued to a finish. Although the foreground figure now has greater definition I've retained the dry-brushed lost-and-found single stroke of paint for his leg, to suggest movement. The modern plate glass office block on the right is a strong lead-in, as well as offering a strong architectural contrast to the curvaceous Baroque of the cathedral.

Some Caveats

As we've seen, Monet devised various strategies in order to work *en plein air* on really quite large canvases. The opportunities for the modern painter to do likewise are much more limited. It's only really practical to return to precisely the same spot on multiple occasions if the location in question is firmly under your control, or at least relatively free from other people. This is one reason why most plein air paintings of today are straight landscape: fields, trees, mountains, rivers, coast, and so on. The other reason is that straight landscape poses fewer technical problems, especially at the drawing stage: trees and fields are far more forgiving to the draughtsman than are buildings and figures.

Setting up your easel in a town or city or any other busy place takes much more nerve, and you need to be a certain kind of person to be able to shrug off or ignore the attention that will inevitably come your way. The original Impressionists have a huge advantage on us here, working at a time when the pace of life was slower, and when public respect for painters and painting was higher. Renoir's son Jean recounts the nice story of Monet's chutzpah in securing the co-operation of the superintendent of Gare St-Lazare, by adopting the dress (complete with gold-topped cane) and condescending manner of a successful, established artist: 'I have decided to paint your station', Monet informed the official; 'For some time I've been hesitating between your station and the Gare du Nord, but I think yours has more character'. The superintendent, suitably impressed, not only let him paint but halted the trains, cleared the platforms, and stoked the engines with coal in order to create more smoke and enhance the picturesque qualities of the scene. Can you imagine trying to do the same at, say, Paddington? You'd be handed a penalty fare and moved on, if you and your easel hadn't already been sent clattering across the concourse in the stampede for the 17.47 to Bristol Temple Meads.

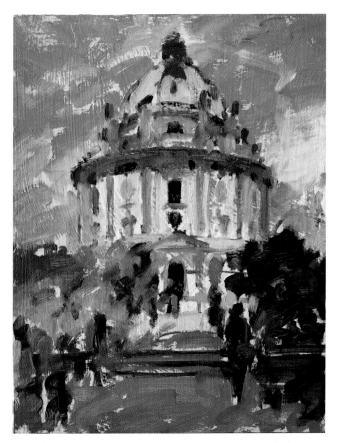

Continuing the theme of domed Baroque buildings, this is Oxford University's Radcliffe Camera. Ellipses are never easy to draw, but at this small scale a certain amount of simplification is possible. The path up to the pedimented doorway was only created a few years ago and is a boon to the painter, as it takes the eye straight to the building. Before, the railings ran right around this side of the building.

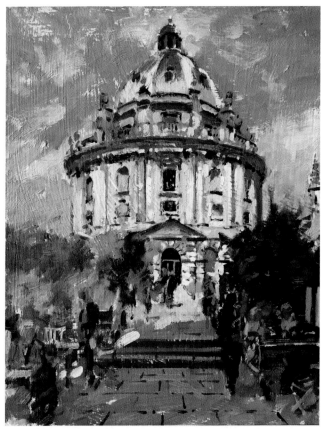

Radcliffe Camera from the South, oil on board, 25cm × 20cm

Small-brush detail added, though as with my other boards the sky has been left largely untouched, to preserve the feeling of a breezily sunny day.

The chance that you might be moved on is actually quite real. In 2018 Ken Howard was painting in front of Basilica San Marco when he was approached by police and asked to stop, since he didn't have the requisite licence. The incident made the national press here in the UK. I myself have witnessed Howard painting in Venice, but it's surprisingly rare to find a painter working *en plein air* in this, the most paintable of cities. I've been going to Venice for over twenty years now, and have only ever come across four. (I'm not counting the peddlers ranged along the Molo San Marco and elsewhere who 'mime paint' their factory-made pictures for the benefit of credulous tourists.) The same is true of other cities where adventurous plein air souls might be expected to gather, such as London, Paris, Rome, and Florence. In all of these supposed artistic meccas I only recall seeing one painter at work – Ken Howard again, standing doughtily before his easel on Hungerford Bridge on a roasting hot July afternoon.

Common sense tells us it's not very likely that bashful plein air enthusiasts have been conspiring to keep out of my line of vision year after year, so I've concluded from this that only a tiny proportion of the paintings that artists claim to have painted on the spot really were painted on the spot. The compulsion to parade one's plein air credentials seems strongest when artists turn author and publish books of their paintings. Captions in these books turn out, far too often, to be somewhat self-satisfied recitations of the manifold hazards the authors have encountered in their plein air struggles with the motif. Such hazards have become rather a cliché: the incoming tide; the collapsing weather; the angry bull in the next door field; the importunate onlooker who wants you to know that their cousin is a *real* painter; the delivery van that draws up in front of the subject, and stays, and stays, and stays.

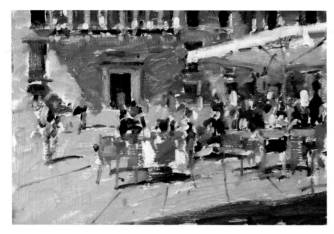

The preliminary small-scale (20cm × 30cm) sketch for a studio step-by-step sequence of a café scene in Campo Santo Stefano, Venice. I've always liked painting café scenes, which I think of as a specifically Impressionist sort of subject. Venetian cafés, moreover, often have a splendid backdrop. Here, the diagonally shadowed wall of Palazzo Loredan provides a particularly striking backdrop. These sorts of scenes need sunshine; flat light wouldn't suit the mood. The foreground shadow is a stabilizing element within the general busyness, though it happens to be thrown by a parasol behind me, not the one in the picture.

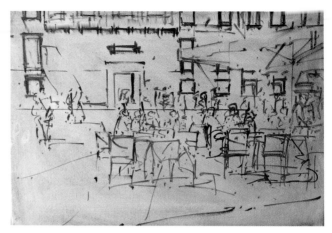

The canvas is exactly the same shape as the board on which the preliminary sketch was made, so the composition may be transferred without much further thinking. My under-drawing is always in paint, not graphite. It gives a positive line that remains comfortably visible through the early stages of the painting and takes me quicker into the painting process. All my under-drawings are made with my standard dark, which is ultramarine blue mixed with burnt umber, put on here with a no. 6 brush and very slightly thinned with white spirit. I've used a T-square to ensure that the horizon line – where building meets ground – is straight and true, and again for the vertical of the parasol pole: I find it faintly disturbing when compositions lean one way or the other, which can happen when you put these in freehand. The perspective lines on the pavement are put in as a sort of visual anchor; they'll most likely be painted over.

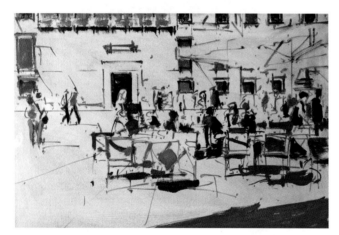

Starting with the darks makes sense for all sorts of reasons. For a start, it is technically safest to lead off with the quickest-drying pigments, which are nearly always the darks (this is explained at greater length in the main text). It also forces you to analyse and establish the tonal range early on, for while the background tint will rarely be the lightest light it will usually be at the opposite end of the tonal spectrum from the dark paints. The painting, as a result, seems to take shape pleasingly fast. I'm here using a no. 8 brush.

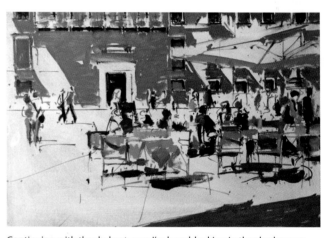

Continuing with the darker tones, I'm here blocking in the shadows on the palazzo wall with a mixture of burnt umber, cobalt blue and raw sienna, lightened here and there with Naples yellow. You can I think tell that the paint is quite turpsy and translucent in places.

If you treat these stories with a healthy dose of scepticism you will, I'm sure, start to feel better about your own plein air efforts. The very experience of painting outside is an educative pleasure. As with drawing from life, you'll learn to look more intently at the world about you, and will notice more in the process. Your sensitivity to subtle changes in colour will develop. By subjecting your technique to time pressure you'll become more at ease with painting at the kind of pace that allows you to capture that fleeting impression. What you produce on site might not – as yet – warrant a signature and a frame, but you should remind yourself that very few plein air pictures do. Most leave the field in

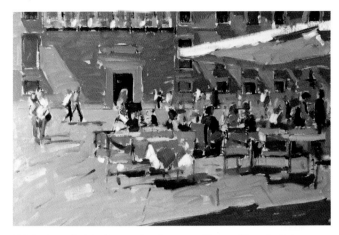

This is the end of the first session. I've moved forward into the lighter tones, finishing off with the sunlit highlights on the parasol, tablecloths and tourists' clothing, as well as the bright accents of colour. The palazzo shadows are not quite as pronounced as I'd hoped but that doesn't matter; the tones can be corrected during the next session. That's the beauty of oil. This whole session has been completed with a no. 8 brush.

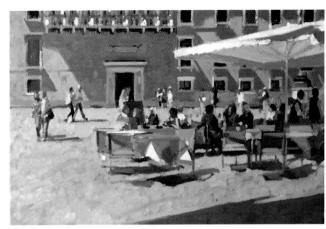

When, as here, the painting is executed in three discrete sessions (a characteristic, I've now learned, of many Impressionist canvases), the second session is usually the longest. I've switched down to a no. 7 brush and worked over the entire canvas to push the painting forward at the same rate, trying to produce a neater and denser paint surface. Along the way I've corrected the tones of the palazzo shadows, which are now stronger than they were at the end of the first session. Most of the background tint has now been eliminated but it still has a presence. The pavement perspective lines have also gone, temporarily.

a crude and unfinished state, and need major surgery back in the studio to bring them to a state of completion. The Impressionists understood this. Or you could, like me, take a leaf out of Sickert's book and treat these paintings as a step in the picture-making process, furnishing you with information with which to make more fully resolved pieces. They may not give you *all* the information you need, but there are supplements available, including the controversial one we need to discuss next.

PHOTOGRAPHY

David Hockney's colourful and underivative paintings are deservedly popular, so I expect I shall be thought wildly eccentric when I say that I consider his biggest contribution to the world of art to be his book *Secret Knowledge,* an exposé of the degree to which artists of the pre-photography age used optical aids when making their uncannily accurate and life-like pictures. I admire *Secret Knowledge* not so much for its revelations about the use of optics as for its underlying and (to me) congenial message that it's possible to enjoy an artwork without obsessing over how it was made. 'A beautiful painting, with an optical base' writes Hockney about a Frans Hals portrait. I love that quiet comma, the gentlest of hints that the praise is being ever so slightly qualified.

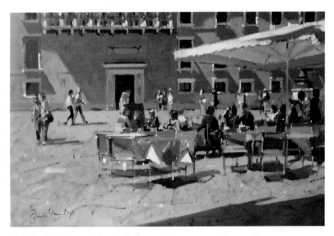

Café Society, Campo Santo Stefano, oil on canvas, 41cm × 61cm

I've not wanted to alter the general look of the paint surface so in this final session I've used only the smaller brushes (sizes 4 and 6) to indicate detail – where the sun is catching the window frames, chairs and so on, the aim being to show that the painting is lit from the left. Paving lines have been restated at dry-brushed speed.

Photography, a new kind of optical aid, engendered fear and fascination in equal measure within the art establishment, from its first appearance in the early-to-middle decades of the nineteenth century. When shown a printed example of the new technology, Turner is said to have expressed relief that his day had passed, as painters like him would soon be redundant. This did not prevent him from cramming his studio with photographic negatives. The Royal Academy and other societies sensed a similar threat, and explicitly

barred from their exhibitions paintings that had overtly been made with the aid of photographs. It thus became a matter of self-preservation for artists to deny or disguise their use of photography. In 1905 Monet was so disconcerted by suggestions that he had used photographs for his recent paintings of the Thames that he abandoned plans to show the pictures in London.

Because – to this day – painters rarely admit to using photographs, it's never easy to find firm evidence of the practice. In the early days of Impressionism exposure times were too long anyway for the photographs to be of much use, certainly for the landscapist looking to take a brisk impression of a scene. They were more relevant to the portraitist or figure painter, and both Manet and Degas used them in this context. By the end of the century exposure times had come right down, and pictures containing moving elements such as people walking could now be taken with relative ease. This made photography a better proposition for the artist who was interested in experimenting with it. Edouard Vuillard, a painter from the generation below the Impressionists and a great admirer of Monet and Morisot, acquired a Kodak camera in about 1897 and went on to assemble a large archive of self-developed snapshots, 1,750 of which survive. He referred to these as 'memoranda' and quarried them for material to use in his paintings.

Which prompts the hypothetical question: if the first Impressionists had enjoyed access to cameras equipped with faster shutter speeds, would they have made greater use of them in their paintings? I feel certain that some would have.

The Pros and Cons of Photographs

We need look no further than Sickert for pithy arguments both for and against the use of photography as a painting aid. As a young man, he argued that reliance on photographs stunted an artist's technical development; he likened it to a swimmer practising while wearing a cork jacket (he can't have been aware that his friend and mentor Degas regularly used them). Precisely when Sickert started using photographs for his own paintings is not clear, but we know that he was making at least some use of them while continuing to condemn the practice in print. He won't have been the first hypocrite on the subject, and he's certainly not the last. As time went on, however, he became an open and unapologetic advocate of the camera, suggesting it gave artists much of the information they needed to construct paintings, and thereby saved them time. Towards the end of his career he was insisting, 'Artists *must* use the camera'.

Sickert possessed a histrionic personality befitting his previous career as an actor, and he often spoke to provoke. But there's no reason to doubt his sincerity, and there's good sense in what he said, whichever hat he was wearing at the time. An artist will never develop observational skills if they gaily snap away and let the camera do their observing for them. And they definitely won't develop drawing skills if, by squaring up a photograph and transferring it onto canvas, they also let the camera do the drawing for them. Sickert squared up photographs in this way because it 'saved time', but then he had the comforting knowledge that he could draw perfectly well unaided. And this is really the point: if you deploy the camera constructively, and not merely as a crutch, you're much less likely to fall into bad habits. My father, a professional painter working mainly in watercolour, is convinced that his drawing actually became more assured after he relaxed his puritanical attitude to the camera. It gave him, he says, the confidence to take on more demanding subjects, ones that required a more disciplined drawing-out than the plein air landscapes that had previously defined his oeuvre. He suspects that many painters have been put off tackling more interesting subject matter because they have been persuaded that *any* use of the camera is somehow unethical.

The value of the camera comes into focus, as it were, when you probe what it means to do without it. Plein air painting, as already noted, is often impractical for the kinds of subject you might wish to take on. Working from sketches and colour notes is fraught with difficulty unless the scene is very fresh in your memory. Painting from memory alone is trickier still, and should probably be left to those blessed with a phenomenal visual recall. Having said that, it doesn't hurt to practise memory-strengthening exercises, perhaps taking Whistler as your model. Sometimes in the company of Sickert, and typically along a stretch of the Thames at night, Whistler would test his powers of recall by staring intently at a view for about ten minutes, after which he would turn his back on the view and describe it to his companion in as much detail as he could call up. Apprised of any corrections and additions, he would return to the studio and, at the first opportunity, paint the scene from memory. The paintings he produced in this way were undoubtedly feats of bravura, but it's telling, I think, that they're almost exclusively spare, misty nocturnes – subjects with a minimum of scenic detail.

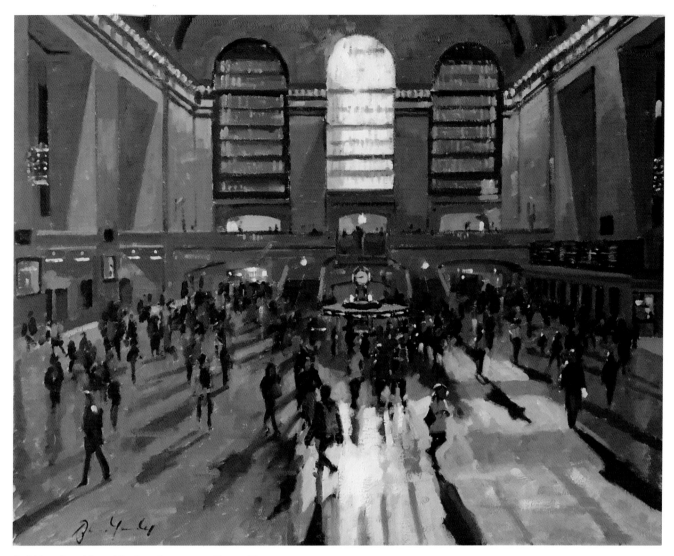

Rush Hour, Grand Central Station, oil on canvas, 61cm × 76cm

It's clearly not realistic to attempt a large-scale oil painting of the concourse at New York's Grand Central Station at rush hour, and I'm always suspicious of artists who claim to have painted this sort of subject entirely on the spot. An alternative is to make drawings or studies backed up with photos for reference. As it happens, the camera doesn't cope well with strongly *contre-jour* images like this, so here I've tried to memorize some of the key tones and colours I saw in Grand Central Station. I've also taken care to ensure that the figures don't look frozen in motion, by painting them with big-brushed brevity. A subject like this is all about movement.

Some Practical Considerations

As painters, we should constantly remind ourselves that a camera sees things differently from us. It does so in two main ways. First – and I'm sorry if this seems obvious, but it is important – the camera has one fixed aperture, while we have two eyes that rotate in sockets. Secondly, cameras have lenses of variable focal length, while ours are fixed. A camera fitted with a wide-angled lens can try to mimic the way in which our eye swivels to obtain a wider field of vision, but it's not a very good mimic: its wide-angled lens makes nearby objects appear larger than they do to the human eye,

and distant objects smaller. These distortions are reversed with the opposite kind of lens, telephoto: nearby objects look smaller, and distant ones larger or closer (what's known as foreshortening).

Accordingly, it makes sense to set your camera to operate within a lens zone similar to that of the human eye, centred around 50mm. If you produce a painting derived from a decidedly wide-angled (<<50mm) or telephoto (>>50mm) lens it will look unnatural. Or put another way, it will look like a photograph, and will no doubt attract the attention of the technique police. Sickert had no qualms on this score. His

painting of *The Lion of St Mark's* (c 1895–6, shortly before he 'came out' on the matter of photography) seems to have been based on a severely foreshortened image that is now thought to be a detached stereoscopic photograph. (Stereoscopes were hugely popular at the time: they hold two photographs placed side by side, which when viewed through a lens at a certain distance fuse into one displaying high 3-D definition.)

There are other quirks to look out for. Modern cameras have very fast shutter speeds that snap off movement in a way the human eye never does. You therefore need to be careful when painting figures from photographs, lest they appear to be frozen in mid motion. Next, many cameras are calibrated in such a way that if the exposure is accurate for what is seen on the ground, the sky will be over-exposed, with attendant loss of colour and detail in the sky portion of the photograph. Where the shot is taken looking directly into the sun (*contre-jour*) the photograph will be more monochromatic than what you see with your own eye. Where the shot is taken with the sun behind you (frontal lighting), the photograph will be more colourful. Finally, where the picture is taken in the evening or at night, when light levels are naturally low, the camera will try to compensate by boosting both light and colour. 'The camera never lies' is not a phrase you'll hear on the lips of a painter with any sensitivity to visual nuance.

You need, in short, to be alive to these little idiosyncrasies, and to guard against making an over-literal transcription of what may be a faulty or 'dishonest' image (painters and critics seem fond of using that word). Of course, digital images may be manipulated and to some extent corrected on your computer, provided you edit them while the original scene is still clear in your mind. The fact that a colour image may, at the click of a button, be converted to a black and white or otherwise monochrome image is another advantage, not least because a black and white print is a good, ready-made tonal analysis of the composition. Some painters – Ken Howard is one – prefer to use black and white prints anyway, finding the ones in colour too 'distracting'.

A further safeguard against an over-dependence upon a rogue image is to combine whatever photographs you take with the sort of oil study I described in the section on plein air painting. This will provide you with a painterly little summary of the scene against which you can measure your camera's interpretation. In particular, it will enable you to replace the colour photograph with that possibly less distracting black and white one, as your oil sketch summary ought to be the more accurate record of the colours you saw. For dusk or night subjects, where it might not be practical to make an oil study, I follow in Whistler's steps and try to memorize those subtle, quiet colours that I know will be amplified by the camera.

All things considered, the combination of an oil study and, where appropriate, carefully vetted photographic reference material seems to me to be a legitimate and efficient means of gathering information for a more fully resolved painting.

RESOLVING THE PAINTING

In the winter of 1990–1 the National Gallery in London hosted an exhibition entitled *Art in the Making: Impressionism*, which helped to overturn our understanding of how the Impressionists made their pictures. The exhibition was, in effect, a pictorial presentation of a science paper. The paint structure of fifteen well-known and representative canvases by seven different artists (Manet, Monet, Renoir, Pissarro, Sisley, Morisot and Cézanne) had been closely analysed, and the major finding of this analysis was that all but one of the canvases had been completed over several sittings, with the paint allowed to dry thoroughly between sittings. The conclusion to be drawn was that the Impressionists worked more methodically and at a more sedate pace than we had been taught to believe.

The point was reinforced ten years later in an exhibition at the same venue, entitled *Impression: Painting Quickly in France, 1860–90*. As the title indicates, this later show concentrated on paintings that gave the appearance of having been rapidly executed, but which were, like the previous exhibits, almost certainly completed over several sessions – however short the total time the artist might, in certain cases, have spent at the easel. Even Monet's notoriously sketchy *Impression: Sunrise* ('Wallpaper in its embryonic state is more laboured than this seascape', said one reviewer at the time) is today categorized as a three-sitting work. Which rather undermines the central conceit of a television documentary I saw many years ago, in which a professional pasticheur – they hate being called copyists – explained that the painting would have been completed in a single sitting of about forty minutes. He proceeded to demonstrate how this could be done.

The curator of *Impression* announced another important revision when he wrote: 'Much of this work, we now know, was carried out in the studio rather than out-of-doors in front of the subject'. That rings true to me, though it seems to be based on supposition rather than firm evidence. The evidence is lacking, I would suggest, because the Impressionists made a noisy virtue out of painting in the open air, and sympathetic observers were always liable to stress this aspect of their art ahead of any studio work. This applies especially to Monet. In 1880 Monet told a visiting journalist that he had never owned a studio, saying, 'Personally, I don't understand why anyone would want to shut themselves up in some room: maybe for drawing, sure; but not for painting'. Then, with a sweep of the arm to indicate the town, the river and the hills beyond, he added, 'that's *my* studio'. It's a scene straight out of a Hollywood biopic, and you can see why it resonates so strongly with the public at large. But it's not true; or rather, it's true only in a very literal sense. For Monet had always had access to studios belonging to others, and when he secured permission to paint at the Gare St-Lazare his well-heeled artist friend Gustave Caillebotte rented a studio for him in the nearby rue de Moncey. Monet acquired his own studio when he settled down at Giverny in 1883, but even then, he seemed to treat it like a dirty secret, never once publicly acknowledging the fact that his major series paintings were all re-worked there. The less deceived observer of today, mindful of the time that it takes oil paint to dry between sittings, is rightly suspicious of the notion that these artists were able to progress their pictures in a prolonged and desultory fashion while working exclusively in front of the motif.

Be that as it may, it makes sense for anyone looking to model their painting style on that of the Impressionists to take a similarly layered approach, and to progress their paintings in stages. Before we take this further, we need to consider the initial, often self-contained stage: the under-drawing.

The Under-Drawing

In the Academy training that the Impressionists received, the *ébauche* could be both a preparatory study and stage one of the painting itself. In its latter guise it was a drawing in pencil or charcoal overlaid with thin, rust-coloured paint (the 'sauce') with which the student established the tonal range of the paint-work to follow, first laying in the darks, then the lights, and finally the mid tones. Only then would they proceed to apply colours and build up the painting. Degas

worked according to this academic formula, but the other Impressionists dispensed with the tonal under-painting, and placed their colours directly on top of the initial line drawing.

For the under-drawing itself, I draw directly on to the canvas with a paintbrush, rather than with pencil or charcoal: paint gives a much more positive, visible line than graphite, which would be lost against all but the weakest of ground colours. Charcoal produces a strong enough line, but it can dirty whatever paint is placed on top – not a problem if the paint on top is the rusty, monochrome *ébauche*, but a definite problem if it is a colour you might not wish to alter later on. I used to think I was unusual in laying down the initial drawing with the paintbrush, but it seems that several of the Impressionists drew with the brush. The paint I use is a mix of French ultramarine and burnt umber, slightly thinned with white spirit. Sickert, who frequently drew with a brush, used black, a colour I would avoid in this role, as it's not sufficiently quick drying. I'm happy to use a ruler or a T-square where necessary, but this doesn't mean I adhere rigidly to the ruled line when laying-in the initial coats of paint: straight lines can be very distracting, especially where the paint handling is otherwise loose. 'Nature abhors a straight line' said the architect and landscape gardener William Kent, a dictum worth keeping in mind when drawing out, particularly for a landscape.

My under-drawing, then, is a line drawing with minimal detail: there seems little point in including details that will be covered up in the initial painting. I start all my pictures this way, regardless of scale. The only adjustment I make is in the size of the brush used: size 3 for the smallest boards, size 6 for small and medium canvases, and size 8 for the larger canvases. Monet's outline drawing was apparently just that, an outline: according to his biographer Geffroy, 'he sketches only a few lines on the bare canvas; several very simple planes, a line for the horizon, and the painting is constructed'.

Progressing the Work

Constructing an oil painting over several discrete sessions or sittings (the words are inter-changeable: I use both at different times for the sake of variation) is not so much a choice as an acknowledgement of the practical constraints imposed by a medium that refuses to dry as quickly as you would like. If you go at your canvas too long the colours will become increasingly muddy; they become, so to speak, 'mid colours'. The same will happen if you return to the canvas too

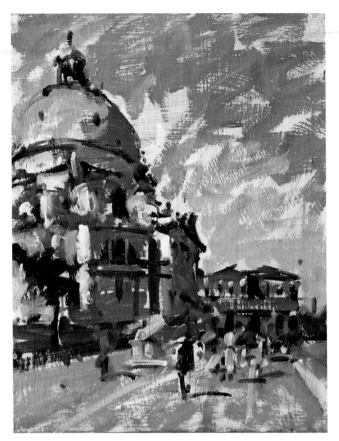

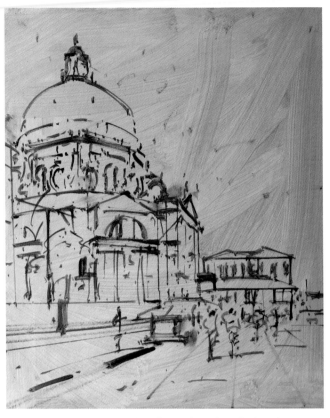

This step-by-step sequence starts with another small oil sketch, of another Baroque domed building, in this case the church of Santa Maria della Salute in Venice, built in the early seventeenth century at the entrance to the Grand Canal in thanksgiving for the city's deliverance from one of its many visitations of plague (hence *salute* – health and safety). Some people find these Baroque confections somewhat vulgar, but you will already have gathered that I find them extremely paintable. And there's a good reason why I do so. The many planes and surface ornamentation of Baroque architecture are designed to maximize the play of light across the building, and play of light is of course a huge draw for an artist of an Impressionist bent. In this view, from the small canal-side campo in front of the church, the side-lit and shadowed white Istrian stone of the Salute contrasts with the warm burnt sienna tones of the neo-Gothic Palazzo Genovese directly ahead.

The canvas I'm using is a slightly different shape from the board on which I made the sketch, so I've widened the composition to the left to give the merest glimpse of the next building along. For this paintbrush under-drawing I've used a straight edge to ensure that certain elements within the architecture are plumb – though in point of fact Venetian buildings are never truly plumb; they all taper slightly as they climb, for foundational reasons. The marks in the sky are a reminder to put in clouds.

soon. And not only that: if you apply fresh paint to paint that's still tacky, the tacky colour underneath will suck oil out of the fresh pigment, and the surface will eventually crack as the paints dry at different rates. You simply have to be patient, and to allow your work to dry thoroughly before coming back to it. When Whistler made his portrait of Théodore Duret (*Arrangement in Flesh Colour and Black*) he tested his sitter's patience by insisting that the paint was completely dry before each sitting; he did so specifically to rule out any possibility of the paint cracking.

Painting in stages means you're likely to have several pictures on the go at any one time, and the longer they take to dry, the more paintings you will find yourself working on. When Sickert was painting in Venice through the winter of 1903–4 he used to stack his canvases around the oil stove in an effort to speed the drying. I quite often have up to ten paintings in progress at any one time, and I like the variety this gives my working week. I don't know if I could cope with many more than that, though. One journalist reported that Monet had over a hundred pictures in progress whilst painting at the Savoy at the turn of the century, a truly mind-boggling figure.

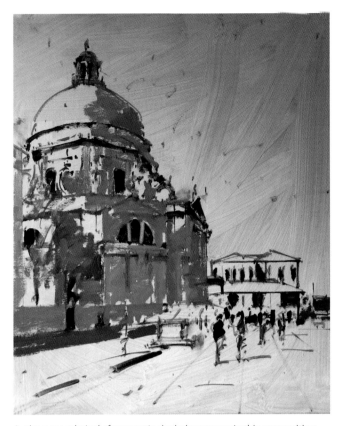

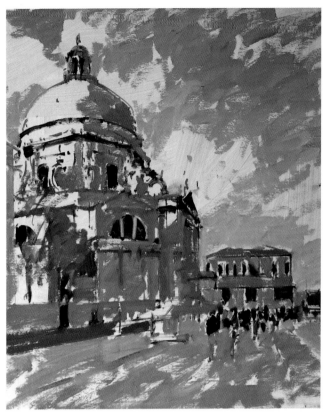

As there are relatively few genuinely dark passages in this composition I've moved fairly quickly from the darks to the bluish mid tones, the shadowed portions of the church. These bluish mid tones are obtained from ultramarine and cobalt blue mixed with burnt umber and Naples yellow. I've also scrubbed in the foliage of the tree, though I've not at this stage cleaned my brush, which is a no. 10 short flat hog. The mullions of the diocletian (semi-circular) window have been ragged out, rather than painted in.

After the first wiping of the brush, some cleaner colours can be introduced – a mix of raw and burnt sienna for the Gothic building, and various shades of blue for the sky, with the clouds left as bare tinted canvas. The blue of the sky is a mix of Old Holland (or sometimes Michael Harding) cobalt blue and Winsor and Newton permanent rose, lightened with Winsor and Newton Naples yellow light. I have a tendency to make the skies more lilac than they look in reality, but I find this a more sympathetic colour, one that integrates better with the rest of the painting. It's usually enjoyable scrubbing on these initial colours, and a part of me always wants to stop painting at this stage, when every brushstroke seems to be pulling its weight, against a honey-coloured ground that is also pulling its weight.

I was interested to learn that many of the sketch-like paintings featured in the *Impression* exhibition were probably three-sitting affairs, for broadly speaking, my own pictures are typically produced over three 'sittings'. I put that word in inverted commas because, in the case of larger canvases, the middle sitting might itself be progressed over several days. How long each of these sittings lasts is a question of temperament, stamina and artistic aim. I very rarely work on an individual painting for more than about two hours at a time, taking comfort from the example of Sickert, who held that an artist risks undoing their good work if they carry on for much longer. Ken Howard allots himself a maximum of one and a half hours, and no one could accuse him of being brush-shy; it's just that his working day is measured out in units of one and a half hours. I usually have a firm idea of how long I expect each session to last, and if I overrun my mental allotment of time it usually means I've started fiddling, at which point I promptly stop.

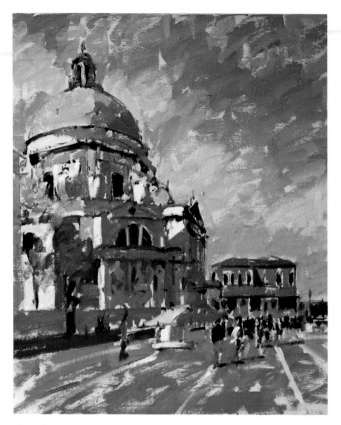

The palest tones are now put on, still using the no. 10 brush. One immediate consequence is that there seems to be some loss of cloud definition. This needs to be addressed in a later session, and perhaps reveals why I was happier at that earlier stage of proceedings. This is the end of the first session.

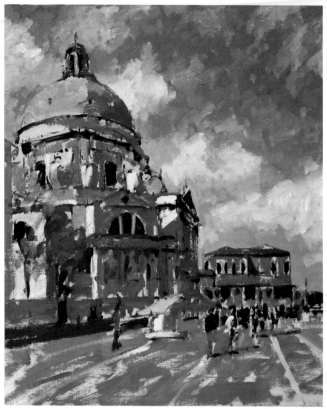

At the start of this second session, I've begun working on the sky, now using a no. 8 brush. The first task is to give the fluffy cumulus clouds some more definition. The palest brushstrokes are a mix of titanium white and Naples yellow light, but you'll see that I have also introduced some lilac (permanent rose plus cobalt blue) and turquoise (cerulean blue plus Naples yellow light) passages. The angular brushstrokes of the short flat hogs are still very prominent, which I don't mind at all: as soon as I took the decision to show the whole height of the Salute, rather than crop it below the dome, I knew the sky had to be a very active element of the painting, as it would inevitably occupy quite a large area of canvas.

For the first session, I aim to cover the canvas with paint quickly and fairly completely. Here as elsewhere, I find my approach has been anticipated by Monet, who is reported to have said: 'the first painting should cover as much of the canvas as possible, no matter how roughly, so as to determine at the outset the tonality of the whole'. I try to get both the tones and colours reasonably accurate in this first session; I don't therefore limit my palette in any way. What I'm trying to do is avoid having to correct the tones and colours further down the line – though some correction is inevitable – as this leads to passages becoming overworked. Like most painters, I work from dark to light, and from lean (thinned) to fat (unthinned). Working from dark to light is pretty much non-negotiable: if you were to start off with the light colours, which are rarely if ever thinned and which dry much more slowly than the darks, and then place quicker-drying dark colours on top, the top layer will start to crack as the slower-drying under-layer contracts.

That first session is usually the most satisfying, for largely psychological reasons. Simply starting a painting is a cause for celebration in my book. It's also liberating to know you can probably later rescue any false start, a comfort denied to watercolourists. As a result, I look on the first session as a low-pressure sketch, taking maybe three quarters of an hour to one and a half hours, depending on the size of the picture.

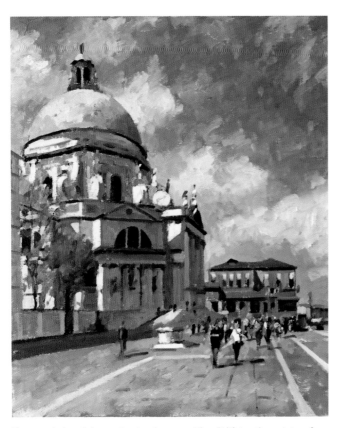

The remainder of the session is taken up with solidifying the paint surface over the rest of the painting. Again, I have used the same sized brush (no. 8) in an effort to promote an integrated look. The pale honey-coloured canvas is now much less visible. The figures are more in focus. Couples usually walk side by side, which to the painter can look distracting, so I have staggered the couple walking towards me by bringing the left-hand figure slightly forward.

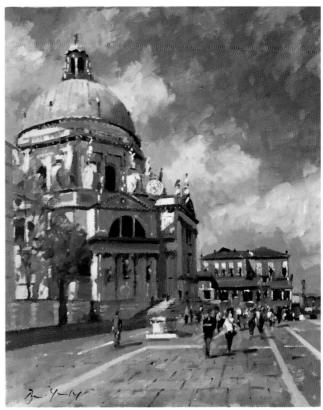

Campo della Salute, oil on canvas, 51cm × 61cm

A lot of Baroque architecture is fussily ornate and the Salute is no different, so in this final, brief session I've been at pains not to overdo the small-brush details. The lucarnes and the rust stains below them give some useful definition to the dome of the church, while further down the building the statuary has been very simply indicated. Other than that, it's just a question of adding a few marks to persuade the viewer of the texture of what they're looking at – the steps up to the church, the foreground paving stones, the sun on the tourists' clothing.

The second or middle session has neither of these satisfactions, and always takes me far longer than the first. I'm sure I'm not alone among Impressionist-type painters in fearing that at this stage all I'm doing is spoiling the sketch. When these negative thoughts take hold, I tell myself that whatever appeal the initial paintwork has is probably meretricious – that the tones need refining, the colours need heightening, the texture needs solidifying, and so on. Viewed in a more positive light, the second session can be said to tidy up the sketchiness of the first. This sense of bringing a picture slowly into focus recalls the practice of Monet, as recounted by his neighbour Lilla Cabot Perry: 'he brought out a canvas on which he had painted only once; it was covered with strokes about an inch apart and a quarter of an inch thick, out to the very edge of the canvas. Then he took out another one on which he had painted twice; the strokes were nearer together and the subject began to emerge more clearly'.

The important thing is to move the whole painting forward at an even pace, and not to allow some areas to develop well ahead of others. To this end, I find it helpful to restrict myself to the same sized brush throughout the session. That doesn't mean I use only the one brush; I might for example use one brush for my darks, another for my lights, and so on, to save having to clean them too often. I move down the brush sizes the further I progress a painting. For a 51cm × 61cm canvas I would typically do the first session with a no. 10 brush, the second with a no. 8, and the final session with several brushes, from no. 6 downwards (all these brushes, I should explain, are short flat hogs). That might sound formulaic, but it prevents me from getting bogged down in detail too

early on in the painting, and makes for greater cohesion. Also, by using brushes one size down from what was used in the previous session you ensure that your task has become subtly different, which prevents you from re-treading the same ground. Having said that, you can use the same sized brush from start to finish if you want to give the illusion that the painting has been completed in a single session. It's believed that Monet achieved the brisk, spontaneous look to *Impression: Sunrise* by doing just this.

For the largest canvases, the middle sitting is, as said, often stretched across multiple sub-sittings. In these cases, the canvas is effectively divided into zones, with each zone worked on in turn. How the zones are determined depends entirely upon the composition, though in very general terms I'm more likely to work from left to right, and from top to bottom, rather than in the opposing directions. Whether this has anything to do with my being left-handed, I don't know. I can progress different zones on consecutive days, or even on the same day, as each is dry when I come to work on it; and again, I use the same sized brush across the zones. At the end of the middle sitting my painting should have a fairly solid covering of paint with a soft focus and a slightly suppressed tonal range – the result of my having used, up to this point, no more than two different brush sizes, and relatively little in the way of pure white pigment.

Finishing Off

In the final session of a painting I'm normally looking to do three things: introduce detail, widen the tonal range, and recover any texture that has been lost in the course of the middle session.

I'm always nervous of detail, for if the painting is to hang together the same level of detail should really be applied across the canvas, and if you're not careful the detail can take over, fatally undermining the 'impression' you were so keen to capture. I therefore try to stop myself from reaching for the smallest brushes: a no. 3 brush is plenty small enough for the smaller canvases, and a no. 6 brush for the larger ones. It's particularly easy to overdo the white highlights, which have an immediate and sometimes insidious impact. I often find myself having to paint out the flecks of white paint I've scattered across the canvas in my anxiety to invest

the painting with greater fizz. This peccadillo puts me in good company: some French critics thought Constable's paintings suffered from a profusion of over-insistent speckled highlights, which they referred to disparagingly as 'snow'.

In practice, widening the tonal range simply means making more use of white paint, not just for the small-scale highlights referred to above, but also for larger passages where my earlier avoidance of the pigment might have given the painting a rather subdued look. I rarely use dark colours in these final sessions, and even more rarely do I feel the need to thin the paint.

So far as the recovery of texture is concerned, I seek to recapture something of the sketchy quality of the first session by breaking up the solid masses of colour, and by generally roughing up any passages that might have become too carefully painted. Cloudless blue skies, in particular, can often appear overly solid, so here I might scrub in off-tones and colours to alleviate the monotony. Empty foregrounds, if too smoothly painted, call for similar treatment. The overriding aim is to give the painting a unified finish, or, if you prefer, a unified lack of finish.

How do you know when a painting is finished? It's a question I'm often asked, and it's not an easy one to answer. Whistler reputedly said, 'A picture is finished when all trace of the means used to bring about the end has disappeared'. The Hunterian Gallery in Glasgow, which has the largest permanent collection of Whistlers in the UK, emblazons this quotation across its advertising literature, so must detect some profundity in it. But it evades me. And it certainly doesn't apply to a typical Impressionist piece, whose paint surface will in no way disguise the means of its production. At risk of being thought shallow or *faux naïf* by the staff at the Hunterian, I have to report that, for me, a painting is finished as soon as I feel I'm no longer adding to it. I think most painters would recognize this feeling. Monet would, if what he told Lilla Cabot Perry is anything to go by; namely, that he stopped painting only when he felt he was no longer 'strengthening' the picture. Years later, his stepson Jean-Pierre Hoschedé recalled that he had never heard his stepfather say that a painting was finished, which might explain why Monet did not generally sign paintings until they were either exhibited or sold.

As is well known, the Impressionists were frequently criticized for the unfinished quality of their work. Morisot seems to have been the worst offender in the eyes of critics at the time. Writing about her submissions to the second (1876) Impressionist exhibition, one wrote: 'Never does Mlle Morisot finish a painting, pastel or watercolour. It is as if she were composing prefaces to books she will never write'. And it was to defend his friend Manet against a similar attack that the poet Stéphane Mallarmé wrote: 'What is an "unfinished work", if all its elements are in accord and if it possesses a charm which could easily be broken by an additional touch? One never sees the judges deal severely with a canvas which is both insignificant and frighteningly detailed'.

Quite so... but again, how do you know when all the elements *are* in accord? It helps, I think, to keep picturing in your mind's eye what effect you were after when you started the painting. If you've achieved it to your satisfaction, that's the time to put down your brushes: by carrying on you risk diluting or spoiling the effect. Some recommend you turn the canvas to face the wall for a few days after the painting is finished, partly to stop you tinkering, and partly to ensure that you bring a fresh eye to it when eventually you turn it back on view. It's not something I do myself, but it sounds sensible. I certainly think it's a good idea, if you're an exhibiting artist, to live with a painting for a few weeks before you let a gallery take it away: you'd be surprised how many faults show up in that cooling-off period, faults you missed in the initial euphoria of completion. This, though, takes us into the realm of troubleshooting, which is dealt with later on.

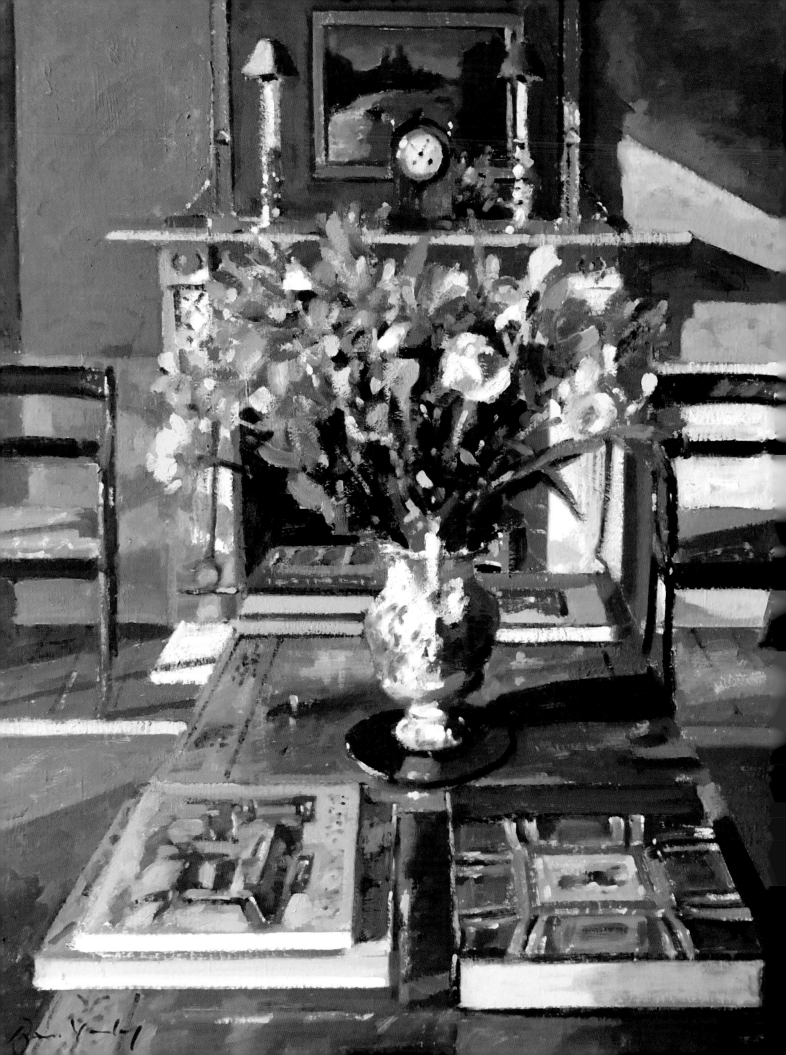

CHAPTER 3

Technical Matters

You don't have to be an artist, or even someone with much of an interest in art, to decide that some scene or other might 'make a good painting'. But to realize that hunch you do have to be able to exercise a succession of delicate artistic judgments, many of which are technical in the sense that they demand a certain level of knowledge, over and above the basic mechanics of drawing and painting. The artistic judgments I'm referring to are all made with the following question in mind: how does the artist persuade the viewer that this *is* a good painting? Well, it certainly helps if (a) its arrangement of shapes attracts and holds the eye; (b) its range of tones convinces or excites; (c) its palette of colours pleases or arrests, and (d) it has an interestingly varied paint surface. Doubtless there are other, less easily defined attributes that people look for in a painting, but surefootedness in these matters of composition, light and tone, colour, and paint handling goes a long way towards ensuring the success of any painting.

COMPOSITION

Composition is the means by which the painter determines how the viewer's eye moves across, and where it settles upon, different parts of the canvas. Painters are not normally referred to as composers in the way that music writers are, but painters arrange their pigments on a two-dimensional surface in order to please or otherwise affect in some intentional way the viewer's eye just as composers arrange their notes to please or otherwise affect the listener's ear. Looked at like this, almost everything about a painting boils down to composition: an artist's colour sense or lack of colour sense, for example, can only be judged by reference to how they arrange their colours on the canvas. Yet even if we acknowledge the all-encompassing influence of composition, it's still better, for the sake of instructional clarity, to discuss it separately from those other elements such as colour.

Finding the Subject

What makes a good composition? Is it in fact completely subjective? I don't believe so; there'd be no point in discussing the matter if it were. But there's undoubtedly a fine line between attracting and distracting the viewer's attention, and every painter runs the risk of crossing it in seeking to produce an interesting composition. Painters with an unusually good compositional sense are the ones who are most alert to how the viewer's eye travels over the canvas. That alertness may well be instinctive, but there are things we can do to improve or sharpen those instincts.

Books on Impressionism have relatively little to say about composition. The reason for this seems plain to me: by starting (if not finishing) their paintings in front of the subject the Impressionists were more or less allowing nature to compose their paintings for them; they were certainly not designing them to anything like the same extent as those artists who would assemble their pictures from preparatory studies, or from figures posed in the studio that were then

◀ *Freesias and Coffee-Table Books,* oil on canvas, 61cm × 51cm

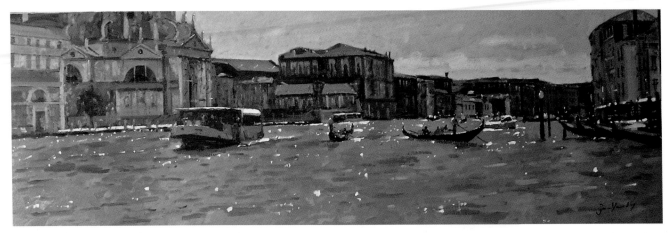

Entrance to the Grand Canal, oil on canvas, 51cm × 152cm

Converting and compressing a three-dimensional reality into a two-dimensional painting is itself an act of cropping, and where to crop is the single most important compositional decision that the artist has to make. In this very wide – treble square – painting of Venice I've sliced the dome off one of the world's most recognizable buildings, the church of Santa Maria della Salute, at a stroke rendering it much more anonymous. Why? Because to include the dome would have made the picture a sky-filled landscape of conventional proportions, and not the watery panorama of canal activity I was after. Not only that, the eye would probably have gone straight to the extreme left of the painting and lodged there, rather than tracking back and across to take in the other components of the picture.

painted as though in an outdoor setting. This is why Monet's (mostly) plein air *Luncheon on the Grass* is so much less theatrical-looking than Manet's studio *Déjeuner sur l'Herbe.* For someone with a plein air mentality, the very act of finding a subject is itself an act of composition. This applies as much to still life or other indoor subjects as to outdoor subjects. For instance, I prefer to come across my subject – townscape, still life, whatever – rather than to arrange it according to some predetermined plan; indeed it's hard to reconcile the Impressionist yen to capture an effect with a more deliberate effort of arrangement. Furthermore, if something in a subject displeases you, it's usually better to shift your position until it does please you, rather than manipulate it from your original position.

This doesn't mean you can't then edit what you see. We can tell, for example, that Monet consciously omitted Cleopatra's Needle from his paintings of Charing Cross Bridge and the Embankment, presumably because he felt that a strong vertical would be intrusive in that particular part of the composition. It's very tempting, especially when painting the modern townscape, to leave out anything that might be considered ugly by most people's aesthetic standards – scaffolding, street furniture, that block of 1960s Brutalism in the middle distance. My general advice in cases like this would be to exercise your artistic judgment ahead of your aesthetic judgment. For the two are not necessarily

the same: that scaffolding might be covered in a shroud that provides a pleasing splash of colour; those road signs might break up or enliven a monotonous patch of tarmac; that 60s monstrosity might give the scene an all-important vertical accent. Before deciding to omit something, ask yourself: is it playing a useful role in the composition?

Besides, there are other ways of helping the eye to find a satisfying composition. You can for instance flex your thumbs and forefingers in front of your eyes to make a viewfinder shape that allows you to isolate subjects within the scenes before you, and of course the camera's actual viewfinder also does just that. By creating a viewfinder you are in effect cropping the scene. Cropping is an area in which the Impressionists were innovators, here taking their lead from Japanese art. Specifically, they adopted the Japanese practice of allowing figures to be cut by the picture frame, the idea being that this enhanced the impression of instantaneous action: a painting where all the figures and objects are neatly contained within the frame could be thought overly tidy and stiff.

More generally, cropping was thought to lend vitality to a composition by bringing the subject closer to the viewer. In Venice, Sickert sought to demonstrate this by producing different pictures of Rialto Bridge and the neighbouring Palazzo dei Camerlenghi from the same drawing: one cropped, the other uncropped. The zoom lens of a camera

West Front, Notre-Dame: Afternoon, oil on canvas, 61cm × 51cm

Monet's canvases of the west front of Rouen Cathedral had a zoomed-in, claustrophobic quality, concentrating as they did on the texture of the surface ornament under different light conditions. This painting of Notre-Dame's west front, completed a few months before the devastating fire in 2019, is similarly concerned with the patterns created on a Gothic structure by a strong slanting sunlight, but is painted from a greater distance than Monet's, in order to capture the overall shape of the building and the touristy buzz in front of it. The foreground shadow, thrown by an unseen tree, is very important in counter-balancing the sloping-away horizontals of the cathedral's façade.

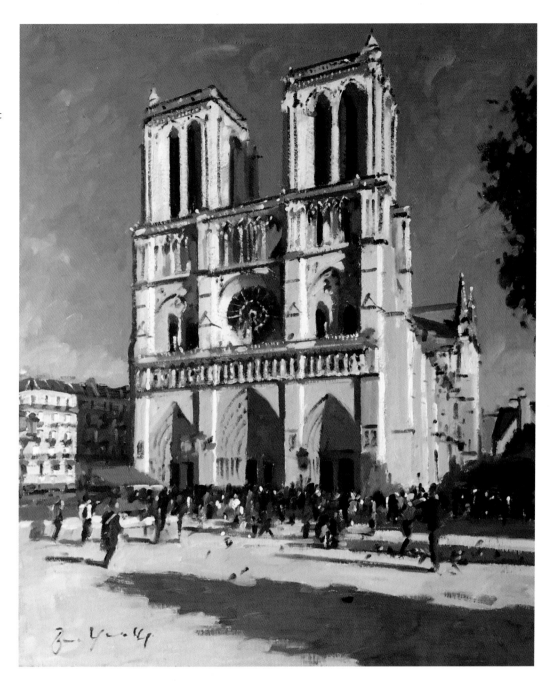

achieves the same effect, albeit with some distortion, and here we might remind ourselves that in seeking to capture the visual moment the early Impressionists were acting very like the cameras of the future. The danger with this kind of cropping is that your subject fills the canvas, leaving little room for the eye to relax and move around. Monet's close-up depictions of the west front of Rouen Cathedral were criticized – legitimately, in my opinion – for having 'not enough sky, not enough ground'. To be fair, this was not the result of overzealous cropping: he was obliged to set up his easel close to the motif, as French cathedrals are hemmed in by other buildings and don't stand in spacious grounds as do most of their English counterparts. Still, Monet chose his viewpoint, and it remains the case that a subject that crowds the canvas is rarely easy on the eye.

Positioning and Balancing the Subject

Some books suggest that a pleasing composition will invariably result if you position your subject or your main points of interest roughly one third into the canvas from any two of its edges. A quick way of plotting this is to divide the canvas into three zones both vertically and horizontally, as though you're about to play a game of noughts and crosses on the painting surface. Where the zonal demarcation lines intersect are four 'hotspots' where the viewer's attention might usefully be focussed. This is known as the 'golden section'. The thinking behind it is that the internal proportions are all in the ratio of 2:1, which gives the composition an emphasis and rhythm it might not have were the subject or main points of interest more centrally located, at a ratio much closer to 1:1. I'm hiding here behind the phrase 'some books suggest' because, while I acknowledge the logic of creating points of interest placed somewhere between the centre and the edges, you have to be careful not to slavishly follow a formula that stops you composing more naturally, that is, by eye and by instinct.

The golden section theory derives or at least takes its name from the 'golden ratio' (sometimes called the 'golden mean'). 'Two quantities are in the golden ratio if their ratio is the same as the ratio of their sum to the larger of the two quantities'. I've put that sentence in quotation marks because they're not my words but those of a geometrician; I'm sure they make immediate sense to the mathematically inclined among you. For the rest of us, all we really need to know is that the ratio in question is 1:1.62 (to two decimal places), which is a standard-looking rectangular shape, but which – uniquely – may be progressively subdivided into rectangles of exactly the same proportions.

You can see why geometricians and the like might get excited about a rectangle with this property, and as far back as classical times, painters, sculptors and architects believed that proportions based upon the golden ratio are intrinsically harmonious. Indeed, it used to be thought that many of the great painters, especially those from the Renaissance, composed their pictures according to golden ratio principles. That view no longer holds, and the golden ratio of 1:1.62 does not in fact figure among the standard canvas sizes available today, which are typically 1:1.2, 1:1.25, 1:1.5, and 1:1.67. I make use of all of these sizes, as well as the more stretched rectangles of 1:2 (double square), 1:3 (treble square), and 1:25. Those whose ratio is closest to that of the golden ratio – for example, a 60cm × 90cm canvas (1:1.5) or a 60cm × 100cm canvas (1:1.67) – are certainly good formats in which to paint a conventional landscape subject, but that does not mean that the painting itself will be a successful composition.

Where the question of ratio does come into play, compositionally speaking, is in the placing of the horizon. It's quite important that the horizon line is not bang in the centre of the painting (a 1:1 ratio, if you like), as this can confuse the viewer as to whether the sky or the ground is the main subject. Canaletto did this uncomfortably often: as a painter, he was relatively uninterested in portraying weather, and his slightly formulaic skies (typically blue, with wispy white clouds) only rarely warrant the area of canvas he allots to them. Whether or not one agrees with this – and don't get me wrong: I think Canaletto is a marvellous painter – most artists would agree that if you have a low horizon your sky needs to pull its weight in terms of painterly interest; skyscapists conventionally place it well down in the picture, at a ratio of about 1:4. Conversely, if you have a high horizon, the sky itself should be quiet and unobtrusive so that it doesn't compete for attention with the main area of the picture.

Even the busiest scenes should have some quiet passages for the sake of balance; the eye needs somewhere to rest every so often. For outdoor subjects, these quieter passages are usually represented by skies and foregrounds; indoors, the background walls play the same sort of role. It's also important to have other kinds of balance within the painting's internal geometry. A particular subject may be strongly vertical or horizontal, but the best compositions nearly always have some sort of tension between the two. Why is the front-on view of St Mark's in Venice such a pleasing composition? It is, I submit, because the predominantly curvaceous and horizontal thrust of the basilica's architecture is offset by the verticals of the campanile and flagstaffs to the side and front of the building: take these away and the composition becomes much less controlled.

Empire State from Uptown, oil on canvas, 91cm × 30cm

Extreme shapes such as this treble square often give a concentrated effect to your chosen composition. Here, the Empire State building occupies a small fraction of the painting area but the eye is prevented from straying far from it by the narrow format; and just to drive the point home, the flags on the left all point towards the art deco masterpiece. Even so, I don't think I'd have risked this particular format had not the wet pavements created interest lower down, tying together the upper and lower halves of the composition. The pedestrian's splash of red is a useful piece of colour relief.

Hot Dog Stand, Fifth Avenue, oil on canvas, 51cm × 41cm

Reflections, by duplicating objects, often prevent paintings from having too many flat areas. This is a busy picture with an almost abstract quality, and the fact that no one is patronizing the hot dog stand is not the handicap it might have been on a dry day, as the wet pavement has lots of compensating energy.

Piazza San Marco, oil on board, 15cm × 30cm

Some views are so strong – or to the jaundiced eye, so obvious – that they make good subjects at whatever size or shape. I've painted the classic front-on view of St Mark's basilica at all sizes from this tiny board right up to canvases of 122cm × 244cm. If you stand some way back in the piazza you can widen the vista to take in the buildings to the left and right (the Procuratie Vecchie e Nuove), which draw the eye into the painting and add to the geometrical interest of the composition.

San Marco Reflection, oil on board, 15cm × 30cm

The same scene in very different weather conditions. It's not actually raining; the water has risen up in the piazza – what's known as the *aqua alta* – after an earlier fall of rain. Without the foreground reflection the light would probably be too flat to make a worthwhile picture. This wet view was painted a couple of years before the sunny view in the previous image, and in those two years the shroud covering the two semi-circular arches in the upper order has, as you might have noticed, migrated from left to right. Very occasionally I will edit these shrouds out, as they can obtrude; but I don't think they're too obtrusive at this very small scale.

Reflections are obviously good at enhancing the internal balance of a composition. For example, the glass of shop windows and office blocks can, when viewed at a sufficiently oblique angle, act as a mirror and introduce visual balance to what might otherwise be a cramped or lopsided composition. Many years ago Ken Howard made a series of paintings in which the towers of Wren's London churches were reflected in the glazed facades of the modern city offices, and by doing so he was able to create a broad, balanced and interesting composition from what was a very enclosed and narrow viewpoint. I was reminded of this when I first went to New York: on the face of it, the streetscape was far too claustrophobic to yield good subject matter, but the shopfronts of Fifth Avenue, like the office blocks in the City, were veritable mirrors of light, and ready-balanced compositions hove into view with almost every step.

These are duplications across the vertical axis. Water that is standing or at least reasonably still – as may be found in rivers, canals, harbours and rain-wet surfaces – creates duplications across the horizontal axis. Such reflections can almost double the compositional interest of a subject, so it's always worth trying to find a viewpoint from which these are maximized. Even if you're denied the helping hand of a reflection, you can create a suggestion of balance through colour, by repeating the same colour accent in different parts of the composition; it need be no more than a dab or two of paint here and there. Look again at the paintings in public art galleries and you'll see how frequently this little stratagem is employed.

St Paul's Reflected, oil on canvas, 51cm × 41cm

No, you don't have a migraine coming on. The fractured look to the dome in this painting is simply the refractive quality of the glass-paned reflection in the right-hand half of the painting. As should now be apparent, I often like to paint major buildings front-on, and a front-on view of St Paul's from Watling Street to the east is only possible in this trick-of-the-eye way. But reflections are useful anyway for introducing symmetrical duplications, symmetry being something generally pleasing to the human eye. A classically minded architect such as Christopher Wren, designer of St Paul's Cathedral, would certainly have argued the case for symmetry. The right-hand side of the painting, representing the reflection in the glass, has been made ever so slightly darker than the left-hand side.

Rain, Trafalgar Square, oil on canvas, 30cm × 51cm

In this picture the symmetry is created by reflections along the horizontal axis: turn the picture upside down and it will still read more or less the same. Those who have only known Trafalgar Square for the last fifteen years or so will probably wonder at the return of so many pigeons. Well, I have conjured them up from my imagination, to produce a greater sense of movement in the painting.

Notre-Dame from Pont St Louis, oil on canvas, 41cm × 51cm

This view may never be the same again, for at the time of writing it is not known what sort of spire is to be rebuilt. The nineteenth-century flèche spire, shown here, had its critics but from a compositional point of view it adds height, thrust and energy, and I'm nervous at what might replace it. The composition as a whole is of the type I often go for in an urban setting: closed on one side, open on the other, and with a number of diagonals pointing towards the central focus, in this case the cathedral's apsidal east end.

Leading the Eye

The way in which an artist directs the viewer's eye around the canvas is the essence of composition, and there are various helpful devices that the artist can deploy to this end. We've already come across linear perspective in relation to drawing skills; it has another important role to play in relation to composition, for lines of perspective lead the eye into the painting, creating a sense of recession and depth. It's therefore worth re-capping the basic rules of perspective, which are: 1) objects appear smaller as their distance from the viewer increases; 2) their dimensions along the line of vision appear shorter than their dimensions across the line of vision, and 3) they recede to vanishing points on an implied horizon line; horizontal lines above eye level travel down towards the vanishing point, and those below eye level travel up to the vanishing point. Accordingly, a scene that has objects placed in foreground, middle ground and background will have many more perspective lines than a scene that has most or all of its objects grouped on the same, shallow plane, and its composition will be the more dynamic for it.

One of the reasons why sunny scenes are generally so much more satisfying than sunless scenes is that shadows, which obey the rules of perspective, help to direct the eye around and also help to tie together different parts of the composition, especially when the sun is low and the shadows long. This partly explains why many painters prefer to work in the early morning or late afternoon, rather than in the middle of the day.

A road or pavement that spreads downwards, and tapers upwards, is a ready-made lead-in for the eye; Pissarro and Sisley both used a centrally placed road in this way to create a sense of depth. If the road snakes or zig-zags, moving the eye left and right as well as up and down, that's all to the good. I often make a point of directing my brushstrokes along the lines of perspective to enhance this feeling of depth and recession, and to ensure that the eye does not stray. For a pavement, the lines demarcating the paving slabs very often add to the directional pull. By the same token, for interior subjects, it's always an advantage when the flooring is of bare boards running along the line of vision, rather than across it, for the floorboard edges can direct the eye into the painting much more efficiently than a carpet or rug.

Interiors lend themselves to a number of compositional devices that are not available to the outdoor painter. Pieces of furniture such as tabletops are always good lead-ins when cropped at the bottom corners of the canvas. Then there is the type of interior composition known by the Dutch word *doorkijke,* which describes a room scene in which a second room is glimpsed through an open door. The compositional value of such an arrangement is enormous: not only does it pull the eye through the painting; it also creates a counterpoint of tone and colour, as this second room is quite

Peonies and Bath Abbey, oil on canvas, 61cm × 51cm

I often pose flowers near the window of my studio, partly to ensure that the sun catches them when it is unlikely to penetrate far into the room, and partly to create depth within the composition by showing what is through the window. If nothing else, it seems a shame to waste the pictorial value of Bath Abbey in the distance.

often differently lit from the main, foreground room. A view through a window is equally if not more useful, since it brings the outdoors into the painting and gives the painter the chance to indicate weather and season. I'm fortunate to have a studio and drawing room looking out over a communal garden to Bath Abbey in the distance, and I like to include this seasonally changing tableau in my interior or still life pictures wherever possible. But whether your composition includes a view through a door or through a window, it's important that you depict the secondary scene in less detail and intensity than the foreground, to preserve the feeling of recession.

Many of Berthe Morisot's paintings are of views through windows or from balconies and verandas. Modern critics attach symbolic significance to this 'threshold space' aspect of her work, especially when the subject of the painting is a young woman on the threshold of adulthood. I think there is indeed a gender-related significance here, but for me it consists more prosaically in the fact that a woman painter of the time was less able than a man to venture outside to paint. In her earlier days Morisot had determinedly painted *en plein air* with her older sister Edma, but when Edma married and gave up art Morisot would only paint outside if chaperoned by her husband Eugène (a younger brother of Manet, and himself a painter of watercolours), a much rarer occurrence than with Edma. By blurring the distinction between interior and exterior, threshold subjects compensated for these reduced opportunities to paint outdoors.

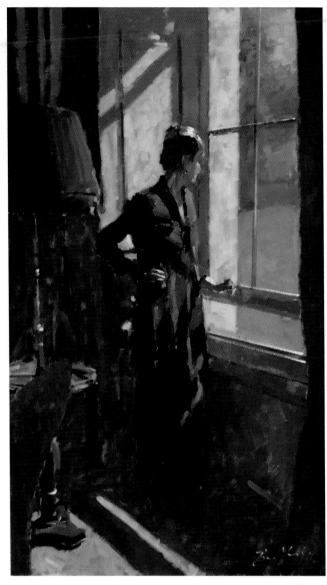

The Mauve Dress, oil on canvas, 102cm × 61cm

Quite a few of Berthe Morisot's figure paintings are of young women posed before windows through which the outside world is glimpsed, and commentators on her work attach great significance to the threshold or 'liminal' aspect of these subjects. I read a more prosaic significance into them; I think she was trying to incorporate an element of landscape painting into her interior scenes at a time when, for social reasons, she was largely prevented from painting outside. Whatever, I don't dispute that a figure looking out of a window makes for a psychologically intriguing composition. This particular painting of my wife Caroline was made nearly twenty years ago.

The compositional possibilities that accrue from including a mirror in your painting are similarly rich; mirrors add depth, balance (via reflections), and a sense of mystery. The most famous Impressionist 'mirror painting' is Manet's late masterpiece, *A Bar at the Folies-Bergère,* a portrait of a barmaid in front of a huge mirror that reflects not only the gentleman she's about to serve but also the theatre audience behind him and, at the very edge of the canvas, the stage act they are watching. It's thought that Sickert's fascination with reflected images and reflected light owes something to his having seen this painting in Manet's studio soon after its completion. Sickert's own pictures of theatres and music halls made extensive use of mirrored reflections to set up intricate and indeed perplexing compositions: he leads the eye on an endlessly playful journey.

The eye both follows and anticipates lines of movement, so if you are prepared to include figures, traffic and so on you'll be in a good position to direct the viewer to what you consider to be the focus of the work. You have to be careful, though. Anything moving directly across the line of vision will quickly take the eye out of the picture if it is not located on the far side of the painting from the direction of travel. For this reason, I like to have my moving parts depicted front-on, rear-on, or at an angle, rather than side-on; I particularly like to place one or more figures walking away from the viewer and into the painting. There may be times when it is more natural for the figures to be moving out of the picture; if so, you can turn their heads inwards – the viewer's eye will likewise turn inwards. Whatever you do, bear in mind that the human form is so familiar that any inaccuracy in the way it's painted will draw the eye, turning what might be a minor painting fault into a larger compositional fault.

There are other compositional pitfalls to watch out for. Often it's just a question of being alert to the potential for objects or lines to collide in an undesirably eye-catching fashion. You can't always anticipate problems of this nature; when they occur, you simply have to make the necessary adjustments once the paint is dry. In *Summer's Day* (probably 1879), an informal portrait of two lady passengers sat in a rowing boat in the Bois du Boulogne, Morisot had to move the horizon line down as it initially clashed with the hats of the two ladies. Where uprights are equal in height and equidistantly placed the effect can be distracting, so here you need to use some artistic licence and vary them. Similarly, when arranging a still life, it's helpful to make sure that the key items (crockery, vases or whatever) are not lined up on the same plane, but are staggered and overlap one another: you want the eye to move smoothly over them, but you don't want it to move in a straight line, which will always feel unnatural. Finally, if you place something too close to the edge of the painting it will probably look as though it has been squeezed in: it's better either to shift it infield, or shift it further out so that the frame crops it. I shall have more to say about these compositional pitfalls in the section on troubleshooting.

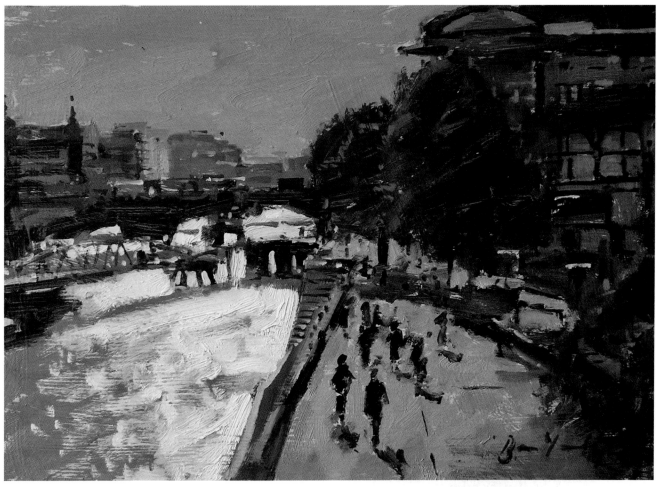

Albert Embankment from Millennium Bridge, oil on board, 17cm × 25cm

This very small painting is an out-and-out tonal piece, illustrating the oft-prescribed progression from lean dark paint to thick (here impasto-like) light paint.

LIGHT AND TONE

'The basis of all Impressionist painting was the empirical observation of colour and light'. So wrote the art historian Phoebe Pool. 'Tone is the essential tool for expressing the effects of light'. So writes the modern artist Ken Howard. These are not contradictory statements, and taken together they reveal the interdependence of light, tone and colour in any consideration of Impressionist and Impressionist-inspired painting. In separating light and tone from colour I'm simply following academic convention. For as described earlier in this book, it was the practice for students of the Impressionists' era to begin a painting with a pencil or charcoal drawing, over which they would set down the tones in red-brown paint, laying in first the darks, then the lights, and finally the mid tones; only when the tones were fully established would they be permitted to lay in the colours. A staged, methodical approach like this is clearly not suitable for the sort of brisk, plein air painting that many of the Impressionists subsequently undertook, but they did so having first been drilled in the close observation of tonal values.

Tonal Value

Tonal value describes the strength of dark or light possessed by any colour, and is conditioned by the quality or intensity of light falling on that colour. Colours do have intrinsic tones. Most people, for instance, would accept that yellow is a lighter toned colour than blue; but place that blue in the sun and that yellow in the shade and there's a good chance that the tonal relationship between the two will be reversed, or at least significantly altered.

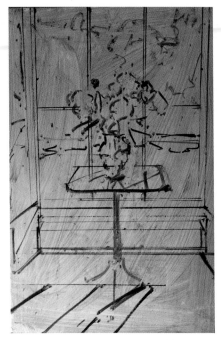 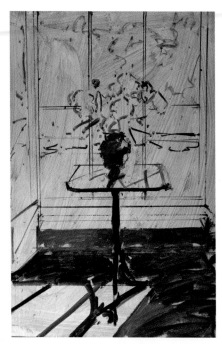 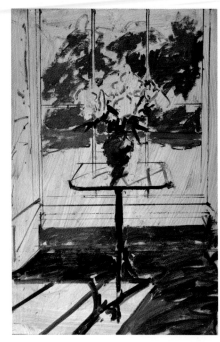

Peonies were a favourite flower subject of several of the Impressionists – Manet, Pissarro, Morisot. In this step-by-step exercise I have posed a vase of peonies centrally against a sash window whose glazing bars tighten up the composition by providing powerful verticals and horizontals. A T-square ensures that these verticals and horizontals are perfectly true. There were some cars parked unhelpfully opposite that I have omitted, since they interfered with the vase and table profiles.

The darkest darks are the silhouetted leading edges of the Regency wine table on which the flowers are sat, so these are put in first, closely followed by the shadowed portions of the floor and vase; the sun is very powerful, so these are very dark too.

Not wishing to interrupt fluency by cleaning my brush (a no. 8 short flat hog), I've started to scrub in the deeply shadowed foliage of the garden seen through the window. The darks here are virtually identical to the darks of the floor and vase, which I hope will promote some palette harmony further down the line.

It's easiest to observe and understand tonal value in terms of the gradations from black to white. Sickert, for instance, appreciated the fact that a black and white photograph would give a clear tonal record of a subject, without the distraction of colour. One could make a tonally accurate painting without the least concern for colour accuracy, and indeed many of Sickert's later paintings, which were based on other people's black and white photos – and therefore of scenes he hadn't witnessed with his own eyes – were just that. (The reverse is not true: you cannot make a chromatically accurate painting without concern for tonal accuracy, for as said, the colours themselves have different tonal values, and a painting with accurate colours will automatically be tonally accurate.) Tones can also be allotted numerical values. There are stories of Whistler walking along the Thames Embankment saying to himself, with a view to memorizing the scene, 'the sky is tone 1, the river is tone 2, the bridge is tone 4', and so on. 'Painting by numbers' is a perfectly respectable way of making a painting when the numbers are applied to tone

rather than, as they are in commercial painting kits, to colour.

You sometimes hear of painters having perfect tone in the way that singers and musicians might have perfect pitch. The comparison with music is a good one, since control of tone makes for visual harmony in much the way that control of pitch in music makes for aural harmony. For those of us not blessed with perfect tonal pitch, there are ways of ensuring that our painting doesn't become too discordant. Like many painters, I prefer to work on a mid-toned canvas, which gives a 'control tone' against which both darks and lights can be judged. A pure white ground is problematic, as every colour will be darker than the ground, and you will probably find yourself lightening the colours so that, by the time the ground is more or less obliterated by paint, the overall key will be too high. When, for the purposes of this book, I tried using an untinted white canvas the finished painting turned out to be both lighter in tone and brighter in colour than my other work. I daresay I'd have been able to make the necessary adjustments to my tones and colours had I persisted with

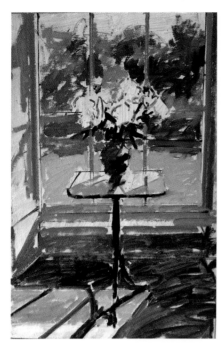 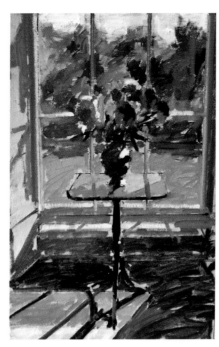 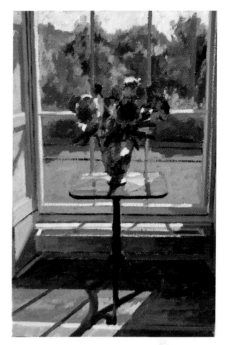

Still working with the same brush, I'm now moving up the tonal register, first with some greens within the trees and shrubbery, then with the lilac-blue reflections of the wine table's top and the pink-browns of the sunlit section of the floor, and finally with the sunlit section of the folded-away shutters on the left. In putting on these paler colours I've departed from strict tonal order, for most of the as-yet unpainted blooms are also in silhouette and will be much darker than these colours. I don't think this matters: the peonies themselves will be the most richly coloured part of the painting, and don't need to fit into the tonal sequence in quite the same way as the background colours do.

The end of the first session, with blooms and highlights added. All the work has been done with the no. 8 brush, and much of the paint has been scrubbed on quite thin with a lot of white spirit.

The long (two hours plus) second session, in which the whole painting has been worked over with a no. 7 brush. As I've said elsewhere, adherence to the same sized brush over the course of these early sittings helps me to push the painting forward at the same rate. If, say, I had used different sized brushes for the peonies and for the background foliage, which on the face of it would seem a feasible thing to do, it would probably have resulted in a greater delineation between the two that, for me at any rate, would be unwanted.

Peonies in the Window, oil on canvas, 61cm × 41cm

Nearly all the final details have been applied with a no. 6 brush; some texture has been added to both the wooden floor and the outside road with just a few strokes of the brush.

the experiment. Monet, for example, used white canvas exclusively in his later years, saying, 'I have always insisted on a white canvas so as to establish my scale of values'. He had conveniently forgotten that for the first twenty-odd years of his painting career he had painted on a variety of differently toned grounds.

Whatever your choice of ground colour, it's usually best to lay the darkest darks on first, not least because these are the pigments that can be thinned most easily, enabling you to cover more of your canvas at speed. Thinning the paint in this way also gives the darks a translucent depth and, once varnished, a glow; if you allow them to become too solid they have a deadening effect on the painting as a whole. You could then choose to add the lights, before filling in with the mid tones, which accords with the French academic practice of the later nineteenth century, but I prefer to work progressively from dark to light, and from lean (thinned paint) to fat (unthinned paint). I aim to get the full range of tones down in the first session; the lightest tones sometimes get lost in the second session, but by then I know their exact placement and can reinstate them later on.

It's easier to keep control of tone if you progress the painting at the same rate, rather than resolving certain sections of the painting ahead of others. And don't be tempted to accentuate the lights and darks at the expense of the mid tones, in the belief that it will widen the tonal range and give the painting more *élan*. Superficially this may be so, but accuracy counts for more. A painting with carefully and accurately observed tones will sing more than one whose darks and lights have been artificially boosted from within your box of paints: the eye tends to know when it's being conned, and rebels.

Tonal Painters and Colourists

These two terms are widely used in art books and art circles. Simply put, tonal painters characteristically deploy a restricted palette in order to produce pictures with a wide and firmly differentiated tonal range, whereas colourists characteristically deploy an extensive palette in order to produce colourful pictures of relatively narrow tonal range. The painter who is concerned to capture the effects of light – I am obviously describing the typical Impressionist – should theoretically be able to move effortlessly between the two, for when you think about it, the tonality and colouration of any given subject is forever changing, according to the condition or angle of the light. A strongly back-lit subject will nearly always result in a tonal painting, while a strongly front-lit subject will nearly always result in a colourist painting. Between these two extremes are a raft of subjects whose lighting is such that the artist is free to treat them either tonally or colouristically, depending on temperament and aesthetic sensibility.

If you wish to be a thoroughgoing Impressionist, you should ideally be looking to paint as many different light conditions as possible. In French art parlance the word *effet* ('effect') denotes a particular light condition, and someone like Monet distinguished hundreds of these, often incorporating the word into the titles of his paintings. One would have expected Monet, as a tenacious investigator of what he called the 'envelope of light', to have remained the supremely versatile painter of both tone and colour that he was from the start, but in his later days he turned into a dedicated practitioner of colourism. This can best be seen by comparing the quiet, tonal paintings of the Thames that he produced on his first trip to London in 1870–1 with the vibrantly coloured paintings of pretty much the same subject that he produced on his later visits, thirty years on. *Houses of Parliament, Effect of Sunlight* (1903) is a classic *contre-jour* (*see* below) scene of sunlight on water, which the younger Monet – and almost any other painter, for that matter – would have rendered with a very restricted palette; yet the older Monet renders it with an almost primary palette.

Is this evidence of Monet's 'incredible eye'? That is the conventional explanation. The art historian Alfred de Lostalot wrote that Monet could perceive ultraviolet (commonly abbreviated to UV, the 'colour' beyond violet, violet having the shortest wavelength of any colour in the visible spectrum), and that the preponderance of violet in his paintings was the result of his seeing an accidental complement to the yellow of the sun. It's true that some humans can perceive near-UV – they can't see UV proper – as a whitish blue or whitish violet, but if Monet's palette had derived from a freakish power of vision it would surely not have developed over time in the way that it did. Or was this brighter palette instead an early indication of the cataracts that were soon to plague him? We know that the cataracts caused him, at different times, to see either blue or yellow as the dominant colour. It's more likely, though, that his later adoption of colourism was a deliberate artistic and aesthetic decision.

Monet aside, it's clear that some artists within the wider Impressionist movement were drawn to tonal subjects, while others were drawn to colourful subjects. Most of the original

Markt, Bruges: Morning, oil on board, 20cm × 51cm

As painters we're sometimes told that if we're not getting on well with what we're painting, to turn around and paint what's behind us. Over the course of a few hours, though, the sun can perform this turnaround for us, giving us two pictures for the price of one. This painting of the market square in Bruges is looking towards the Belfort, and looking into the sun (*contre-jour,* in the art world jargon). All the buildings, as a result, are more or less in silhouette. The dark paint of silhouettes can lead to a heavy, deadened quality, so I've tried to overcome this by thinning the paint considerably with white spirit, especially within the central Belfort building.

Markt, Bruges: Afternoon, oil on board, 20cm × 51cm

A few hours later, with the sun now on the Belfort, a quite different painting is possible, from virtually the same spot. Although it is no more detailed than the morning painting, this one has called for a bit more drawing: with front-lit subjects, you can't define objects with a few flicks of paint for highlights as you can with *contre-jour* subjects. I conceived the paintings as a contrasting pair; it's the kind of thing I'd like to do more often.

French Impressionists would I think be classed as colourists, whereas most of their counterparts across the Channel, as well as the proto-Impressionists of the Barbizon school, would be classed as tonal painters. The out-and-out tonalist Whistler played up any differences that might have existed between the two camps by jeering at the Impressionists' 'screaming blues and violets and greens'.

Whistler's sometime pupil Sickert was another essentially tonal painter, his acute tonal sense having been, in the words of his most recent biographer, Matthew Sturgis, 'honed in the flaring lights and dim reflections of the music halls'. Sickert made a specialism of these low-lit, moody interior subjects, and even outdoors he favoured the darker pigments, painting in an idiosyncratically low tonal key, which drew the

From Ponte de Dom Luis I, Oporto, oil on canvas, 51cm × 76cm

The fact that I actively seek out *contre-jour* subject matter is a sure sign that I am at heart a tonal painter, rather than a colourist. The most dramatic light effects are in the early morning or the evening, when the sun is low. In this painting of the quay at Oporto it is evening, looking into the setting sun. There's a danger these pictures can become too monochromatic, which is why I've been at pains to introduce variations of colour throughout: lilac, lemon and turquoise in the water, bronze and gold in the quayside buildings and on the traditional barge-like boats (*rabelos*).

following quip from Degas: 'it all seems a bit like something taking place at night'. Sickert was known to abhor using thick paint, and since many of the paler colours are rather opaque and don't lend themselves to thinning, his paint handling would have reinforced his predilection for the darker hues. I too prefer to work with thin or thinnish paint, and for this reason find large expanses of pale colour rather daunting: my paintings, as a result, are probably lower keyed than those of a painter who relishes thick, impasto-like paint. As for Sickert, he did eventually lighten and brighten his palette, partly through the influence of Pissarro, whom he got to know in 1901–2, and partly through a growing awareness that his low-key palette was holding him back commercially.

Contre-Jour

Contre-jour ('against the day') is the artists' term for a back-lit subject, or one that looks into the sun. This kind of subject, which is in silhouette to a greater or lesser degree, has several benefits for the painter of impressions. Most obviously, it widens the tonal range, producing a sharp contrast between lights and darks: what's known in the art world as *chiaroscuro* ('light-dark'). This makes for a dramatic picture, and whatever might be lost in subtlety is more than made up for in atmosphere. By way of corollary, *contre-jour* also narrows the colour range. I call this a benefit because the reduced palette is almost always harmonious, with none of the potential distractions that come from clashing or forceful colour. It also eliminates detail, a key article of faith within the Impressionist credo. A front-lit subject will usually be far more detailed than a *contre-jour* one, and therefore harder to render impressionistically. Figures, in particular, are usefully simplified when back-lit, and are especially paintable when seen against a background that is itself in shadow, for here the light encircles the figure and throws it into sharp relief. Finally, *contre-jour* creates shadows that come towards the viewer and act as helpful lead-ins for the eye; the shadows created in front-lit subjects, by contrast, lie behind the objects that cast them, and are not nearly so helpful in the composition.

Café le Flore en l'Ile, oil on canvas, 41cm × 51cm

A typical (for me) *contre-jour* café scene where a strong sun is striking the clientele from behind, enabling me to depict them with just a few dabs of paint. The shade comes not from the usual umbrellas and canopies but from the central tree, whose shadow helps to animate the foreground.

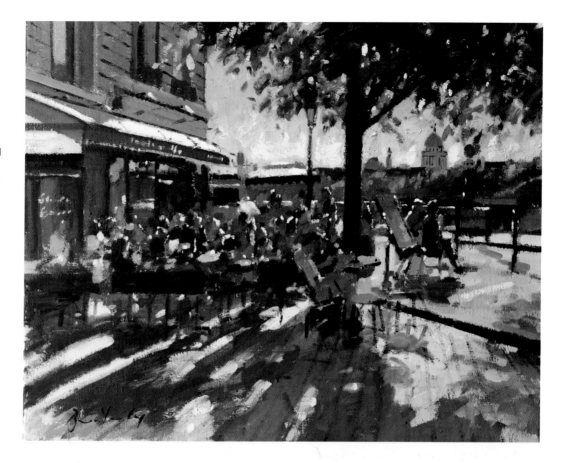

Hotel Dieu, Ile de la Cité, oil on canvas, 30cm × 41cm

This *contre-jour* view of Paris has the sun striking the tourists, lamp-posts and trees from the right. I've introduced rather more pigeons than there were in order to break up the foreground.

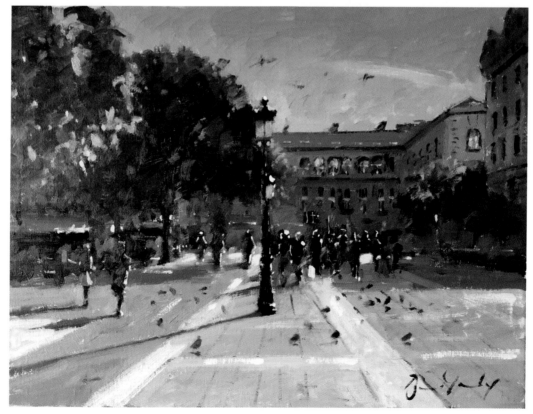

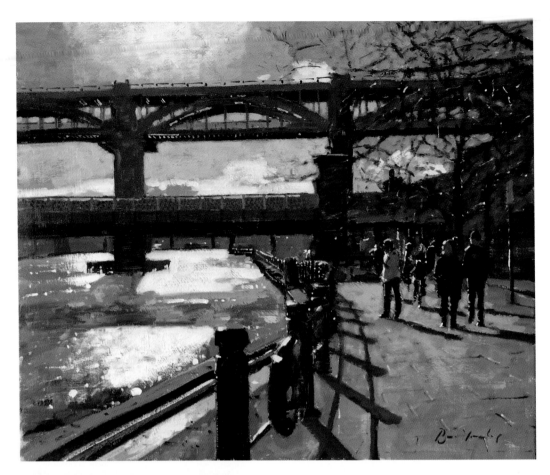

High Level Bridge, Newcastle, oil on canvas, 51cm × 61cm

Had Monet made it up to Newcastle during any of his trips to England he would I'm sure have loved to paint this marvellous iron bridge, which is not unlike one he did paint (several times) at Argenteuil. The low sun of a crisp early spring afternoon is haloing the walkers on the promenade in the way it does when silhouetted figures are set against a backdrop that is itself in silhouette. The sun is also enlivening what was a dull red lifebelt, giving the composition the often-recommended central splash of red.

Low Sun, Burton Street, oil on canvas, 30cm × 41cm

Another *contre-jour* scene in which a low wintry sun is encircling the figures in such a way as to allow the painter to capture their poses with just a few economical strokes of paint. I think a lot of artists would agree that the lower the sun, the greater potential there is for an interesting painting.

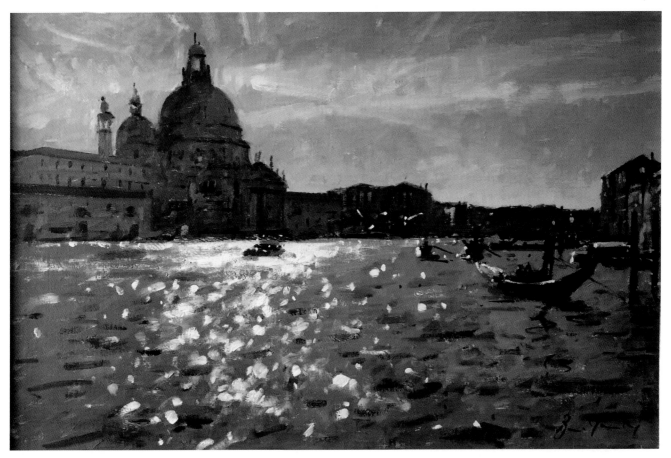

Salute: Afternoon Sparkle, oil on canvas, 41cm × 61cm

Venetian *contre-jour* seems to have an intensity all of its own. In this much-painted view of the Salute there are the beginnings of a mackerel sky, which has a dancing quality to balance that of the water.

My natural inclination is to seek out *contre-jour* scenes whenever the sun is out, which is fair evidence that I am at heart a tonal painter. When I first went to Venice, for instance, I found the light so intense that I shied away from the vivid colours of frontal lighting and gravitated towards the dramatic monochrome of *contre-jour* sun on water. This entailed plotting an itinerary that would take me to certain spots along the Grand Canal at specific times of day. There's an eye-stinging brilliance to Venetian sun coming off Venetian water, which seems to the naked eye to be much more powerful than the sunlight on, say, a road surface, and in my early days I made the mistake of supposing that the best way of capturing this intensity of white light was to lather on the most powerful light pigment at my disposal, titanium white. It later dawned on me that we rarely want our eyes to be stung, and that softening the white with Naples yellow or an equivalent would make for a less harsh

viewing experience. Later still, I caught on to the fact that the tone of the brilliants on the water should correspond to the 'temperature' of the surrounding colours; a cold white such as titanium looks all right against cold, grey water, but does not look right against a warmer or bluer water, where a softer, creamier light colour is needed.

For outdoor subjects, *contre-jour* implies the presence of strong, often low, sunlight. There is no such implication with interior subjects. A *contre-jour* interior subject – where the painter is sited directly opposite a window or windows – can offer the same dramatic *chiaroscuro* without any need for sunshine, for here the light source is confined within the dimensions of the window, which acts as an intensifier. If anything, strong sunlight is unwanted in these interior scenes, for it blanks out whatever lies beyond the window (which is otherwise a good recessional aid) and makes the rest of the picture extremely dark. A *contre-jour* scene in

Mantelpiece Tulips, oil on canvas, 41cm × 61cm

In midwinter, when the days are at their shortest, the sun comes right into our drawing room and reaches this elegant white marble chimneypiece, creating interestingly jagged shadow forms (the time of year can be guessed from the presence of Christmas cards). As for the tulips, I like to paint these when they start to nod in all directions, throwing interesting shapes and shadows of their own.

a single-aspect room will normally need some shiny hard surfaces between window and painter to reflect the light and create balancing pools of paleness within the composition. The need for these reflective surfaces disappears when the room has a dual or triple aspect, for here the subject is no longer exclusively back-lit, and hence no longer *contre-jour* in any meaningful sense.

Other Light Effects

Interior subjects may not offer the varied light effects of outside weather, but the way in which light enters a room, framed first by the window and then contained and bounced around by the walls and the floor and the ceiling, creates shapes and patterns rarely found outdoors, and these are often rich in tonal contrast. I try to exploit this light quality by painting my still life pictures, which make up the bulk of my interior compositions, on clear winter days, when the sun is low and reaches much farther into the room or studio than it would in the high noon of summer. On days like this the sun throws sharp geometrical shapes of light across all of the room's surfaces, and as often as not the subject of the painting becomes as much the play of light as, say, the flowers that might have been identified in the title of the picture. If the sun is really powerful it will bleach the colour from the surfaces it strikes, and here again I find myself using a lot of titanium white mixed with Naples yellow in order to express that intensity. There's nothing like splashes of strong sunlight for altering one's perception of tone and colour, which lends weight to the old adage: 'paint what you see, not what you know to be there'.

Where the light is subdued or dingy the tonal range is compressed, and outdoor subjects in particular need to be really strong in other ways to be able to carry the lack of tonal interest. Some painters seem willing to use their imagination to convert these sunless scenes into sunny ones, but it's awfully hard to pull off convincingly. What effect will this imagined sunlight have on the various colours and tonal relationships? What kind of shadows will be created – what shape, how intense, and how will they fall across different objects and surfaces? You have to be very practised at this sort of thing, for the slightest error will jar.

Whenever I am faced with the prospect of painting in flat, monotonous light I try to seek out strong compositions with at least some tonal modulation that is not dependent upon the presence of sunshine. This, in practice, means I look for water. As a subject for the artist, water is wonderfully good at making the most of what little light there may be. Still or stillish water is as reflective in flat light as it is in sunlight, and while a river or canal may not on a grey day offer the dancing brilliants or vivid colours that materialize when the sun comes out, its reflections will nevertheless give the painting a lot more tonal contrast and balance than a waterless scene would offer. Some artists actually welcome what they see as the subtlety of tone and colour that comes with this flatter light: Boudin and Sargent, for example, both preferred to paint in Venice when the sun wasn't shining – an eccentric point of view, in my opinion, but one that commands respect, given the calibre of artist they were.

The subject matter with the narrowest tonal range is mist or fog. On the rare occasions that I have tackled these sorts of scenes the overall key has been lighter than that of the underlying ground colour, and as a result I've found myself reversing my normal painting procedure by working from light to dark; something not really to be recommended, as the slower drying time of the paler under-paint can cause the quicker-drying upper layer to crack, if the paint is laid wet on wet.

Monet loved the mist, fog and smoke that drifted across the Thames, and painted this kind of subject on each of his trips to London. *The Thames Below Westminster* (c 1871), from his first visit, is a misty scene with a very restricted earth palette, in which careful control of tone provides a strong sense of recession. The many misty/foggy/smoky scenes that he painted on his later visits (1899–1901) were utterly different: for a start, they were much more colourful, sometimes bordering on the psychedelic; also, they had much

less differentiation of tone, which means they have a weaker sense of recession. I doubt that any other painter would have seen these 'misty' colours in the way that Monet did, and indeed, it's true that we all see colours differently – a salutary thought to take with us into the next section.

COLOUR

Colour is defined as the sensation on the eye resulting from the way in which light is reflected or emitted by what is being viewed, so I must here re-emphasize the essential interdependence of colour and light. The Impressionists had a much more sophisticated understanding of colour than previous generations of painters, as they had access to the writings of scientists and theorists who were in the process of emending and extending the known rules of colour. First, though, we need to take a quick look at those basic rules of colour.

Colour Rules

Nearly every instruction manual for beginners in art contains an illustration of the colour wheel, with the seven colours of the spectrum (red, orange, yellow, green, blue, indigo, violet) shown either as bleeding into one another, or as separate wedges of graduated colour. I've never found these colour wheels to be of much use. I feel they belong in a (for me, dreaded) physics textbook, and not in an art book. The colours themselves bear little resemblance to the complex set of primaries, whites and earth colours that go to make up a typical artist's palette, and the circular layout gives little clue as to how one should set about mixing them. In any case, paint mixing in practice rarely corresponds to colour mixing in theory: red plus blue ought to equal purple, but a much dirtier colour invariably results. I thus have great sympathy for Lady Marchmain in *Brideshead Revisited,* whose feeble attempts at oil painting were ridiculed by her son Sebastian: 'however bright the colours were in the tubes, by the time mummy had mixed them up, they came out a kind of khaki'.

It is important, nevertheless, to have some grasp of the colour hierarchy. Primary colours (red, blue, yellow) are those that cannot be formed by mixing other colours together; secondary colours (green, purple, orange) are those that are formed by mixing together any two primaries; and tertiary colours are those formed by mixing a primary colour with a secondary. The complement of a primary colour is a mix of

Tea with Nancy Astor, oil on canvas, 51cm × 61cm

This painting shows a corner of the Great Hall in Cliveden House, Buckinghamshire. I've always had a soft spot for Cliveden, having spent some years as a postgraduate history student studying the seventeenth-century grandee who first built the house. For over forty years the building has been a super-luxury country house hotel, and whenever I went there I was always bowled over by the low-key beauty of the Great Hall, composed of colours that had no right to work together: cherry-red rug and olive green sofas against a rich brown of walnut panelling. Yet work they did, having faded into a harmonious relationship with one another. I've here tried here to get across something of that harmony. Nancy Astor, if you hadn't already guessed, is the Edwardian lady on the wall – a famous portrait by John Singer Sargent.

Tea at Cliveden, oil on canvas, 30cm × 51cm

The scale and grandeur of the Great Hall at Cliveden is perhaps more readily apparent from this picture. It was done a year or two after the previous one, with the hotel under different ownership. Afternoon tea is a big deal under this new regime, and there are now many more soft furnishings in the room. As a lot of the cherry-red carpet was on show from this angle I decided to make the walnut panelling less brown-brown and more purple-brown, which I think helps to integrate the upper and lower portions of the painting.

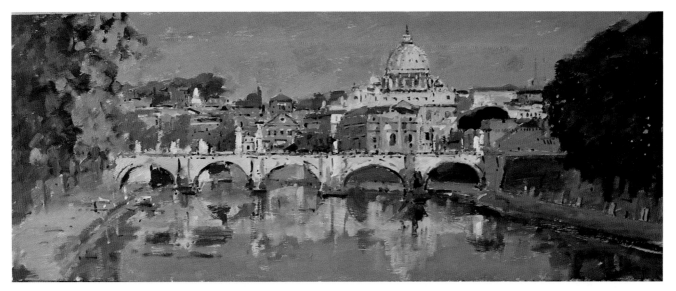

St Peter's from Ponte Umberto, oil on board, 20cm × 51cm

If the sun is sufficiently low in the sky, a front-lit subject can offer up a pleasingly restricted palette. Here, in early morning Rome, the pale gold of basilica and bridge is a near-complement of the lilac-blue of sky and water, so there was a ready-made chromatic harmony to the scene. I was tempted to move St Peter's to a more central position, but in doing so I would have lost the foliage that enlivens the composition on the left, so kept it where it was.

the other two primaries; hence green is the complement of red, purple the complement of yellow, and orange that of blue. Complements mixed together should theoretically produce black, but in practice produce a darkish grey, since manufactured paints are never sufficiently pure.

Colour Contrast

Combinations based on complementary colours are intrinsically harmonious, because the human eye, when exposed to a single colour in saturation, can't help but see a tinge of its complement, as if seeking some chromatic balance. The French chemist Michel Eugène Chevreul, who was also a director of the Gobelins tapestry factory in Paris, investigated this and other aspects of colour contrast, and observed that any colour seen alone appears to be surrounded by a faint aureole of its complement, and the complement remains in vision even after the eye has looked away. These after-images are known as 'accidental colours', and the Impressionists, who were much influenced by Chevreul's work, made considerable use of the discovery in their treatment of colour contrast. You can see it, for example, in the way they painted shadows: purplish-red was often used for the shadows of green-leaved trees, and dull violet for the shadows on yellowish roads.

Pace some commentators, I wouldn't call this the result of 'empirical observation' on the part of the Impressionists,

as I don't think many people observe shadows coloured this way. It looks to me like a wilful application of their theoretical reading. The striving after colour contrast in general was something they learned from Japanese printmakers, who placed loud, contrasting colours side by side for decorative impact. Many Western artists found these pictures gaudy, but not the Impressionists. As to the lesson for the modern painter, I'd say that where colour contrast is sought or desirable, it certainly pays to be aware of complementary colours, for these nearly always produce a pleasing effect. But I'd add that if you're forever reaching for the complements your painting might start to look a touch pre-programmed.

Both their admirers and their detractors were aware that the Impressionists were also using colour and colour contrast to describe form in a way that had not been attempted before. Among their admirers, Jules Laforgue wrote: 'In Impressionism, forms are obtained not by contour drawing but solely by means of vibrations and contrasts of colours… all of Nature can be reduced to coloured vibrations and must be obtained on canvas strictly in terms of coloured vibrations'. In other words, the colours were no longer neatly contained within visible or understood lines of drawing, but were clashed against one another as a kind of substitute for a more disciplined under-drawing.

Subject Matter

The notion that only certain subjects are suitable for painting was being challenged by the more adventurous artists long before the Impressionists opened the doors on their group exhibitions, but it was the Impressionists who finally destroyed any lingering belief in a hierarchy of subject matter. They did so by impartially painting whatever was in front of their eyes, judging the artistic merit of each subject according to the kind of technical considerations discussed in the previous chapter: composition, light and tone, colour, and so on. A subject that a previous generation would have dismissed as trivial or mundane might be far more satisfying from a technical or aesthetic point of view than one that was traditionally seen as serious and worthy.

As an aspiring Impressionist, then, you should be willing to tackle as wide a range of subject matter as possible, constrained only by your own awareness of what does and doesn't work in paint. That qualification is quite important, for most of us quickly discover that certain subjects just don't suit our painting style or temperament, and we quietly drop them from our repertoire. The alternative, which is to adapt the way you paint according to your subject matter, will probably prevent you from achieving a recognizable style of your own. A painter with a formidable technique such as Manet had both a 'quick manner' and a more considered manner, yet he often used his quick manner for portraits and still life, as well as for scenes of higher visual tempo, such as urban and landscape genre. The Impressionists' vigorous painting style inevitably drew them to subjects with a definite

sense of movement and activity. This is most apparent in their liking for peopled scenes, but it also comes across in many of their unpeopled landscapes, where the animation comes from, say, windy or unsettled weather; *A Gust of Wind* is the title of several Impressionist paintings.

I used the phrase 'urban and landscape genre' above to suggest the depiction of everyday contemporary life within a town or country setting. This was an important subject to the Impressionists, even though their works were never as fully 'genre' as the seventeenth-century Dutch paintings so described. For the Impressionists, the portrayal of everyday life was very much subordinate to the looser ambition of portraying light and mood. They were as aware as any that narrative painting can easily shade into illustration, which, on my understanding, sets out to deliver a single pictorial message, and succeeds or fails on that one level. A painterly picture has a more complex purpose and, one hopes, a more varied appeal. You should therefore try to keep any narrative element in check, lest it takes hold of your painting and pushes it into the realm of illustration.

What follows is a survey of the main categories of subject matter. The order in which the entries appear is not significant, for that would be to recreate the hierarchy that I am here suggesting disappeared with the Impressionists. I hope at least that one entry flows into the next with a sense of logic. In each case I've tried to place the Impressionist approach in an art historical context, as I firmly believe that a greater understanding of context does benefit your painting, or at any rate gives you more confidence in your own approach. We start with skies – not really a category like those that follow, but an important element that nearly all the outdoor subjects share.

◀ *Roses on the Sofa Table*, oil on canvas, 51cm × 41cm

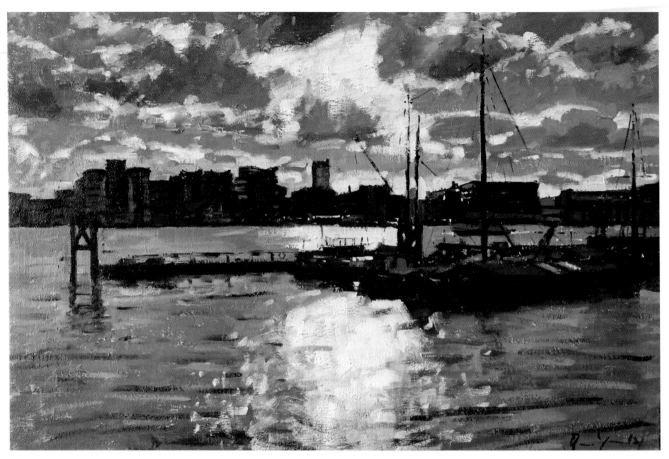

The Thames: April Sun, oil on canvas, 41cm × 61cm

A dramatic sky makes up for the fact that the stretch of the Thames to the east of Tower Bridge is not blessed with many recognizable landmarks. I've used hog brushes that have become rounded with wear; new or newish brushes would be too sharp-edged to portray the cumulus clouds that are here breaking down into sunshine.

SKIES

The way in which the sky is painted often sets the mood or tempo for an outdoor scene. This doesn't mean you have to paint the sky first, despite Corot's injunction that you should do just that and then relate everything in the landscape to it; this is to accord the sky an importance it may not merit in the particular scene you have chosen to paint. But nor should you automatically leave the sky until last, tempting though this is if, like me, you like to work from dark to light in the initial stages of a painting. It's a question of priority. The most interesting skies are by their very nature unstable and need to be got down as soon as they assume their most appealing formation, whereas a clear blue sky or a dense blanket of cloud are relatively stable and can be safely left to some later, quieter time in the painting process.

To make a faithful record of a sky that is changing by the second you have either to rely on the briskest of sketches, or to use a camera. Constable was one of the first artists to make a systematic study of skies through the medium of the sketch, producing small oil studies as aides-memoire, inscribed with the date, time of day and wind direction. Boudin did exactly the same in pastel, and in this way both artists were able to build up a visual reference library of different types of sky. As a result, the skies in their oil paintings always convince (Corot called Boudin 'king of the skies').

The camera was never a realistic option for a nineteenth-century painter of skies, and I think even its staunchest advocates today would acknowledge that it is not very good at conveying the drama and detail of the more active skyscapes. This may be because, as noted earlier, most cameras are calibrated in such a way that the sky gets over-exposed. Furthermore, photographs whose skies have been manipulated with colour filters and the like rarely look natural – though I have to say I'm often surprised at how garish some sunsets can be. Whenever I use a camera to capture a suddenly felicitous sky, I try very hard to memorize the colours and contrasts I saw with my naked eye.

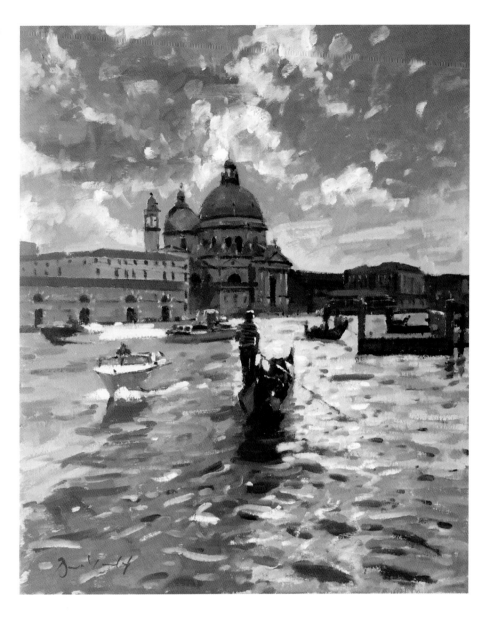

Lagoon Traffic, oil on canvas, 61cm x 51cm

I think I'm right in saying that all of the sky in this picture was painted with a no. 10 brush, and it looks as though, in keeping with Impressionist practice, I have stroked the paint on with no attempt to smooth the edges. The result is what is called gestural painting.

The Impressionists, as we have learnt to expect, painted their skies much more sketchily than did earlier artists. In particular, their habit of leaving the cream-coloured canvas to show through the quickly scrubbed-in blue paint was an effective way of suggesting the shimmering warmth of a sunny day. Sickert, for his part, liked to suggest hazy heat with vertical brushstrokes. The lesson here is not to allow the blue of a sky to become too solid, which is not only dull to look at, but also destroys any hint of movement. Bear in mind, too, that a clear blue sky is seldom a homogeneous colour; it nearly always pales as it nears the horizon. I usually see cerulean as the dominant hue in this near-horizon zone,

but others may see a different shade; the important thing is to modulate the colour in order to achieve a sense of recession.

Another necessity, I find, is to take down the blue of a cloudless sky: on such days, the blue can be rather piercing, and fight with the colours in the rest of the painting, unless balanced by the (usually deeper-toned) blue of any water that is reflecting it back. I take the colour down by using Naples yellow light to lighten a blue such as cobalt; this imparts a greenish tinge that then needs correcting with a warmer colour such as permanent rose. The resulting sky colour is far less pure than that seen in reality but is easier on the eye and makes for a more integrated palette.

I also use Naples yellow light to soften the white when it comes to painting clouds; my staple white pigment of titanium white is far too hard and cold a colour to be used on its own in this role. You need to be aware that clouds are lit by the sun like any other object, so will often have sunny and shady sides that have to match the direction of lighting in the picture as a whole. The soft forms of clouds don't really lend themselves to the angular brushstrokes of flat hog brushes; when I need to paint fluffy cumulus I reach for my oldest brushes, those most rounded with age. Streaky or menacing clouds seem better suited to the flat hog, and these are the sorts of cloud formation I prefer to paint. Maybe this is why none of the main Impressionists was, in my opinion, truly exceptional when it came to painting skies. Or is it perhaps that clouds are difficult to render convincingly on the positive tooth of a canvas? The brilliant, much imitated cloudscapes of the modern English Impressionist Fred Cuming are exclusively oil on board and would look quite different, I feel, were they painted on canvas.

RURAL LANDSCAPE

The popular perception of an Impressionist artist at work probably resembles Sargent's picture *Claude Monet Painting by the Edge of a Wood* (1885), the title of which is self-explanatory. Landscape painting as a separate genre within art teaching had been growing in importance from the early nineteenth century, and the mid-century arrival of paints in tubes, coupled with the swift development of the railway network, made it possible for artists not only to paint outside, but also to leave the towns and cities where their studios were sited and commute into the countryside for a day's painting.

In view of this, we might expect rural scenes to feature more prominently within the Impressionist *oeuvre* than they in fact do. Degas evinced no more than a passing interest in landscape, and although Monet painted a vast number of unpopulated, wild landscapes in the last two decades of the nineteenth century, his earlier work, even when it purported to be straight landscape, was often tinged with an urban character. As the novelist Emile Zola, writing in 1868 near the start of Monet's career, put it: 'Like a true Parisian, he takes the city with him to the country, and cannot paint a landscape without putting in men and women dressed in their finery. Nature seems to lose its interest for him as soon

as it no longer bears the stamp of our mores.' Another writer, Théodore Duret, later commented that Monet was never attracted to rustic scenes: 'you will discover no cows or sheep, and even fewer peasants'.

If the Impressionists did nurse a prejudice against soft or rural landscape it probably derived in the first instance from their young person's anxiety to distance themselves from the older generation of landscape painters as represented by the Barbizon school, and to counter-assert their own urban sophistication. Monet's later embrace of pure landscape may therefore be a case of an artist with his reputation secured being more able to choose his subject matter. Or it may relate to the death of his wife Camille in 1879, after which he turned emphatically away from figure painting for many years; landscape painting evidently helped to fill the void. A more practical impulse lay behind Sickert's decision to paint the English countryside for the first time in his mid fifties, when he was living in the middle of Dartmoor; apparently he could find nothing else to paint.

Rural landscape is an appealing subject for the novice, as it poses far fewer drawing challenges than do urban or figure subjects, and what little drawing it does demand from the artist is unusually forgiving: after all, who would know that that tree trunk is too thick, and that it shouldn't be leaning at that angle?

I confess that as a painter I've never been strongly attracted to pure landscape, with its vocabulary of hills and mountains, trees and fields; the populated urban landscape has always exerted a greater pull. Palette is part of the problem. My father always said that he found green an over-assertive colour, especially in summer, when the trees are in full leaf and rather blowsy in profile. I've always found this true, and like him, I prefer the more subdued palette and the skeletal arboriculture of winter, which gives the composition more texture and grip. Tree foliage is difficult to simplify at the best of times – for let's not forget an Impressionist will always be looking to simplify – without falling back on some ready-made formula. Sickert was told that Monet and Sisley took their handling of trees in sunlight directly from Charles Keene's drawings of trees in London squares, which is illuminating since Keene had nothing in common with the Impressionists in terms of technique. With grass, meanwhile, there's always the temptation to add in tussocky detail, where once you start, it's not always easy to stop.

Many landscapists seek out or introduce from their imagination some animating element, such as sheep or cattle. Black and white Friesian cattle are especially useful as they also bring an injection of colour contrast (insofar as black and white are colours) to what may be a predominantly green or brown composition. The insertion of the human figure on the same principle is generally less successful; the figures themselves are often tiny, and unlike urban scenes, where crowds congregate and can be suggested with a few flicks of paint, there is not the same scope for such abbreviation. In a rural setting, moreover, the figure usually needs a positive role if it is to look natural, and that risks making the painting less a piece of Impressionism and more a piece of reportage.

SNOW

One solution to the problem of an over-dominant green is to paint the landscape when it is covered in snow, which has the effect of inverting the usual tonal relationships. The sky will no longer be the lightest value, as it is in normal landscapes, but will be a useful mid tone between the darks of the trees and the white of the snow. The picture as a whole will have a wider tonal range, yet a more restricted palette. Whites such as titanium, which are usually too cold to be used unmixed, come into their own here, while the combination of snow and sunshine offers a rare opportunity to use colours you might not have used before. On sunny days, for instance, the shadows that are thrown across the snow are a vivid violet-blue one never sees in snowless scenes.

Snow and sun are an evanescent partnership, which obviously prevents you from working in front of the subject for any great length of time. This is particularly so for cityscapes, where snow melts much quicker than in the country. The town where I live, Bath in southwest England, has on average snow every other year but it rarely stays on the ground long enough to be painted, except for brief sketches. As a result, I like to make small-board sketches of snow scenes; I hardly ever tackle a large-scale snowscape. The difficulty of thinning white paint in order to cover large areas is another factor here: thinned white is never powerful enough – you have to reconcile yourself to going through a lot of paint. For larger paintings like this you might usefully call in the aid of the camera, to fix the image before the snow disappears. Cézanne's *Melting Snow at Fontainebleau* (1880) was apparently based on a photograph for this very reason.

Crescent Fields: Snow, oil on board, 15cm × 30cm

A brisk oil sketch of Bath's most famous crescent under snow, the buildings lit by low winter sun, and the dog-running party helpfully breaking the main horizontal.

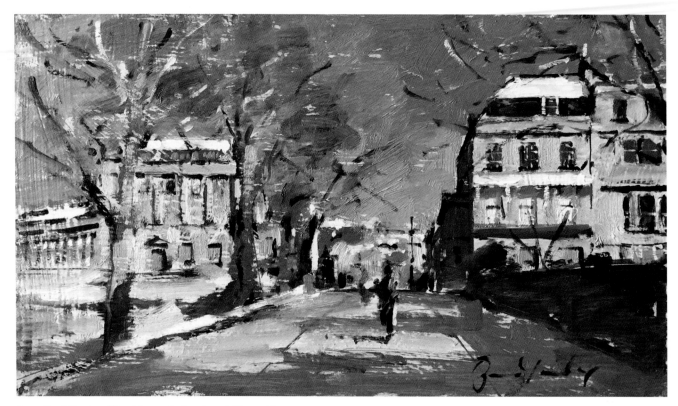

Snow: Brock Street and Royal Crescent, oil on board, 15cm × 25cm

An even smaller oil snowscape sketch, where all the brushwork remains very visible.

The accompanying cold doesn't make for fluent painting either; limbs and paints both stiffen up. You can tell a great deal about a painter's temperament by their attitude to painting snow. Monet relished the challenge, at least in his younger days. In 1869 he painted snowscapes around Paris; in 1875 he painted no fewer than eighteen snowscapes around Argenteuil; and in the severe winter of 1880 he painted ten of Vétheuil and Lavacourt. Renoir, on the other hand, could not understand his friend's enthusiasm for snow, which he called 'the leprosy of nature'.

NOCTURNES

Another type of subject in which the normal tonal relationships are reversed is that of nocturnes – paintings of dusk and night. Nocturne ('of the night') is originally a musical term for a romantic composition; Whistler commandeered its use for his pictures of the Thames at night, presumably to show they were intended to affect the viewer's senses in the direct, emotional way that a musical nocturne should. In fact, he had originally called his night scenes 'moonlights';

it was his patron Frederick Leyland, an amateur pianist, who suggested the word nocturne to him.

Whistler was attracted to dusk and dark because forms could be simplified, and colours lost in one general hue. He especially liked painting (or rather, memorizing) in fading light, when the details of the scene before him slowly receded, leaving only the essentials. No other Impressionist specialized in nocturnes to quite the same extent as Whistler. Monet took them on occasionally, treating them as part of a wider design of documenting light effects at different times of day. His sequence in the port of Le Havre, of which *Impression: Sunrise* is by far the best known, embraced dawn, day, dusk and dark. New types of port and ship lighting had transformed the nightscape in ports and harbours like Le Havre, making them paintable most nights and providing a variety of twinkling light; before, painters had been reliant on the presence of moonlight.

The introduction of street lighting in Venice was controversial, prompting protests among those who wished to preserve the city's unlit mystique. Sickert painted a number of nocturnes in Venice from 1895 to 1903, the street lighting hinted at rather than shown. The skies in these Sickert

From Rialto Bridge: Dusk, oil on canvas, 51cm × 76cm

Paintings of twilight allow the artist to deploy a different sort of palette, one that should have an inbuilt harmony since all the colours are fading together. In this view from Rialto Bridge the just-gone sunset is nevertheless bathing the whole scene in a rosy glow. The gentle wake from the nearest water-taxi breaks up the expanse of water.

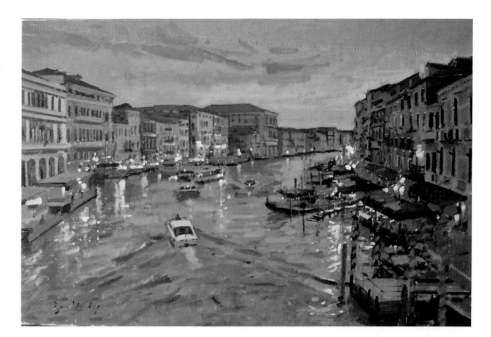

Belfort from Rosenhoedkaai, oil on board, 20cm × 25cm

This is apparently the most picturesque view of Bruges' defining building, and is also the time of day at which to catch the view, for as the sun went down I was surrounded by a band of photographers, many of whom had expensive-looking, tripod-mounted kit.

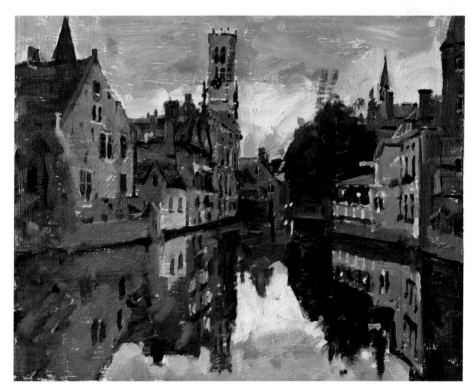

nocturnes were extraordinarily varied: red, green, blue and black. During the same period in Paris, the theme of night in the rain was briefly fashionable among art collectors, as exemplified by Pissarro's famous *The Boulevard Montmartre at Night* (1897). The fame of this picture, good as it is, probably derives from the fact that it hangs in the National Gallery; it's not representative of his work as a whole since it was, I believe, his only nocturne.

When painting nocturnes you will probably need to adjust your normal technique. They call for considerable thinning of dark pigments, and given that the sky is likely to be the darkest element in the composition this is best laid in first; the subsequent tones can then be related to the sky. It's obviously tricky to tackle these subjects on site. I remember seeing one dedicated plein air artist at work in front of Pulteney Bridge in Bath, with a torch strapped to

The detail-eliminating nature of nocturnes makes them congenial subjects for the Impressionist, and the first stage of this step-by-step sequence shows how little drawing is required to get things underway. The Embankment wall is the key lead-in device. The canvas has been used before; you can see the ghost of an earlier painting under the primed and tinted ground.

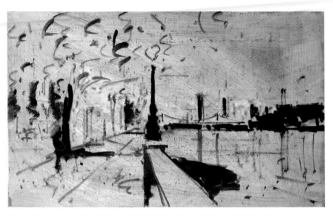

Even though much of the painting is going to be dark, it's still worth starting with the very darkest colours: these are a mix of ultramarine, burnt umber and permanent rose.

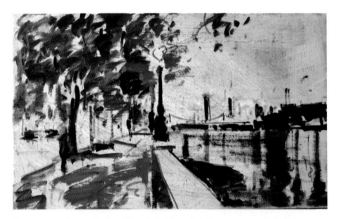

I'm now scrubbing in the slightly lighter, slightly warmer colours of the autumn foliage, all the time using the same brush, a no. 8 short flat hog.

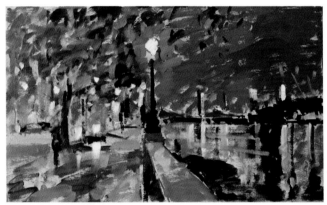

For the remainder of this first sitting I've continued to work with the no. 8 brush; I haven't bothered to clean it until getting to the highlights and coloured reflections, which do need to be of clean colour, even at this early stage of the painting. Note how the sky is lighter around the foreground wall lamp. Some of the light reflections in the river have been brushed on with a Morisot-like zig-zag that will probably disappear at some later stage. This first sitting has taken about thirty minutes in total.

his forehead like a surgeon so that he could see what he was doing. I suppose this is something you could get used to, but it looked to me an encumbrance. Most cameras, though, are pretty hopeless when it comes to night scenes: they boost whatever light is present, and many cast a yellowish sheen on the colours. Modern phone cameras are surprisingly accurate in their colouration but can't cope with the delicate pinpricks of light one sees at night, which through the camera lens flare into magnesium-like explosions of white. You simply have to try to memorize these facets of the scene; there's no other way. This indeed is how the nocturne supremo Whistler came to develop his memory-training exercises.

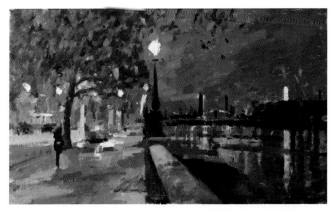

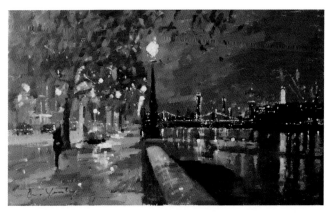

The whole painting has been worked over with a no. 7 brush to solidify the colours and define the forms. In these second sittings I no longer paint in strict tonal order. Broadly speaking, I work from left to right and from top to bottom, but this is not hard and fast – the composition itself will often pull my brush in different directions.

Chelsea Embankment at Night, oil on canvas, 30cm × 51cm

The final sitting revolves around the small-brush highlights. A subject like this is all but impossible to paint on site, but anyone who has tried to photograph night-time illuminations will know that it is equally tricky to capture the delicacy of those illuminations with the camera. Through the camera lens the strings of lights on the distant suspensions of Chelsea Bridge flare into an explosion of white light, so it's a question of noting down or memorizing the lacy interplay of light – just as Whistler did some 150 years ago (he lived in Cheyne Walk, about 100 yards from this vantage point).

Campo Santo Spirito: Night, oil on canvas, 61cm × 76cm

Brunelleschi's church and its square were just around the corner from the flat in which we were staying, in Florence's Oltrarno district. By day the square was not at all promising as a subject: it hosted a market and was clogged with the usual paraphernalia of transit vans and plastic tubs. By night, however, the café-goers reclaimed the space, and on this occasion there was just the right number of people to animate the scene while still allowing the eye to move through the tables and chairs.

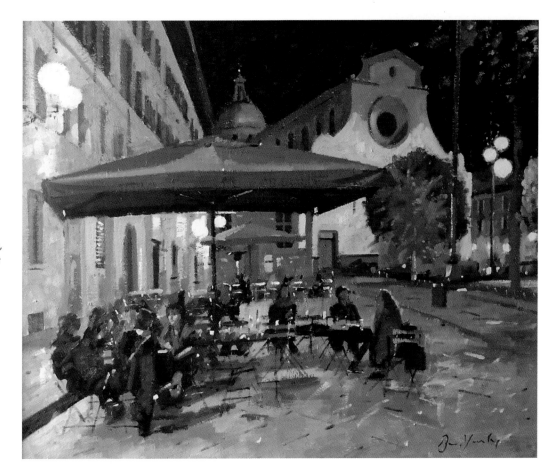

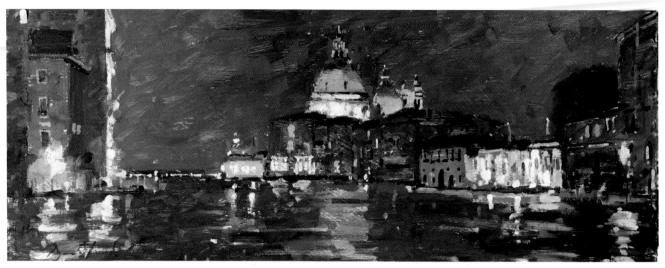

Salute at Night, oil on board, 20cm × 51cm

Those who in the late nineteenth century campaigned against the introduction of street lighting in Venice must be turning in their graves at the knowledge that several of the city's key buildings are floodlit at night. The modern painter, however, will applaud this development, for it extends our range of subject matter. In this panoramic board I've tried to keep all the darks skinny and almost translucent; thick, compact paint has a deadening effect.

MARINE

Marine or maritime art is strictly defined as the painting of seafaring subjects and was pioneered by that great seafaring nation the Dutch in their seventeenth-century heyday. The term has since been extended to include pictures of boats on rivers and estuaries as well as the open sea, and coastline and beach scenes. As such, it was a staple of several of the Impressionists, partly through the influence of Boudin and the Dutch marine artist Johan Jongkind, who together guided Monet's early painting forays on the Normandy coast. (Jongkind was invited to exhibit in the first Impressionist show but declined; had he not, he would probably be much better known today.) Monet was initially dismissive of Boudin's work, and reluctant to accompany him on painting expeditions, but after meeting him properly he quickly adopted the older man's methods and subject matter. In 1868 Monet spent much of the year painting the Channel shoreline, and two years later, newly married, he again joined Boudin to paint at the coastal resort of Trouville. Although Monet's Trouville paintings were for the most part informal studies of his wife and her companion, the beach setting is very important to their general ambience.

The Normandy coast, easily accessible from both Paris and England, was a great attraction to Impressionist painters on both sides of the channel. In Dieppe, Sickert worked alongside Degas and Whistler, and settled there for seven years from 1898. Morisot added marine scenes to her repertoire when the first leg of her honeymoon took her to the Isle of Wight. Later on, living mainly in Paris, her opportunities to paint the sea were limited, although like Monet she did at one point use a boat studio, from which she could tackle river subjects.

In 1868 the writer Emile Zola gave a big puff to the marine paintings of the still-young Monet, concluding: 'he's one of the few painters who can paint water without a silly limpidity or mendacious glitter'. Those adjectives are themselves silly and mendacious, but it's true that Monet's water – at this stage of his painting career, certainly – never looks forced or over-dramatic. He was especially good at capturing that most difficult thing, a gently rippling surface, as in his well-known painting of the boating lake, *La Grenouillère* (1869); poor old Renoir's treatment of the same piece of water looks positively jejune by comparison. Elsewhere in his piece, Zola wrote: 'In [Monet's] seascapes, you can always spot the edge of a jetty, the corner of a dock, something that fixes it in time and place.' These little glimpses of structure also help to fix the composition; a sea study without such compositional anchorage would be too loose and abstract to serve as an Impressionist painting. For it's worth remembering that a marine painting need only hint at the sea's presence; the sea does not have to dominate.

The great appeal of the sea, to the painter, is that it always responds to the sky, and consequently marine pictures should possess a built-in harmony of palette. The blue sky of a sunny

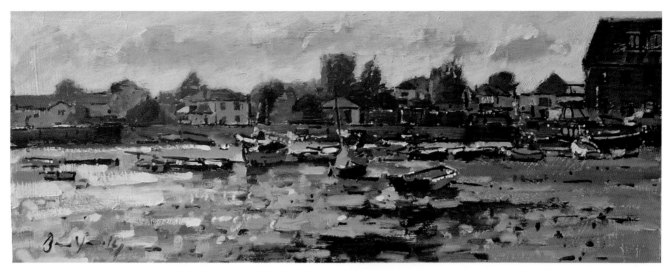

Emsworth Quay, oil on board, 18cm × 45cm

When I was growing up many of our family holidays were taken on the East Anglian coast, where my father could paint the fishing villages such as Blakeney, Pin Mill, Wivenhoe and Woodbridge. I wonder whether I have subconsciously steered clear of such subject matter in an effort to carve out a separate identity for myself as a painter. Whatever the case, this is a rare example of a marine picture, though even here it is the sun catching at the clouds and low water that makes the subject for me.

Seine Moorings, oil on canvas, 41cm × 30cm

In this painting of boats moored on the Seine only the Louvre in the background gives the game away that we are in a city, and that the city in question is Paris. The intersection of mast and bridge is crucial in firming up the composition.

day will normally produce a much deeper blue or blue-green in the water. A grey sky might yield a range of sea colours from grey to green, whose tones are closer to those of the sky than they would be on a sunny day. Broken cloud on a sunny day will often throw lilac or purple shadows across the surface of the sea, which typically makes the surrounding blue colour greener, presumably because the eye is overlaying the blue with yellow, the complement of lilac or purple. When the sky is dark with storm clouds the normal tonal values are reversed, and the sea appears a lighter tone than the sky. Finally, shallow water is more often than not a warmer, paler colour than deep water. The sea, in short, has plenty for both the colourist and the tonal painter to get their teeth into.

Sea is rarely still enough to offer up strong reflections, even on the calmest days. What reflections there are tend to be broken reflections, which is no bad thing, as they are well suited to the Impressionists' penchant for broken colour and the *tache.* For more stable reflections, we need to head for the harbour, where the water is pacified behind sea walls, or the rivers. Here, too, close observation is called for. Reflections in water nearer to you will be less distinct than those further away, while the nearest water will itself be darker in colour than that further away.

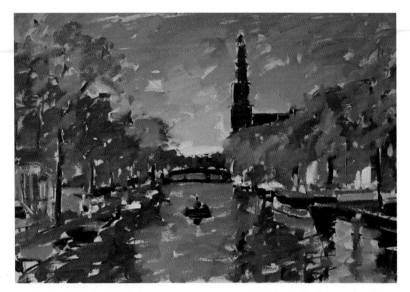

Marine meets urban landscape again in canalized cities such as Amsterdam, and many of the bridges across the concentric canals at the heart of Amsterdam have paintable views, especially when there is the strong vertical of a church tower to act as a focal point. For this painting of the Westerkerk I've illustrated the first session to show the contrast between the warm ground colour and the various paint applications: the ground tint imparts a golden glow that helps to unify the palette.

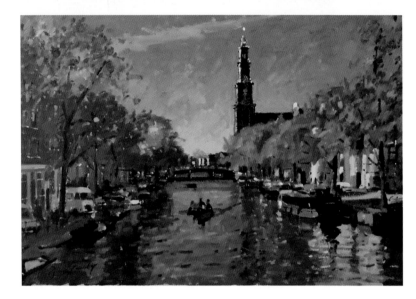

Westerkerk, Amsterdam, oil on canvas, 41cm × 61cm

Although much of the ground colour has now been covered over there is still, I hope, the sense of a glow beneath the paint surface. Monet's paintings of Amsterdam were at the back of my mind when I did this canvas. I should like to return to the city when the trees are not in leaf, and one can see more of the seventeenth-century canal-side buildings.

With regard to the watercraft, whether they're on the river or the open sea, I can only envy the nineteenth-century painters their mix of tall ships and steamboats. The modern craft of today seldom offer the same aesthetic satisfactions, and I can well understand why so many painters continue to seek out vintage specimens such as Thames barges, thereby risking having their work stigmatized as nostalgic and sentimental. Boats of whatever shape or age are notoriously difficult to paint anyway: they have to sit convincingly in the water, and to my eye the windowed cabins of many modern boats have 'faces' that insist you catch a likeness, as though you were painting their portrait. Of course, there are occasions when you can get away with treating the various watercraft in a very impressionistic manner, as did Monet in the misty dawn of *Impression: Sunrise* (1872), but on the whole you need to take care to get them right; inaccuracy here upsets people with any nautical experience.

Beach scenes are really a category of their own, as they may or may not feature boats or even the sea. Boudin's small-scale oils of Trouville beach are probably the best models for the aspiring Impressionist. The beachscapes of two modern English Impressionists, Ken Howard and Fred Cuming, are also inspirational. Howard's depict holidaymakers on Cornwall's south coast disporting themselves around colourfully striped windbreaks that he has, for reasons that become obvious once you have seen the pictures, re-named lightbreaks. Cuming's paintings of the East Sussex coast are altogether moodier, peopled only by the odd dog-runner or kite-flyer, and with the beach providing a low-level sub-structure for the dramatic skyscape above.

URBAN LANDSCAPE

There are relatively few pre-Impressionist paintings of towns and cities *per se.* In the seventeenth century the Dutch produced detailed cityscapes within the wider landscape genre, of which Vermeer's *View of Delft* (c 1659–61) is perhaps the best-known example. These were aimed at and bought by local merchants proud of their centres of commerce. The following century Italian and Italian-trained artists made *vedute* ('view paintings') for the Grand Tour visitors to such places as Rome, Venice and Florence. The French and British, however, remained resolutely uninterested in painting their own towns and cities; if Canaletto had not decided, in 1746, to move to England to be closer to his market (that had been disrupted by the War of Austrian Succession) we would have an even patchier painted record of the English urban scene in the mid eighteenth century. Later on, in the early nineteenth century, the city was emphatically off limits to the Romantic school of artists in obsessive pursuit of the bucolic picturesque.

Unlike these isolated early practitioners of urban landscape painting, the Impressionists were not, or at least not directly, painting for metropolitan parvenus and aristocratic souvenir hunters. They painted the city simply because it was there, and insofar as their pictures celebrate urban living, they do so from a more painterly concern with our old friends composition, light and tone, colour. Monet, in particular, was quick to grasp the pictorial possibilities of a modern working city, and his smoke-and-steam studies of Paris's Gare St-Lazare have no real precedent in art. Turner's

depiction of an early locomotive whooshing across a viaduct, *Rain, Steam and Speed* (1844), is not really the same, as it lacks the urban setting. The London that Monet painted was also grimily atmospheric, concentrating as he did on the fog and smoke that drifted over the Thames, as if playing up to French assumptions about London's murky light ('a setting sun seen through grey crêpe', in the words of the poet Arthur Rimbaud).

Monet's paintings of London satisfy because the angularity of the buildings, however softened they might be by gauzy light, serves to cut through the formlessness of the fog and smoke. This is what I like about the urban landscape. The straight lines that nature abhors, but which pervade the typical cityscape, are excellent at directing the eye around the painting and generally tying the composition together. Bridges are particularly useful linking features, and where their horizontal thrust is balanced by the vertical thrust of the architecture, a satisfying composition inevitably results. Bridges are also ideal places from which to find good subjects, as the rivers they span will naturally lead the eye into the scene, as well as supplying their own watery reflections. Whenever I am in a city to paint, I always make for the bridges.

One of the problems for the Impressionist painter of cityscapes is how far to simplify the often intimidatingly detailed architecture. As said before, I try to stop myself from becoming bogged down in detail by steering clear of the smaller brushes, a self-denial I find essential when it comes to buildings: an Impressionist painting should not look as though it has been commissioned from an architect's

Pont Neuf, oil on board, 20cm × 61cm

Where would the painter be without bridges? They supply both the subject matter and the means to paint it. This view of Paris' most venerable and inaptly named bridge is from a pedestrian-only bridge, the Passerelle des Arts. What made the subject for me was that the sun was striking all the cutwaters of Pont Neuf and from there reflecting in the water, which means there is enough action in the lower half of the painting without the need for river traffic – though two pleasure craft are in fact visible.

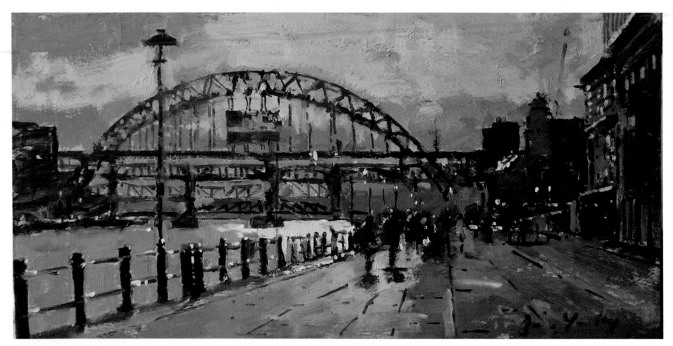

Tyne Bridge, Newcastle, oil on board, 15cm × 30cm

Newcastle's most famous bridge, a scaled-down version of the same firm's earlier structure in Sydney Harbour, is a complex of ironwork that I thought was best tackled on a small board. The *contre-jour* lighting makes it a very tonal painting.

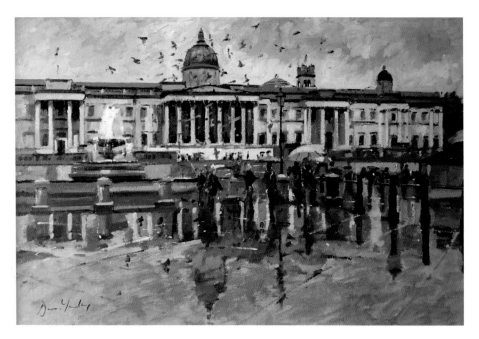

National Gallery Reflections, oil on canvas, 51cm × 76cm

The paved areas of Trafalgar Square are wonderfully reflective in wet weather, and a balanced composition is more or less assured in such conditions. When I first completed this painting I found the verticals rather too insistent, especially within the main portico. I toyed with the idea of moving the fountain across to obscure part of the portico, but this would have thrown all of the foreground details out, so in the end I introduced some pigeon action in order to take attention away from the pillars. The increased sense of movement was an unlooked-for bonus.

office. When a building is itself the subject of your painting, however, you do need to respect its architectural grammar and styling, for this is, in a sense, a portrait demanding a likeness. But even here, detail can be conveyed by suggestion, by for example observing the broad patterns of light and shade that play across it (surface ornament is all about the shadows such ornament will cast when lit by the sun). If you can analyse buildings in this somewhat abstracted way you will find yourself looking more kindly on ones that in normal circumstances might offend your architectural sensibilities. Sickert, for instance, told fellow painter Jacques-Émile Blanche that modern architecture added 'pictorial value' to the urban landscape of Dieppe, and in the case of London, the painter in me is not nearly as distressed as the tourist in me at its remorseless high-rise development. (I do though draw the line at New Zealand House, a 1960s nineteen-storey eyesore

Fifth Avenue Reflections, oil on canvas, 102cm × 122cm

Glazed shopfronts offer reflections across the vertical axis, and in this large painting of New York it's not immediately apparent which side is reflecting which. There is, in consequence, an almost abstract quality of geometrical repetition. The ground-storey scaffolding you can see on the left and right is a 'sidewalk shed', one of many that have been put up in Manhattan following the death of a child from a piece of falling debris a few years back – an urban hymn to the country's litigiousness. Fortunately, this stretch of Fifth Avenue was relatively free of them.

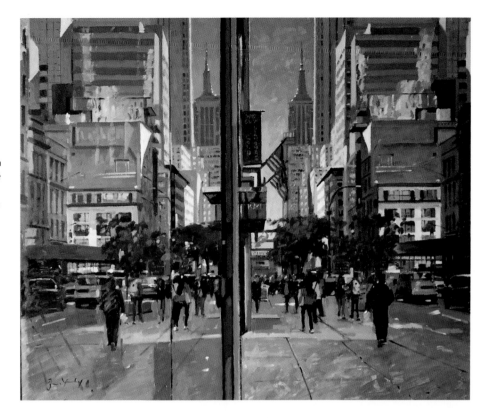

Manhattan Rain, oil on canvas, 76cm × 61cm

Move away from the shopfront and you lose the window reflection but, in wet weather, gain all sorts of traffic reflections. The brake lights show that these vehicles are slow-moving if not stationary, so they really need to be drawn and painted with some care and attention.

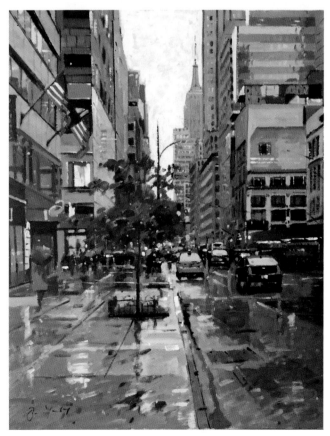

that photo-bombs almost every prospect of the otherwise very paintable Pall Mall.)

Besides, if you start removing what you think of as ugly, your work will quickly take on a romanticized feel that is quite at odds with the Impressionist embrace of the city in all its multi-faceted modernity. Road signage and other types of street furniture might be a clutter and a distraction, but for the painter, clutter and distraction can make for visual interest. Similarly, for many of us the modern car is an unlovely thing, but cars help to animate a scene, and in sunshine parked vehicles throw out an array of highlights that is not unlike the effect of sun dancing on water. Such highlights can usually be indicated with brief flicks of paint, as can the groups of shoppers and tourists who congregate in city centres. The urban painter should also learn to cherish

that unloved citizen of the world, the feral pigeon, who, whether on the ground or in the air, brings a distinctive animation to any urban composition. When Trafalgar Square was pedestrianized and de-pigeoned about twenty years ago it suddenly became a much more salubrious space in which to wander, sketch or paint; but something was lost in the process, and whenever I paint Trafalgar Square I re-pigeon it.

Rainy subjects are paintable in a city in a way they aren't in the countryside: the hard, wet road and pavement surfaces glisten with reflections, and the odd colourful umbrella prevents any rainy day tableau from becoming too monochromatic. In a high-rise city like New York sun is not such an advantage anyway, as so much of the streetscape is in heavy shadow. Rain is therefore a blessing to the painter of New York. It's a shame that Monet didn't take up an invitation that he received from one of his art dealers in 1908 to paint there; it would be fascinating to have an authentic Impressionist take on that city.

VENICE

Venice has a section to itself because it is a unique blend of marine and urban landscape. Nor is there anything quite like Venice for the painter of light. 'The loveliest city in the world' was the succinct verdict of Sickert, who made several trips between 1895 and 1903, a period when large numbers of painters from many different countries were gathering there. Monet, Manet and Renoir all painted there, as would have Morisot, had she not been prevented from going by an outbreak of cholera in the city. Monet was nearing seventy when he went, in the autumn of 1908. He was by then world famous, and the trip attracted considerable press attention. He stayed nine weeks in all, painting the classic, touristy views of the Doge's Palace and the churches of San Giorgio Maggiore and Santa Maria della Salute. These were the scenes that Turner had painted a hundred years before, and the fact that such a restlessly innovative artist as Monet saw no reason to look beyond the familiar should give pause to all those who complain that Venice is over-painted and impossible to treat in an original manner. As Ken Howard says, clearly with Venice in mind: 'It is nonsense to think that another artist may have had the last word about a particular subject. Whether it has been painted a thousand times before or not, it will never have been painted through *your* eyes.'

The first thing those eyes of yours will notice about Venice is the glowing, crystalline quality of the light, conditioned by the water that surrounds and permeates the city. A marine artist could enjoy a lifetime's worth of subject matter without once leaving the waters of the lagoon. The urban landscapist will be equally sated, as Venice has an extraordinarily rich architectural heritage – Byzantine, Gothic, Renaissance, Baroque, and Neo-Classical – all shimmering above the reflective surface of a canal network. And it doesn't stop there: the city's varied water traffic (*gondole, traghetti, vaporetti, motoscafi*) is wonderfully idiosyncratic, as are, in their more modest way, the canal mooring posts (*pali*) and lagoon channel markers (*bricole*). More than any other city, Venice is paintable in all weathers, all seasons, all times of day. In September, my favourite month there, the angle of the sun seems to be pleasing throughout the day, and there is also a good chance of a useful mix of weather. Summer is less rewarding: the sun climbs very high very fast, and shadow interest is quickly lost. Winter brings some of the most dramatic light, the only small problem being that the never-faraway figures are for the most part clad in black, which adds an oddly funereal note to your painting.

As for individual subjects, St Mark's Square (or Piazza San Marco) and its domed basilica have been painted by artists from medieval times onwards, the scene remarkably unchanged today. Early evening, with the sun just about to set, is widely considered the best time of day to paint the building's façade, but even better, to my mind, is after a fall of rain (and it may be days after, for the water finds its way into the city off the Dolomite mountains), when the façade is reflected in the standing water of the *aqua alta*. Its orientation is such that a *contre-jour* treatment is impossible, except very early in the morning when the days are longest. Like many, I prefer to paint it fully front-on, with the strong horizontals of its Byzantine architecture balanced and broken up by the equally strong verticals of the three flagpoles – which have also been there since medieval times – and the huge, seemingly out of scale campanile alongside. In 1901 Sickert planned a sequence of canvases of the basilica in different light conditions, all in the same large format (85cm × 100cm), very much in the mould of Monet and the west front of Rouen Cathedral from a few years before. The planned sequence never came to fruition, but he did complete several large-scale and influential pictures of the façade.

The oil sketch can be used as a test-run for a larger painting, and this twenty-minute study of Basilica San Marco was not only worked up into a finished painting but also acted as a preliminary study for a much larger canvas. The sketch was made with a no. 6 flat hog, and I think you can deduce the springy bristles of the brush from the ridged-paint brushstrokes.

Basilica San Marco: Study, oil on board, 20cm × 25cm

Returning to the initial sketch, I've added in a fair amount of detail with my 0 series nylon brush. I fear that some of the brushstroke vigour has been lost along the way, but the strong verticals and horizontals respectively of flag posts and architecture do need emphasizing, which can only really be done with the smaller brush. In truth, I didn't need a preliminary study to tell me what 600 years of Venice paintings had already told me, that the front-on view of Basilica San Marco makes a terrific subject.

Receding Water, Basilica San Marco, oil on canvas, 102cm × 122cm

In this much larger version I've tried to preserve something of the quality of the sketch by, for example, indicating the crowds of tourists as little more than patches of differentiated colour. Originally there was a bright pink umbrella in the middle of the painting, standing out against the dark of the central portal. I later removed it as it rather undermined the tightly controlled palette.

Morning Sun, Piazza San Marco, oil on canvas, 41cm × 61cm

Nearly all of my paintings of Piazza San Marco are directly in front of the cathedral façade. For this picture I've shifted position so that I can show the clocktower (Torre dell'Orologio) and its surrounding buildings, which unlike the cathedral are catching the morning sun, providing an all-important patch of high tone. In the foreground shade I've made the marble lines that are set within the paving slabs follow the lines of perspective – they didn't in reality – in order to balance the sloping horizontals of the basilica's architecture.

From Accademia Bridge: Study, oil on board, 20cm × 25cm

I make no apology for adding to the thousands of depictions of this particular view. It's one of the great views of the world. A lot of golden ground is left to shine through the brisk brushwork in this oil sketch, as there is always a sort of gold-and-silver glow to the scene as the morning sun moves up and to the right.

From Accademia Bridge, Looking East, oil on canvas, 102cm × 122cm

Again, in this large painting I've tried to preserve at least something of the quality of the preliminary sketch. The treatment of the sky, in which lilacs and salmon-pinks are scrubbed in dryish paint over a cream-coloured under-painting, owes much to the example of Monet.

Grand Canal from S Angelo, oil on canvas, 30cm × 51cm

The stretch of the Grand Canal from La Volta up to Rialto Bridge is front-lit for much of the day, and consequently there's no getting away from the architectural detail on view. I've therefore used my smallest brush – 0 series nylon round – to indicate that level of detail. I don't often use this size of brush on my canvas works.

Grand Canal from Rialto Bridge, oil on canvas, 76cm × 102cm

It follows from what I say in the caption to the previous image that the light from Rialto Bridge itself is *contre-jour* for much of the day, which in turn allows the artist to simplify the architectural detail. The canal traffic is at its busiest here, with gondolas, taxis and waterbuses constantly manoeuvring around one another.

Because the Grand Canal snakes in a reversed S through the city, the light and mood of all subject matter centred on it are constantly changing. As in other cities, the views from the (very few) bridges over the canal are the obvious starting points for the painter. The famous vista from the Accademia Bridge looking towards the lagoon, with the church of Santa Maria della Salute looming above the palazzi on the right, is breathtaking and uplifting, however much the novelty-chasers might yawn. The current bridge is a 1980s replica of the wooden one erected in 1933, which was itself intended as a temporary replacement of an iron one erected in 1854. I'm therefore a bit surprised that none of the Impressionists took advantage of this new viewpoint. Monet's pictures of the Salute were painted from Palazzo Barbaro, looking past the leaning mooring posts. The same view can be had

from Fondamenta di Traghetto, a discreet pavement just off Campo San Maurizio. Unfortunately, the number of mooring posts has steadily increased in recent years, and whenever I paint this view I now have to eliminate a lot of them. Past the Grand Canal's first bend, known as La Volta, the focus switches to the Rialto Bridge: subjects looking towards it are generally front-lit; those from it, looking back towards La Volta, are generally *contre-jour*. Round the second bend, just beyond the bridge, the fishmarket (La Pescheria) is another focal point; the stalls and ever-wet pavements in the shrouded loggia beneath the neo-Gothic building are themselves a marvellous subject.

As a painter, I find the quiet side canals a touch too claustrophobic and static, though I acknowledge that for many artists these are quintessential Venice. Not all Venice

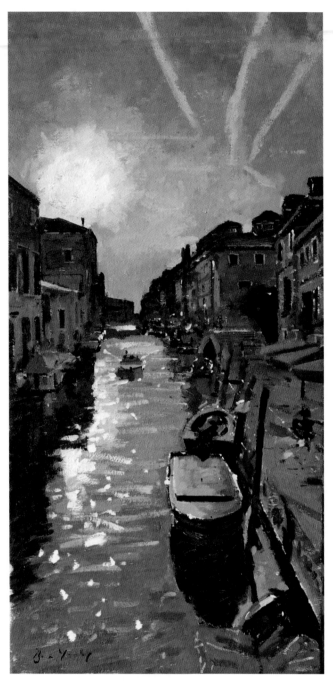

Sundown, Cannaregio, oil on canvas, 61cm × 30cm

Venice's side canals have never attracted me as much as the Grand Canal; there's a somewhat claustrophobic feeling to them, their waters a bit too still and mirror-like. The Cannaregio canal is wider, and compositions based upon it have more room to breathe. I like to think that the vapour trails and the approaching water-taxi prevent the picture from being too quiet and cosy a portrayal of a sunset.

Campo Santo Stefano: Afternoon, oil on canvas, 41cm × 61cm

I've painted this large square in the San Marco district at all times of day. I've here used a warm-tinted canvas, which shines through the paint in several places – sky, foreground and, in particular, the dark sienna pigment of the building in the centre, where the paint has been greatly thinned with white spirit. The central two figures were put in after the painting was finished, as I felt the foreground was slightly too empty.

paintings feature water, however, and the squares (or *campi:* only San Marco qualifies as a piazza), with their alluring blend of churches, cafés and prominent statues – especially the Colleoni monument, in front of the Scuola di San Marco in Campo SS Giovanni e Paolo – are invariably paintable. My first choice of square in which to paint is Campo Santo Stefano, in the San Marco district. It helps, of course, that there are no cars.

Venice paintings are instantly recognizable thanks to the topographical peculiarities outlined above. But I can't say I notice any other unifying factor to them, despite the city's incomparable 'envelope of light'. Ultimately the artist puts their own stamp on Venice. With their splintered brushwork and their vibrant, slightly acidic colours, Monet's 1908 paintings of Venice have much in common with his 1899–1901 paintings of London: when I see these pictures, I don't think 'Venice' and 'London'; I think, 'late period Monet'. Similarly, Sickert's fondness for the darker, sludgier colours transcends place, and his pictures of Venice and Dieppe seem to me to possess the same crepuscular dimension. Does this matter? I don't believe so. Every painting is a dialogue between the artist and their subject matter, and sometimes the artist's voice will be louder. I myself make no conscious effort to adjust my palette for Venice, all the while hoping that what I produce communicates something of the *genius loci.* Any Impressionist would hope that.

PORTRAITS AND FIGURES

Drawing and painting the human figure was and is the central concern of academic art teaching, and the academically trained Impressionists never entirely abandoned it in their own painting careers – or never for long. Their early figure paintings, when their professional prospects were governed by their performance in the annual Salon, were understandably conventional. Monet's life-size portrait of his companion Camille Doncieux, *The Green Dress*, was greatly admired at the 1866 Salon: it had a reassuringly high level of finish, despite having been painted at great speed (in four days, by repute). When he attempted the same kind of subject in an outdoor setting, employing techniques that we would now label as Impressionist, the Salon jury rejected the submission. He continued to paint Camille, albeit on a smaller scale, until her early death in 1879, at which point the human form disappears completely from his work for several years.

Degas, Renoir and Morisot were all figure painters first and foremost, and unlike Monet, Renoir painted the human figure more, not less, in his later career. But these were hardly ever portraits in the full sense: indeed, I can't think of any mainstream Impressionist for whom commissioned portraiture was important in a way it clearly was for, say, Whistler and Sargent. Sickert, like Degas, didn't want his figure paintings to be 'too definite' portraits; he wanted instead to capture an emotion suggested by a pose. In most of these paintings the figure itself is anonymous, representing a mood or action. This is the sphere in which an impressionistic technique comes into its own, as distinct from one that is intended to catch a close likeness. It's correspondingly more important, to the Impressionist, that the figure looks right in its setting, and that its tones and colours relate to those of its surroundings. When painting from the model in his studio, for example, Ken Howard paints the background colours first, before painting the model, 'partly', he says, 'because the subtle colours of the figure are affected by the more obvious surrounding colours'.

A portraitist or figure painter working in a stable north light can afford to take such a methodical approach. If, like me, you work in a studio in which the sun comes in you can't be so disciplined: you have to get things down on canvas quickly. My own figure paintings take as their inspiration the *intimiste* figure studies of Degas, Sickert and, especially, Bernard Dunstan, a twentieth-century English Impressionist much influenced by the first two names. (I should really add to this triumvirate Berthe Morisot, whose earliest paintings

Sonia at Ston Easton, oil on canvas, 61cm × 51cm

This was commissioned by a friend as a surprise birthday present for his wife, whose portrait it is. The surprise element meant I couldn't have sittings in the normal way; I adapted photographic reference material that was sent to me. The unifying element is the low sun coming deep into the room, so much so that one doesn't immediately notice how many different colours there are on view.

of women at their toilette actually predated Degas', but I confess that at the time – the mid 1990s – I was only familiar with a few of her paintings.) Dunstan's constant model was his wife Diana Armfield, herself a distinguished painter, and his informal – sometimes *very* informal – bedroom and bathroom portraits of her have a quiet tenderness. My wife Caroline sat for me in much the same way for several years. Sickert, who worked exclusively with professional models (or professionals of one kind or another), would not have approved; he thought it 'good artistic hygiene' not to use one's own circle for modelling duties. Someone else might have envied Sickert his business-like arrangements: it's said that Monet was persuaded by Renoir to take up figure painting again after the years-long hiatus referred to earlier, but the plan was vetoed by Madame Monet when she found he had engaged a good-looking woman to sit for him.

Lamplight, oil on canvas, 61cm × 76cm

In my early days of painting I was much influenced by the *intimiste* portraiture of Bernard Dunstan, who was himself much influenced by Degas, Sickert and Vuillard. Dunstan's pictures were mainly bedroom studies of his wife Diana, herself a well-known artist. In this bedroom study of mine, the paint has been dabbed on with discrete strokes, with virtually no shaping and modelling. There's a restless quality to the paint surface that ultimately I felt was not my own, so I moved away from the Dunstan idiom.

Morning Sun in the Bedroom, oil on canvas, 61cm × 122cm

The other painter from the generation above mine who has most influenced me (besides, of course, my father) is Ken Howard. It was after seeing some of his paintings of the model in his sun-filled Cornish studio that I attempted this bedroom study of Caroline. In order that the sun catches her hair I've turned her head-to-foot on the bed, which I concede is a bit contrived. The main draw, though, is the sun glowing through the silk curtain.

Many cityscapes and interiors have figures in them in a subsidiary role: these sorts of scenes would in fact look rather unnatural without the human presence. Figures provide a sense of movement and, quite often, some useful accents of colour. It's therefore important to develop a technique that allows you to render them convincingly but in a way that doesn't distract. The challenge here is that the human form is so familiar to us that the slightest error in drawing and painting stands out. Problems of scale are magnified when figures are present; so often, it seems, one comes across painted scenes populated by dwarves and giants. Impressionists such as Morisot, taking their lead from Manet, began placing identifiable people in their landscapes. This required them to paint those figures in some detail, with facial features and so on. I'd caution against such an approach, unless you are specifically painting a conversation piece or multiple portrait, for as soon as you apply features to a face the viewer's eye will go straight to them, creating a potential source of distraction.

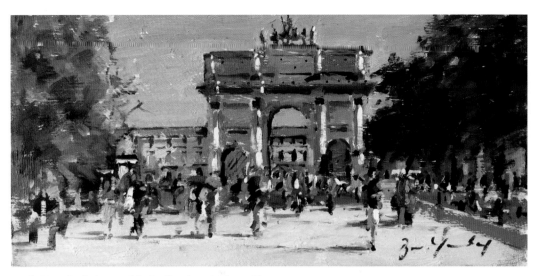

Arc de Triomphe du Carrousel, Paris, oil on board, 15cm × 30cm

The smaller, lesser-known Arc de Triomphe of Paris is located next to the Louvre, and is thronged not by cars but by tourists. At this small scale it is feasible to render figures with just a few dabs of the brush, which should in turn communicate a sense of movement. If you start to paint your figures with too much care and definition they'll stiffen up on you. The viewer will know that those flicks of paint represent figures and will mentally supply the missing information in order to 'read' them.

When the figures are small enough, a few deft strokes of the brush ought to suffice to make them recognizable as such: the viewer should know what those flicks of paint are meant to represent, and will be able to supply the rest of the information themselves. Before the Impressionists, it would have been almost unthinkable to treat the human form in such a manner. The abbreviated way in which the figures were painted in Monet's *Fishing Boats Leaving Port, Le Havre,* shown at the first Impressionist exhibition of 1874, drew derision from the sketchwriter for *Le Charivari,* who imagined the following exchange between two exhibition visitors:

'Tell me, what are these countless little black licking marks at the bottom of the painting.'
'Those? They're people strolling.'
'But these blotches were done the way they whitewash granite for a fountain.'

Actually, Monet's black-dressed strollers don't look to me to be at all roughly painted, but at this period any departure from the accepted Salon practice was bound to meet opposition.

A good general rule is to paint your figures in exactly the same way as the rest of the painting, again to ensure that they do not jump out at the viewer. If, as is usually the case, the figures are in motion, walking either towards or away from the viewer, you can suggest this movement economically by painting one leg shorter than the other, and perhaps using dry paint to create a broken, lost-and-found sort of line, which is less eye-catching than a solid, carefully painted one. This is more of a watercolour technique but it works well in oil too. At all events, it helps, I think, to try to view the figure – the figure in its subsidiary, animating role, that is – as an abstract dab or assemblage of colour; if you start to think of it as a real person you're liable to become over-anxious about your depiction, and your painting might lose fluency.

CAFÉS

Café or leisure scenes are a sub-category either of urban landscape or of figure painting, depending on how the artist treats them. Either way, the Impressionists were the first to popularize the subject. As a depiction of contemporary urban life in an outdoor setting, Manet's *Music in the Tuileries Gardens* (1862) was highly influential on the Impressionists as a whole, while Degas' portrayals of popular entertainments such as café-concerts were a particular inspiration for his admirer Sickert. I must say I've always enjoyed painting café scenes: cafés tend to be located in attractive spots within the town or city and there is usually a pleasing three-fold contrast of colour, tone and texture between the café's awnings and umbrellas (when sunlit) and its clientele in the shade beneath. My slightly defensive note registers the fact that

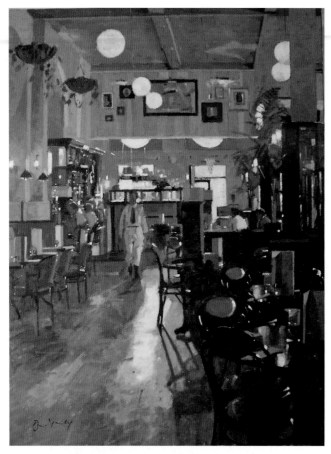

Browns Restaurant, Bristol, oil on canvas, 102cm × 76cm

The compressed palette, attractive fittings and shiny floor make this café-restaurant a favourite subject of mine. In this painting the foreground is relatively empty and the eye can wander at leisure to the approaching figure of the waiter and thence to the globe lighting above, which seems to echo the oval back-pads of the bentwood chairs.

these are unashamedly light-hearted subjects, and are often sneered at by the more puritanical painter or critic. Well, it's a comfort to know that the Impressionists themselves were not so jaundiced.

The paintings work best when the cafés are about half full: the mix of occupied and unoccupied seating and tables introduces a desirable modulation and allows the eye to move comfortably through the picture. The same principle applies whether it is an outdoor or indoor café subject. Indoors the light is less direct and there is not the same tonal contrast such as you get from a sunny day outside, so here it helps to have reflective surfaces that bounce the light around. This is why I like painting café interiors where there is lots of shiny, polished wood. Polished wood – floors, tables, chairs – gives the painting plenty of light-dark passages, which in turn helps to energize the composition. The majority of my paintings in

this vein are of one particular interior, that of Browns, a chain of café-brasseries whose styling owes much to fin-de-siècle Paris. I claim no credit for this subject matter: my father was painting it (mainly in watercolour) back in the late 1970s, when there were only two branches.

In restaurants where the floors are carpeted and the tables dressed in linen, the light, like the sound, is absorbed, so here you need another source of scintillation, such as glassware and cutlery. Whenever I come across a promising café or restaurant subject in which the tables are undressed I mentally dress them myself. The additions I make can be very simply indicated, especially the glassware, which I find looks most convincing when it is represented by just a few flicks of paint. The more interesting the table setting, the less important it is that the table is occupied; the painting should already have a good variety of light effect and texture.

STILL LIFE

That last word, texture, is perhaps the key element of our final category of subject matter. Still life requires its practitioner to closely observe stationary objects, and as such it may be felt that this is not a type of art that lends itself to Impressionism, which is primarily concerned with capturing the fleeting moment. I wouldn't disagree with that proposition, for I can't off the top of my head think of any influential or celebrated still life painting by an Impressionist. (You will have gathered that I don't consider Van Gogh to have been an Impressionist.) Yet we do have glimpses of accomplished still life painting within Impressionist pictures of a wider compass, the best known being the foreground bottles, fruit and flowers in Manet's *A Bar at the Folies-Bergère* (1882).

When not relegated to a supporting role like this, still life as painted by the Impressionists tended to be small-scale and floral. This is significant, for flowers, notwithstanding the French term for still life (*nature morte*), are living when cut: they open, close, curl, droop and drop petals. An Impressionist floral still life will seek to get across that sense of fragile vitality. Manet's signature flower was the peony, which is also one of my favourite flowers to paint. It runs through a spectrum of colours and a variety of shapes from bud to full bloom, without ever being too blowsy or blobby, such as roses can be. The peony has a narrow season here in the UK but there are plenty of good alternatives. The tulip's elegant goblets assume wonderfully varied angles as the stems continue to grow at different rates. The horn and trumpet of lily and daffodil respectively are strong,

Last of the Sun, Molo San Marco, oil on canvas, 61cm × 76cm

So many Venetian cafés have delightful backdrops, but this one takes some beating. Towards the end of the day the crowds thin and the eye is free to move through the scene to the Dogana and Salute on the horizon. I liked the colour combination of the blue umbrellas and mustard tablecloths. The tables themselves were undressed and looked a touch forlorn, so I have dressed them myself with some flicks of paint to suggest water tumblers.

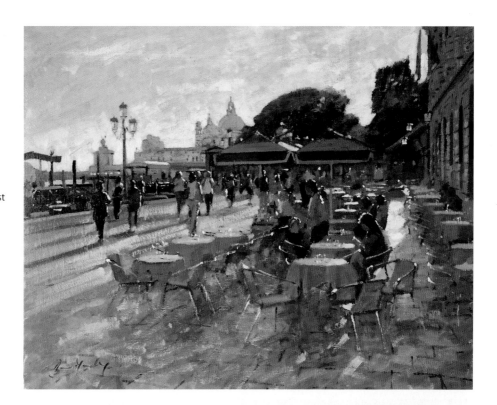

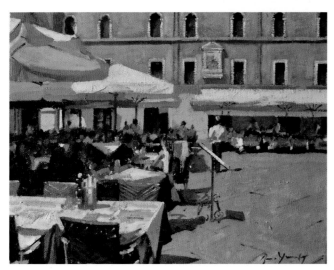

Cafés in Piazza Signori, Verona, oil on canvas, 41cm × 51cm

Another café scene in which the unoccupied foreground tables allow the eye to rove through the composition. The sillband on the background building performs the same visual function in the painting as it does on the building itself: it ties together the different architectural elements.

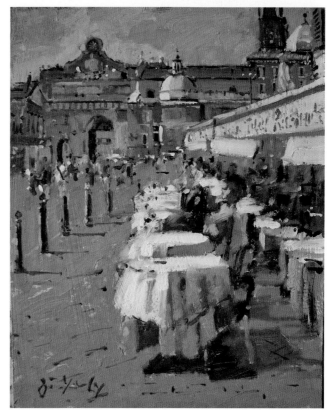

Piazza del Popolo Café, oil on board, 25cm × 20cm

A Roman café this time, with the same desirable combination of occupied and unoccupied tables.

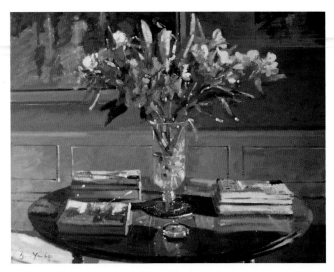

Still Life with Lilies and Paperweight, oil on canvas, 61cm × 76cm

This is very typical of my still life paintings inasmuch as (a) the flowers are caught in a low sun that is streaming deep into the room, and (b) the flowers are posed on a polished tabletop surrounded by books and magazines. The dado rail behind provides a strong horizontal.

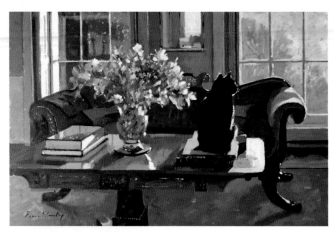

Phoebe Where She Shouldn't Be, oil on canvas, 51cm × 76cm

Our cat Phoebe kept gatecrashing this painting – any jumpable surface is irresistible to her – so in the end I just had to put her in. And I'm very glad I did, as she makes a striking light-ringed presence in this *contre-jour* study of flowers and Regency furniture. I gather that black cats are more likely than other cats to be abandoned by their owners, because they don't photograph as well in selfies. If this is true I despair at some people's aesthetic judgement, as well as their cruelty.

Mantelpiece, December Sun, oil on canvas, 41cm × 61cm

Mantelpieces make great still life subjects not only for the structure they bring to the painting, but also for the variety of object you can place on it to paint. Here I have brass and silver candlesticks, glass decanters, flowers, and greetings cards – different textures that all make for interest.

distinctive shapes that remain recognizable even when painted very impressionistically. Smaller-petalled flowers such as carnations and daisies are not so easy to capture with brisk economy.

The flowers I paint are not arranged with a view to painting them; they're simply placed in vases in different rooms in the normal way. I like to be surprised by a subject, and I couldn't be this if I had constructed the composition beforehand. Usually it is the way in which the light suddenly strikes the

arrangement that makes the subject; half an hour later, the light will have changed and the subject gone. The flowers are often set up near a window where they will catch the sun, the view through the window at the same time adding depth and interest. These, then, are essentially interiors with the flowers serving as a focal point, rather than studies of flowers in their own right. In winter the sun comes much further into the rooms, enabling the arrangements to be sited away from the windows, which in turn allows more of the room to feature in the composition. The peripheral domestic details are accordingly very important. Most of the paintings feature Regency antiques (the same is true of many of Berthe Morisot's interior paintings: in her case, family heirlooms from the Empire period, the French equivalent of Regency). The furniture is of a period with the sash windows and other Georgian fixtures so I like to think it looks right, rather than self-consciously old-fashioned. The polished surfaces of the tables perform the same reflective role here as they do in the café scenes.

In most of these paintings the vases holding the flowers are sitting on round mats, which reminds me that round objects, when viewed on the angle, form themselves into ellipses. These are notoriously difficult to draw. Recent decades have seen a fashion for still life painting that dispenses with perspective altogether: and so we get wonky vases, plates and so on floating front-on to the viewer above table settings that have become mere backdrops. An Impressionist would never abandon perspective in this way.

The more static kind of still life subject (bottles, glasses, plates, food of various kinds) was traditionally painted in super-realist detail – especially by the Dutch – so that the viewer could better appreciate the colours and textures of the objects on show. This was obviously a very different artistic ambition from that of the Impressionists, and when I have tackled this sort of subject matter my main inspiration has been someone outside the Impressionist mainstream – William Nicholson, an underrated twentieth-century British artist whose beautifully intense still life paintings are not as well known as they should be. A Nicholson still life will typically contrast textures, such as a silver bowl beside a handful of shell-on peas, or a glass jar behind a pair of gloves. My own non-floral still life paintings are almost exclusively of mantelpieces, on which stand glass decanters, brass candlesticks, greetings cards, a mahogany mantel clock – a line-up of Nicholsonesque textural contrast, with the mantelpiece itself providing the linking structure. I make a point of painting these pictures front-on to get the strongest verticals and horizontals, and as with the flowers, I prefer to come across the subject rather than pre-arrange it. They're nearly always midwinter subjects, for only then will the sun reach the mantelpiece and play off the various objects standing on it.

SCALE

I want to close this chapter on subject matter with a few words on scale – the size at which you execute your painting. I do so here to engage with the sometimes-quoted comment of the Scottish watercolourist Dugald Sutherland MacColl: 'subjects have their sizes'. Even if you doubt that there's a firm correlation between subject matter and size, it still makes sense to keep a variety of sizes of canvas or board in stock, to ensure that you're always able to paint at the scale you feel is right for the picture you had in mind. Whenever I run low on canvases there's a good chance I'll choose and start a subject that doesn't for one reason or another suit the canvas I have available. The fact that I usually realize my error long before the painting is finished is small comfort.

There's no rule or easy way of matching subject to canvas size; it comes with experience, a constant evaluation of which paintings – both yours and others' – sit comfortably in the canvas, and which don't. This is why it infuriates me when art books fail to give the dimensions of the pictures they illustrate: it's so much easier to judge or enjoy a work when you can

conjure up a mental image of its actual size. Some gallery websites now offer a 'view on the wall' facility, which allows you at the click of a button to view the selected painting in graphically represented actual size with, say, a chair displayed alongside for scale. That strikes me as a very useful tool for anyone who struggles to picture bald dimensions.

A few years ago I went through a phase of painting outdoor/busy subjects small and indoor/sedate subjects large. I must have felt at the time that scale was related to visual tempo, and that large busy paintings would be exhausting on the eye. This was overly schematic and I no longer compartmentalize my paintings in this way. The strongest subjects, after all, make good paintings in many different sizes, and it's often a good idea anyway to test out your largest works on a much smaller scale first. Many of my largest canvases, which in recent years have stabilized at 102cm × 122cm, are trialled as 20cm × 25cm sketches. (The eagle-eyed among you will have spotted that these are not identical shapes; they are, however, the conventional dimensions at those respective scales, and are not so dissimilar in shape as to be misleading.) The subjects of these paintings are usually architectural with a sense of grandeur – St Mark's Basilica, St Paul's Cathedral, Empire State Building from Fifth Avenue, the view from Accademia Bridge. They work as small-scale sketches because the architectural detail can be efficiently indicated with the smallest brushes. As a result, my oil on board sketches often look more detailed than many of my middle-sized canvases, where the use of small brushes is prohibited.

Sickert's largest paintings were likewise of monumental buildings: St Mark's again, and the Church of St Jacques in Dieppe. In general, though, he was suspicious of working on a large scale, which he compared to drinking green Chartreuse from a mug. Figures in *intimiste* interior settings, at which he excelled, lose much of their defining intimacy when painted on anything approaching a large scale. And then there is the commercial imperative. Sickert wouldn't have been the first artist to discover that modest-sized paintings have a better chance of selling; his smallish Venice paintings did very well both commercially and critically, but at the time averaged only £4 per picture. Monet's enormous waterlily compositions were literally inconceivable before he had acquired fame and wealth, and could build the necessarily capacious studio in which to work. Finally, plein air painters, such as Monet had been, are conditioned by what they can accomplish in the time, and it is rare to find a genuinely plein air painting above a certain size, regardless of subject matter.

End Matters

Renoir is supposed to have said, 'the purpose of paintings is to decorate walls'. That may well be apocryphal, for it's the sort of thing that any number of artists might have said at one time or another. But in essence it's true, and it applies equally to paintings of every level of ambition and accomplishment. This final, brief chapter discusses the various ways in which we make our painting ready to decorate that wall – whether a gallery wall or just a wall at home – looking first at how we may correct earlier errors in the painting, and then at how we should title, varnish and frame it. Although these end matters are not at all Impressionism-specific I shall again intersperse my commentary with accounts of how the principal Impressionists dealt with them.

TROUBLESHOOTING

The great advantage that oil enjoys over watercolour and other water-based mediums is that it is relatively easy to correct mistakes with the viewer none the wiser. Embrace this quality: there's precious little virtue in leaving your faults on display. To those who suggest that your technique might suffer if you give yourself the crutch of revisiting and altering work I'd simply say, life is too short for such counsels of perfection, and the ability to recognize and correct faults is itself an important part of an artist's equipment. Besides, perfectionism takes artists in different ways. Berthe Morisot, for instance, preferred to abandon work rather than try to

rectify a blunder; Degas, by contrast, was prepared to rework the same painting over many years.

It was unusual for an Impressionist to sign a painting while it was still wet. The painting was allowed to dry, it's now thought, so that any mistakes could be painted over. The technical term for these overpainted mistakes is *pentimenti* and art historians delight in detecting them. Some are clear to the naked eye, others emerge ghost-like through X-ray. In Monet's *Bathers at La Grenouillère* (1869) there's evidence that he painted out a section of sky in the upper right-hand corner, while Renoir's *At the Theatre* (*La Première Sortie*) (1876–7) was originally a very different composition. Many's the painting of mine that has received remedial treatment, sometimes long after completion and exhibition in galleries. On occasion, the galleries themselves have alerted me to what they feel might be holding a painting back, and while I don't always agree with what they tell me I'm always grateful for the opportunity to take a hard, critical look at the work in question, with a view to improving it.

Photographs that I've managed to keep of the original paintings have made possible these 'before' and 'after' images to illustrate this process. I refer the reader to these captioned images as the best way of understanding what can go wrong in a painting and how it may be corrected, but some broad observations are in order here. A lot of the time I find I simply haven't communicated the brilliance of sunshine in the way I'd hoped, and therefore need to strengthen the lighter tones, or alternatively deepen the darker tones. I can't think that I've ever had to do the opposite, which is to compress the tonal range in order to subdue the brilliance. With regard to colours, though, I often find myself having to take these down for the sake of palette harmony. Prime candidates for

◀ *From Accademia Bridge: Morning,* oil on canvas, 76cm × 51cm

This painting, of the Double Cube Room at Wilton House, suffers from a lack of credible tonality. The blinds were half-drawn, casting a dull, even light over the chamber, which forced me to import some spurious pizzazz. The result is a busyness of twinkling light that doesn't 'read'. I was about to paint over the thing when I remembered, many years ago, my father telling me that one of his favourite paintings was John Lavery's oil of the Double Cube Room. It's called *The Van Dyke Room* (1920) and is everything my picture wasn't. In Lavery's painting the room was mainly in shadow, with shafts of strong sunlight from unseen windows catching a couple seated in conversation on the long sofa at the far end. Most of the floor was unrugged, the floorboards providing a quiet contrast to the ornateness of the room's other furnishings. I now saw a way forward for my own painting.

Baroque Saloon, oil on canvas, 51cm × 61cm

The first thing I did was to substitute floorboards, with their gentle sheen, for the visually unrelaxing carpet. Next, I cooled the entire palette, which meant scumbling thinned paint over virtually the whole painting. Finally, I eliminated most of the fussy gilded highlights. I did consider introducing a seated couple *à la* Lavery, but in the end decided that this would be an act of homage too far, and anyway difficult to pull off convincingly. My painting lacks the animation of Lavery's (among other things) but is much easier on the eye than it had been.

What's going wrong in this painting of the Pitti Palace in Florence? Well, the lawn is boringly empty. Also, the blue of the sky has the same tonal value as the green of the lawn, and there's nothing to link the three horizontal segments of sky, building and grass; on this last score it would have helped if the obelisk had been more centrally placed on the canvas.

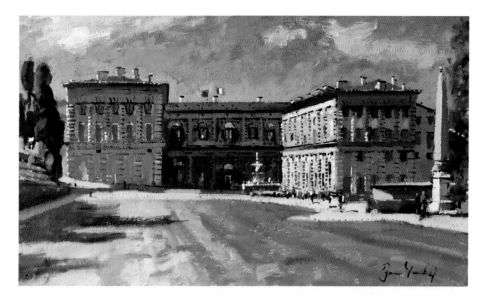

Pitti Palace, Garden Front, oil on canvas, 30cm × 51cm

The obvious solution to the first problem was to people the lawn. When adding figures like this, you need to make sure that they are lit in accordance with the lighting conditions of the picture, which in this case means lit from the left. I took my figures from a couple of paintings I had done some years before of operagoers at Glyndebourne. They look rather over-dressed to be regular tourists but it's entirely conceivable that somewhere such as Pitti Palace would host a smart reception. The sky, meanwhile, was lightened and scuffed up with dryish paint to give it a different value from that of the lawn.

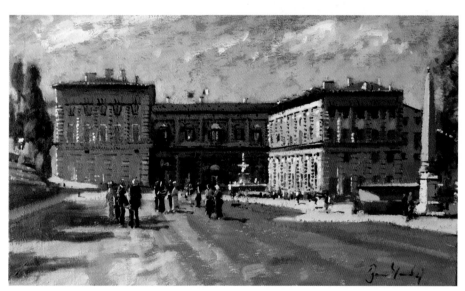

this treatment are the greens of grass and the blues of sky and water. The greens are dirtied up with earth colours, while the blues are rendered greyer with the addition of, say, permanent rose and Naples yellow. I must re-emphasize that there is nothing to be ashamed of in altering the tone/colour register in this way; only artists with perfect tone or colour pitch get these things right straight off.

Nearly every other problem relates to composition. Even if you have tested a composition with a sketch or small-scale version beforehand, the finished painting could still reveal nagging infelicities you hadn't anticipated. Eye-catching figures or objects might need to be moved or removed. Dull, empty spaces might need to be filled or enlivened with greater texture. Horizons might need to be raised or lowered. The possibilities are endless. For the most serious

compositional failings the final resort is to cut down the painting. This is obviously easier to do with board than it is with canvas, which needs to be restretched at the new size. I keep a store of differently sized stretcher pieces for this eventuality. It wasn't unknown for the Impressionists to cut down paintings. Degas' portrait of a trapeze artist, *Miss La La at the Cirque Fernando* (1879), was originally a larger composition – the careful preliminary drawings he'd made had not immunized him against compositional error.

One accidental benefit of cutting down a painting is that its brushwork and paint handling will suddenly appear more confident at its new, smaller scale. I imagine we've all at some time or another looked at a passage within one of our pictures and thought, 'that would make a vigorous little painting, if only I had the courage to cut it down.'

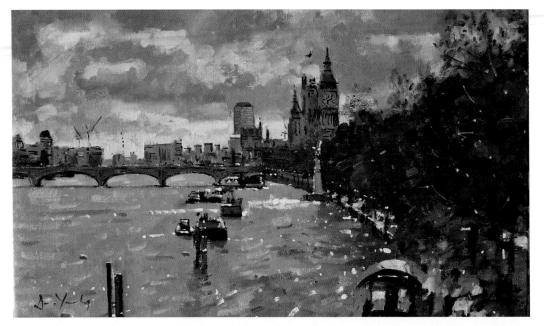

In this picture of Westminster from Hungerford Bridge the floating bar that usually occupied the foreground area had been taken away for repainting, and the view was emptier as a result. Although the sun was beginning to break through the clouds and twinkle on the river surface, I didn't think there was enough going on in the painting: sky and water were both a bit grey and uninspiring.

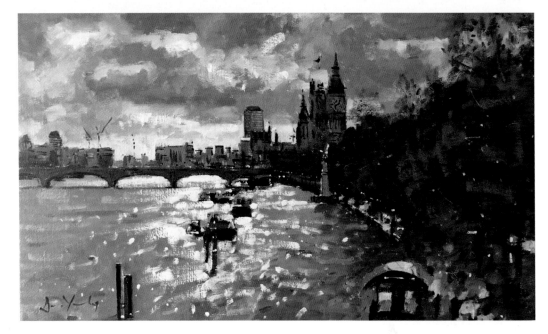

Lightbreak over Westminster, oil on canvas, 30cm × 51cm

I therefore decided to re-imagine the picture with the sun breaking through and lighting up the water much more extensively. The sky only needed a few extra highlights, while the water received a lot of dry-brushed sparkle – titanium white mixed with Naples yellow light. Note how the red hull, which should now be in silhouette, has been darkened. I've also introduced some olive green relief to the tree foliage along Victoria Embankment.

The other advantage of oil over watercolour is that canvas, unlike paper, may be re-used, so one shouldn't get too distraught when a painting has to be put out of its misery. I have in my time painted over (re-primed and re-tinted the canvas) nearly 500 pictures. Of course, it's slightly depressing when you realize that this represents several years' work, but a more sanguine way of looking at it is that each paint-over represents a salutary lesson, and one that also halves the cost of the canvas. The actual experience of painting on a once-used (or even twice-used) canvas is not very different from painting on a new canvas: the tooth is slightly less pronounced, that's all.

Only once, I think, have I destroyed the canvas along with the painting. Perhaps I'm just not volatile enough to be a true artist. There are, unsurprisingly, lots of stories of the Impressionists destroying their work, which are always lapped up by journalists as they serve to confirm the popular perception of the artistic temperament. Berthe Morisot is said to have dropped her failures in the lake on the Bois de Boulogne when at work there, and it seems likely that she

In general, I prefer not to edit out things like scaffolding: they are part of the picture, and sometimes have a pictorial value beyond the surface unattractiveness. However, once I'd completed and exhibited this view of Piazzetta San Marco it became quickly clear that the shrouding on the Basilica was holding the painting back.

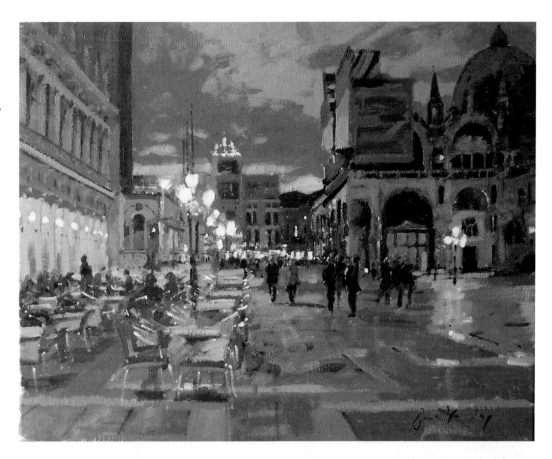

Piazzetta at Night, Looking North, oil on canvas, 41cm × 51cm

We go to Venice quite regularly, and there was a good chance that on our next trip the scaffold shroud would have been taken down. So it proved, and I was able to paint in the newly exposed architecture. Nothing else needed altering – any slight difference in colouration between the two images is accounted for by the fact that they were photographed on different cameras.

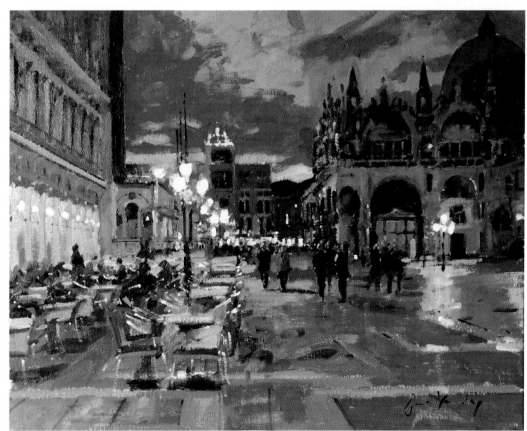

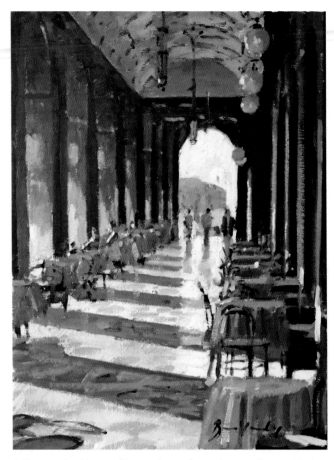

A Piazzetta San Marco café scene that really needs more clients: a 50:50 blend of occupied and unoccupied tables seems to work best, pictorially speaking. Unfortunately, it's very difficult to add seated figures that convince, especially when the lighting effects are so complex, as they are here. So, what to do?

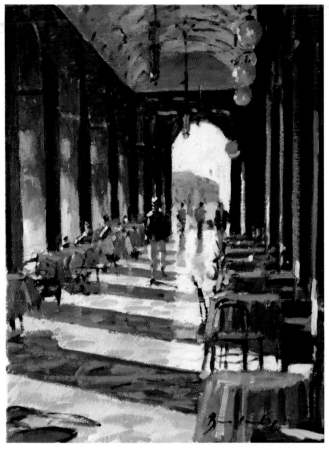

Arcade Café, oil on canvas, 41cm × 30cm

My solution is a sort of conjuring trick. I've painted in a walking figure that, while not large, is now the main focus: the figure draws the eye, and it no longer matters (except to the proprietors of the establishment) that most of the tables are empty. The painting has become a study of a figure strolling through shafts of light in a handsome Venetian arcade; it's no longer a study of a depressingly under-patronized café.

destroyed many of her more youthful efforts, since only two dozen canvases painted before she was thirty are known to survive. In 1907 Monet casually told Lilla Cabot Perry that he had burned over thirty paintings that morning. As he explained to her: 'I must look after my artistic reputation while I can. Once I am dead no one will destroy any of my paintings, no matter how poor they may be.' The following year the *Washington Post* reported that Monet had destroyed pictures worth $100,000 that he considered 'overworked'. Well, it would be nice to have that luxury.

TITLES

The purpose of a painting's title is not always straightforward. Quite often it is the artist's way of telling the viewer what to look for in the painting. You could, for example, use it to draw their attention to what you think is a telling detail, or a passage you're especially pleased with. The title, in other words, is part of the composition, and I did consider dealing with it in my earlier discussion of compositional matters. If you can't think of a title for a particular painting it might point to a fatal flaw in the work itself, namely a lack of a subject. If on the other hand a number of titles suggest themselves to you during or after the painting process, that's probably all to the good; a painting may have more than one subject, as different viewers will readily attest.

One of my bêtes noire is galleries who change the titles of paintings without reference to the artist, almost always in order to substitute some generality of location. I blush to see in catalogues or on websites paintings of mine unhelpfully titled *Venice* or *London*. A certain level of information is simple good manners. For topographical scenes, I often try to indicate not only what the painting is of, but also from where it is painted. This should be of particular interest to any viewers who are themselves painters; I for one like to have this angle when looking at others' work.

If the light or weather is clearly a strong element in the painting this too ought to be recorded in some way or other – season, month, time of day and so on. I find it curious that Monet made no reference to the time of day in his titles, given the precision with which he sought to record a moment in time. The titles of his Venice paintings have the whiff of the gallery substitution about them – *The Doge's Palace, San Giorgio Maggiore*. Surely he wasn't that unimaginative... or maybe he was? One story has it that Renoir's younger brother, Edmond-Victor, impatient with Monet's banal titles in his submissions for the first group exhibition of 1874, persuaded him to vary them by calling one *Impression: Sunrise*. Later on, Monet did reference the light and weather conditions with

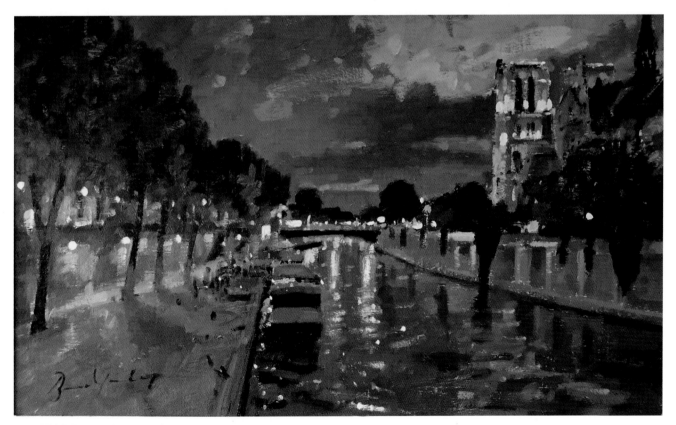

From Pont de l'Archevêché: Night, oil on canvas, 30cm × 51cm

This is a classic view of Notre-Dame so it's both more imaginative and more helpful to use the title to identify the bridge from where the picture is made.

Radcliffe Square from Hertford College, oil on board, 25cm × 20cm

The painting here is not just of the Bodleian Library's Radcliffe Camera – the Baroque rotunda in the centre – but of the architectural ensemble around the Camera, and I think a title such as this helps to get that across to the viewer.

such formulations as 'snow effect', 'rain effect'. Here one feels that something has got lost in translation, for these are not very evocative phrases in English.

Any consideration of Impressionist titles has to recognize that they may not have been chosen by the artists themselves. Renoir's *At the Theatre* (1876–7) has been known by various names in the course of its life, while Sisley's *Factory in a Flood, Bougival* (1873) – which admittedly trips off the tongue rather nicely in English – is now assumed to be a modern invention, for the building in question is patently not a factory but a lock-keeper's house with a detached, smoking chimney alongside. Still, the titles provided by certain artists, where known to be authentic, are revealing and instructive. Those from the pens of Whistler and Sickert are characteristically

flamboyant. Whistler, seeking to associate his art with the perhaps more universal emotive power of music, borrowed the vocabulary of musical taxonomy (harmonies, symphonies, nocturnes, arrangements, variations and so on) and wedded it to his customary, and equally idiosyncratic, pairings of colours (such as pink and green, grey and brown); a more conventional description of the subject matter was tacked on as a sub-heading. The resulting titles have all the conceit and preciosity of the man himself, and I wouldn't recommend you copy his formula: it's not really for you, the artist, to proclaim the 'harmony' of what you've done. That said, I have occasionally applied a Whistlerian pairing of words to the titles of certain of my Venice paintings. They often exude a mineralogical air, as in *Grand Canal, Silver and Bronze*; or

Tower Bridge from London Bridge: Morning, oil on board, 20cm × 25cm

This is a very straightforward style of title, but it's one I find myself using all the time: in the space of a very few words it tells the viewer what the painting is of, where it is painted from, and at what time of day. Any fellow painter – indeed, anyone at all – should want to know these details.

La Salute: Copper and Lead. Pretentious? Some might think so, but I'd counter that all I'm trying to do is direct the viewer to what I consider to be the dominant theme of the painting, which in both these cases is the restricted palette of colours.

Sickert, an ex-actor who enjoyed drawing-room theatricals, often gave his paintings playfully obscure literary titles, to induce a sense of mystery and intrigue. In titles such as *La Callera* (a woman of the streets) and *A Marengo* ('To Hell with It') he flaunted – to those in the know – his familiarity with Venetian colloquialisms.

The fact that titles can't be copyrighted allows artists to use their own titles to reference other works of art or entertainment. Sargent's famous picture of young girls playing with Chinese lanterns, *Carnation, Lily, Lily, Rose* (1885–6), takes its memorably rhythmical title from a line in a popular song of the time, 'The Wreath'. In the past I've smuggled in the odd reference to books, songs, films and other paintings. It seems a harmless way of acknowledging an artistic debt: those who don't spot the reference can't object, and those who do spot it should get something more out of the picture. A title, when all's said, should make you want to go and look at the painting it names. Early on in my career I did a small oil of my niece Florence holding two teddy bears, one of which was upside down. I called it *Teddy Up, Teddy Down,* and exhibited it in a mixed show at a local gallery, where at the private view I was delighted to hear a young girl, clutching a printed list of the exhibits, remonstrating with her parents: 'No, I don't want to see that one – *I* want to see *Teddy Up, Teddy Down*!' She'd have been flummoxed when she stood before the actual painting, as the gallery had decided to rename it *Florence with Bears.*

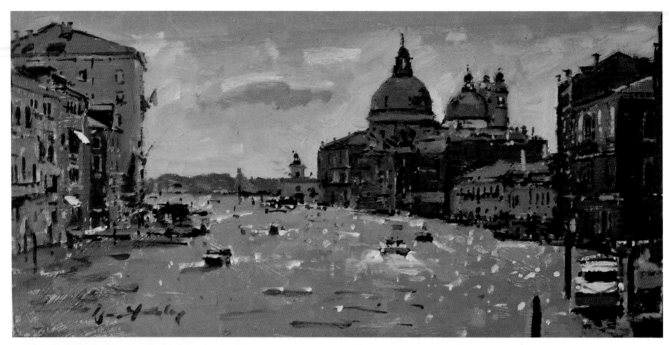

Grand Canal: Silver and Bronze, oil on board, 18cm × 35cm

I hesitated before using a Whistlerian pairing of colours in any of my titles as it could be thought pretentious, but when I view a painting like this I really do feel that silver and bronze sum up the look I was trying to achieve – silver for the twinkling water, bronze for the semi-silhouetted palazzi.

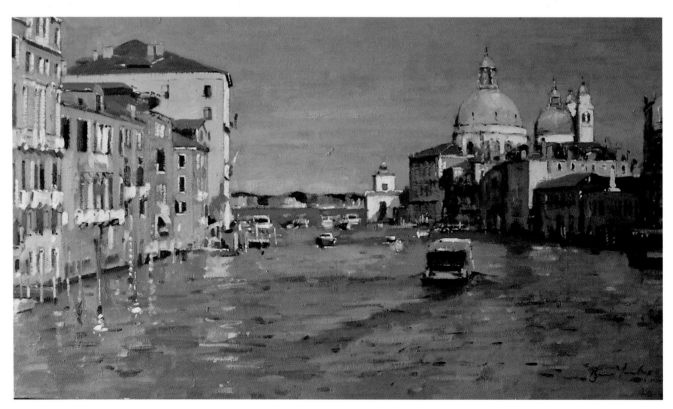

La Salute: Copper and Lead, oil on canvas, 51cm × 91cm

Another Whistler-inspired title – in this case, the copper colour is in the buildings, the lead colour in the water. This sort of title can quickly pall if you overdo it, of course.

VARNISHING

The reason for varnishing a picture is two-fold: first, to protect the paint from dirt and grease; and secondly, to restore to the colours a unified gloss, saturation and clarity, which they may have lost during the drying process. When to varnish is another matter, for there's little agreement over how long that drying process can take. Some people will tell you that oil paints need about nine months to dry thoroughly, others maintain that they don't completely dry out for several years.

Temporary or re-touching varnishes are the obvious solution for those of us who wish to exhibit our work, and have to get it to galleries in the space of weeks rather than months. But even here, much needless confusion is caused by the inconsistent claims of the manufacturers. At various times I've bought and used the re-touching varnishes marketed by Winsor & Newton, Daler-Rowney and Roberson. Winsor & Newton's calls itself 'a temporary protection for recently finished oil paintings', which seems clear enough. Daler-Rowney's, however, is 'to improve cohesion when fresh oil colour is applied to a dry painting', while Roberson's is for 'refreshing sunken patches during the painting'. It may well be that all three products can be used for all three purposes, but I'd feel happier if the makers came out and said so, particularly as the recipes are sometimes tweaked. For instance, I noticed that the composition of one jar of Roberson varnish was damar resin/rectified turpentine, while the next was damar resin/white spirit – which sounds like a cheaper substitute.

I use re-touching varnish in the role prescribed by Winsor & Newton, as a temporary protection for the newly finished work. I wait until the painting is touch-dry – typically about one week later – and lay it on as a single thin layer. I have to say it never unifies the gloss, saturation and clarity in the way it's been advertised; if anything, it exaggerates the contrast between the matt and gloss passages, before fading to a duller finish in a few months or so. I deduce from this that a more uniform finish can only be had from a more permanent form of varnish. This has traditionally been applied to the painting by dealers rather than artists, and the practice was wont to create tension between the two parties. Many of the Impressionists strove for a matt look and tried to discourage their dealers from varnishing the pictures, while the dealers believed that a shiny, varnished painting stood a better chance of selling. Monet's long-time dealer Durand-Ruel told him bluntly, 'Collectors find your canvases too plastery'.

Today we have the choice of gloss, matt or semi-gloss varnish, so squabbles like this should be a thing of the past. Naturally, my sympathies are with Monet and the other Impressionists. A high gloss finish will submerge any subtle differences in texture and brushwork, and its reflective quality means the painting is only really visible from front-on – all very well in a gallery where the paintings are scrutinized in this methodical, slightly artificial way, but rather off-putting at home where the paintings are perforce an everyday background presence. I think I'm right in saying that most serious painters of an Impressionist bent would favour one of the more matt-like varnishes.

If you're worried about your distant, posthumous reputation you'll be vexed to know that the long-term consequences of varnishing and not varnishing are equally problematical. According to those charged with cleaning Impressionist paintings, the resins present in varnish cause discoloration and the 'complete distortion of key values of colour and texture'. On the other hand, when a painting has never been varnished, 'the build-up of grey dirt directly on the paint surface can be both distorting for the image and difficult to remove'. That's probably why many of us choose to stick with the halfway house of re-touching varnish, however it is described on the label.

FRAMING

There's little doubt in my mind that an Impressionist-inspired painting needs a frame to complete it. The modern trend of hanging unframed canvases works all right for large abstract pieces, whose artists probably view the demarcation between wall and artwork as something fluid anyway, but an Impressionist piece will always look scruffily incomplete when it is hung without a frame.

The old adage that a frame can make or break a painting is probably right, so it goes without saying that you should never skimp on framing costs. The quality of a frame is readily discernible to the least discerning observer, and what you spend on your frame announces to the world what you think of your work. We're all no doubt accustomed to seeing quite accomplished paintings in local art societies peering out apologetically from frames that look as though they've been knocked up from some two-by-four, then painted white. Yet it's a shock to find frames like this turning up on professional paintings in commercial galleries. I have the impression here

I've used handmade, hand-gilded frames for almost as long as I have been painting professionally. Extravagant? Yes, but not unwarrantedly so. Gold paint cannot replicate the lustre of gold leaf, nor can a machine-made finish replicate the modulation of a hand-finished colour-wash. This frame has a neutral-coloured, fairly angular profile and single inner band of gold; until a few years ago my frames had an outer band of gold as well, a less fashionable look than it once was.

order of craftsmanship from mass-produced products, and when my work began to sell I thought myself justified in having them on my pictures. Looking back, I suppose this was presumptuous and not very business-like. One gallery owner told me straight that my frames were too expensive; framing, she said, should never be more than ten per cent of the wall price (mine must have been closer to twenty per cent). I saw her point – and I pass it on for the benefit of the reader – but this was my expense, not the gallery's, and I have never regretted that youthful extravagance. So far as I was concerned, the frames dignified the paintings. Twenty-five years on, I still use Christina Leder frames, and they now represent a conventionally acceptable proportion of my costs.

The frames are not fully bespoke: I cannot justify commissioning individual frames for individual paintings, much as I should like to. In practice, canvases are constantly being put in and taken out of one frame or another. I therefore ask Christina, who knows my palette well, to colour-wash a batch of frames in subtly different ways within the same broad tint, to give me the best chance of matching painting with frame at some unspecified point in the future. Until about five or six years ago the frames had two gold bands – one inner and one outer – but latterly have had just the single inner band. This reduction in the gilded element reflects both my own changing taste and that of the marketplace – an increasing number of people seem to find gilded frames a touch old-fashioned. (The combination of gilding and coloured wood is known in antiques trade parlance as 'parcel gilt'.) For the same reason, I've also inclined towards the flatter and more angular moulding profiles in recent years.

The frames for my smallest paintings, the oils on board, are again handmade. I've been able to witness how these are made, and for those interested the process is as follows. First, raw wood mouldings plus slip insert are bought from a specialist supplier, Rose & Hollis, and assembled in a local gallery workshop. They're then sealed and coated with several layers of gesso, as described in the section on boards in Chapter 1. The finish is achieved by overlaying an off-white paint with dry-brushed strokes of various chalk paints, which are then rubbed and waxed to create a slightly glossy yet slightly distressed look. For the band of gold, sections of gold leaf are water-gilded on to a ground of red or black bole in the traditional manner. The level of distressing and of gilding burnish varies from frame to frame but I want always to have at least some distressing, for I believe this helps to integrate painting and frame.

that it's not simply a question of cost. The plain white frame, which is usually very cheap, is perhaps the art equivalent of the home decorator's plain white wall: an easy non-decision. It *might* not ruin the picture, and the picture *might* still sell, but the artist has narrowed their market by not giving much thought to their framing obligations.

The benefits of a really good frame were brought home to me early on. My father had been painting professionally for over ten years by the time I took up painting in earnest, and had progressively upgraded his framing as his work became better known. For oils, he had frames handmade by a London framer-gilder, Christina Leder, who also supplied painters such as Ken Howard. I could never have afforded these sorts of frame when I first started painting, but it was immediately apparent that they were of a completely different

If you're framing up a number of pictures there's a balance to be struck between making sure the frame is right for the individual painting and maintaining some uniformity of style across the group. This latter consideration partly explains the ubiquity of the plain white frame. Another justification for the use of white that's sometimes put forward is that it permits every colour within the painting to play its full part. Maybe so, but the white itself should be soft, not the harsh, brilliant white one so often encounters, which does nothing for the palette of a typical Impressionist-type painting.

My own preference for a pale, slightly variegated colour wash on a flattish moulding with a restrained amount of gold would, I think, earn the approval of the Impressionists themselves, though I claim no credit here, as I've only recently learned about their framing stipulations. Most of them disliked the ornately carved and gilded frames that had been in fashion throughout the eighteenth and nineteenth centuries. Degas, for example, felt that the heavy gold frames promoted by the Academy 'crushed' his pictures. The deep mouldings of frames like these throw a shadow across the painting and the wall, spoiling Degas' desire for blending painting, frame and surrounding wall-space. He designed his own frames, which had shallower, flatter mouldings and were subtly coloured or white, though he did on occasion use gold, as did Renoir, especially for his portraits. The commercially minded Monet also favoured at least some gold on his frames, as he thought it lent a touch of luxury that would help the painting sell. In his 1883 essay on Impressionism, Jules Laforgue argued that different subjects called for differently coloured frames, something anticipated by Mary Cassatt at the fourth Impressionist exhibition of 1879, when she exhibited portraits in red and green frames. Later on, Pissarro showed paintings in frames of the complementary colour to the dominant colour of the painting itself.

And finally, in order that someone can get a proper look at your newly framed painting, hang it at eye level. It's all too common to see in domestic homes pictures hanging far too high on the wall, where only professional basketball players can appreciate them. In over-subscribed, juried shows such as the Salon in Paris and Royal Academy in London it was always a mark of high favour to have your work selected and hung at eye level ('on the line'), and a corresponding mark of disfavour to have it hung high up ('skied'). If nothing else, it's much more aesthetically pleasing to show pictures at a comfortable-to-view height. The exception to this rule is mass hanging, where naturally some pictures will be more difficult to view than others. But no artist – certainly no artist looking to make a living from painting – is likely to complain about someone mass hanging original art.

INDEX

RELATED TITLES FROM CROWOOD

978 1 78500 240 3

978 1 78500 324 0

978 1 78500 108 6

978 1 78500 671 5

978 1 78500 673 9

978 1 84797 750 2

978 1 78500 601 2

978 1 84797 715 1

978 1 78500 230 4